Related Twilights

For Nini, David and Rebeka

Josef Herman

Related Twilights

Notes from an Artist's Diary

Edited by Tony Curtis

Preface by Nini Herman

seren

Seren is the book imprint of
Poetry Wales Press Ltd
Nolton Street, Bridgend, Wales
www.seren-books.com

First published in 1975 by Robson Books
© The Estate of Josef Herman, 2002
Preface © Nini Herman, 2002
Introduction © Tony Curtis, 2002

ISBN 1-85411-312-7

*The publisher works with the financial assistance of the
Arts Council of Wales*

Printed in Plantin by Gomer Press, Llandysul

Contents

Preface to the First Edition

The reading of this book may not prove to be a feast or a banquet: I did not intend anything so grand. Some of the material was written over the years, in various forms, for various occasions. The reason for bringing them together was perhaps purely egotistical – a kind of exercise in self-awareness: the first part is all memory, the second part all observation, the third an attempt to understand myself through the vision of others. I hope that the threads of subjective moods and opinions are enough to hold all three together.

For a complete sense of the book as autobiography, all three sections do need to be considered. Each of the places I have visited or lived in meant something in my life. For instance, places like La Rochepot or Andalusia enriched my instinct for draughtsmanship and nourished my imagination for some time. The artists I write about are included not for what they meant in themselves but rather for some qualities which were particularly meaningful to me; each has contributed to my artistic self-revelation. A meeting with Morandi, for example, unplanned and unexpected though it was, made me more conscious of the need to live as an artist – of the need for an artist to shape his destiny through his work and only through his work. He was for me a shining example of a painter totally committed to his work.

In composing the book I did not intend to set myself up as a writer, but simply to explain myself in words and talk about ideas and atmosphere which – precisely because of their literary and anecdotal nature could not find their way into the medium of painting. Besides, I must confess to deriving enormous pleasure from writing now and again, no matter how little my success. In this I am probably like so many other painters past and present who have found the struggle for words yet another way of self-expression both necessary and satisfying.

J. H., 1975

Preface to the Second Edition

In the early 1970s Josef Herman was painting the portraits of a number of Anglo-Jewish literary figures including Dannie Abse, Arnold Wesker and the publisher Jeremy Robson. It was in the course of Jeremy's sittings that this book was born. Josef was at the time one of Britain's leading post-war artists. Later he would receive an OBE, gold and silver medals from the Royal National Eisteddfod of Wales and be elected to the Royal Academy in 1990. Essentially a collection of pieces 'written over the years in various forms for various occasions' the three sections of *Related Twilights* cover Autobiography, Places and Artists. But the totality has a single voice, that of a major artist reflecting on his early life, on art and on other artists; through it all emerges an unwavering dedication to work.

Strangely, the section Autobiography, the only attempt Josef ever made at setting down his life story, ends abruptly in 1955. Did the wrench of finally leaving Ystradgynlais in Wales that summer, 'his' mining village with its close community, so deeply embedded as his second home, evoke such agonising memories of parting from Warsaw and his family in 1938, that he could not envisage 'another life', even if by the early seventies it was well under way with a second marriage and two children? Certainly when we met, later in 1955 in his rented studio in Swiss Cottage, although he was once more fully at work, there was a distinct sense of something provisional, almost of camping, with the marriage to his first wife, Catriona, at an end following the stillbirth of their baby and her subsequent disorientation and despair. Looking back on those traumatic years it would seem that the creation of this book helped him finally to put another past behind him and to enter a new present.

In the 'The Years of the Sun', in Autobiography, we find a deeply moving – a heartbreaking – evocation of his childhood in Jewish Warsaw; three generations in a single room, in an area of tall, overcrowded tenements to be presently destroyed by the Nazis. There is something excruciatingly vulnerable, a sense of a child's helplessness, in the little one's passionate devotion to his young mother and in his instinctive, almost prophetic search for any rare, quiet corner where he could be left to his dreams in what he describes as 'my street'.

He was a child who, like the others, left school with a sense of relief at the age of thirteen to fail abysmally at successive, irrelevant jobs: the eldest son wanting desperately to support his family in its near destitution. The mood changes in 'The Years of the Moon' and the storms of adolescence, as when he and his

friend Stephan 'like two hunters set out to look for a girl or two... Our spirits too were full of light! There would never again be any darkness! The light would go on forever... Hurray for freedom, for girls and for light!' Already as an eight year old he had been enchanted when Master Xavery Rex – 'the greatest artist who ever lived' – sent him out from his shop to buy 'half a pound of ultramarine', the colour of the paint still peeling from the gate of Josef's former home in Ystradgynlais. It was not until a friend of his uncle, concerned at the stalemate in the teenager's life, took him to meet Eli Adler that things fell into place. An idealistic and progressive type-setter, it was Adler who initiated in his apprentice a growing recognition of the direction his life was irrevocably to take.

<p style="text-align:center">* * *</p>

Almost like a miracle against unsurmountable-seeming odds grew Josef's ultimate decision to leave Warsaw, its provinciality, anti-semitism, pogroms – and home – to follow the call to Belgium, 'the country of Breughel, the peasant Breughel... for whom the peasant represented a doorway to humanism', a concept still something of a harbinger at the time. And so, by 1939, at the age of twenty-eight, settled in Brussels, with a successful exhibition behind him, the direction of his life seemed set when, with the outbreak of the war, he fled ahead of the invading German armies through Belgium and across France. A further succession of miracles found him among a boatload of Polish airmen bound for Canada but diverted by threat of submarines to Liverpool. From there, again by pure chance, a journalist drove him to Glasgow. He wanted company.

Glasgow, with a first exhibition, new friendships and marriage, was to prove a stepping stone to London from where another lift, this time from Dai Alexander Williams, took Josef for what was intended to be a stay of a few days at the writer's home, the mining village of Ystradgynlais. The visit, from within moments of catching sight of miners crossing a bridge 'against the full body of the sun', turned into a stay of eleven years. After a period of aimlessness, Josef 'felt my inner emptiness filling'.

When we come to the Places section in this book, 'A Welsh Mining Village', 'A Strange Son of the Valley', 'La Rochepot' and 'Amsterdam' belong to the earlier post-war years and the marriage to Catriona. On to the time of his visit to Israel, Josef was recovering from a serious bout of bronchitis which the doctors attributed to the damp climate of the Swansea Valley. More probably the great task of producing the large panel of miners for the Festival of Britain in 1951, and the breakdown of his wife, had put Josef into hospital for a number of weeks after which some 'time in the sun' was recommended as a cure. In Andalusia we spent six months of the winter of 1958, and the chapter on the Mexican village grew out of our stay of some weeks on the shores of Lake Patzcuaro. New York Josef visited several times in the early nineteen-seventies.

With regard to the Artists section, not long after Josef's return from Israel the collector and art dealer Eric Estorick took him as an adviser through France and

Italy to visit the studios of Derain and Morandi. Epstein and Gotlib were both friends, while work by Marsden Hartley, 'who spent years in Nova Scotia amidst the fishermen', and Millet formed part of his collection of work by artists close to his heart that lined both flights of stairs and wherever there was space in our home. Artists who influenced Josef's own work and his whole thinking on art included Permeke, the Mexican Revolutionary artists and Courbet. Foremost, perhaps, his beloved Rembrandt.

<div align="center">* * *</div>

In 1975, the year in which *Related Twilights* was first published, Josef Herman, then sixty-four, was still a leading name whose exhibitions drew crowds on opening days. He was seen as having arrived not so much from his native Poland as sprung from the heart of the Swansea Valley, a place with an impossible name: Ystradgynlais. No matter how much his range of subjects would widen to include ballet dancers from the stage of Covent Garden, athletes, snooker players, nudes, birds, trees and flowers to mention only a few, the 'Painter of Miners' he remained. The demand for a painting or drawing of miners, at rest or at work was, and has remained, inexhaustible.

If the reputation of 'Joe Bach' was, by the 'fifties, already spreading further afield it was in part due to Josef's essay 'A Welsh Mining Village', originally a radio broadcast but published in *The Welsh Review* in 1946. For its insight, almost an identification with that tradition-bound, close-knit community, it could well have been written by one born and bred in the valley. Sentence by sentence there was about the piece a child's love for his mother – beyond compare – and indeed Ystradgynlais had given Josef a new lease of life after the wrench of losing his family, an orphan left to mourn, often despairingly and for the rest of his life, the end they met in German gas vans.

Recognised as perhaps the most extraordinary feature of 'A Welsh Mining Village' was that its author had only landed in Britain in 1940, in the middle of a war, without a word of English. Such was his need to communicate with one and all around him that, at the age of twenty-nine, he had taken English by the scruff of the neck, even if the rumble of a Polish accent would always remain. After a lecture he gave in Glasgow, unbelievably only a year or perhaps two after his arrival, if not in Glaswegian, one listener commented wryly: 'I have never in my life heard such bad English spoken so fluently'. 'A Welsh Mining Village', translated into a large number of languages including Japanese, would turn up over the years in the most unexpected places. There was something about Josef and whatever he undertook that recognised no frontiers.

Nor was it simply that his growing reputation as a serious – an important – artist, newcomer to the strictures and wartime sorrows of this island, would focus exclusively on the short span of time within which he had made his name with a series of one-man shows in Glasgow, Edinburgh and then London, followed by two retrospective exhibitions. Beyond that professional success there

was something uniquely irrepressible about the man. Yet if he came to be regarded as something of a phenomenon, the projection was never larger than life. A deeply rooted humanism, still valued at the time, which had brought about his adoption into the mining community where he was within weeks of arrival seen as 'one of us' and endearingly named 'Joe Bach' glowed not only from his canvasses but embraced and fortified with an almost childlike innocence all who met him. If we are currently in an interlude where that tide of values has turned, Josef remained utterly faithful to his credo that an artist's primary concern was for his work to be almost religiously infused with feeling. Indeed, where he felt that a painting of his had, even marginally, failed in this respect it was obliterated with black paint with the intention to start again even if the years sometimes defeated that brave intention. That message was unfailingly passed on to young artists, from the depth of his ancient leather armchair, when the Keeper of the RA brought students to Josef's studio for a long morning of coffee and talk when he was well into his late eighties.

Further mention should be made of his invitation to contribute a work to the Festival of Britain, on the South Bank, in 1951. The mural of six, almost lifesized, miners glowed in the Pavilion of Minerals of the Island: royalty from the darkest earth of their ancient land of Wales. It was the time of a spirit of triumphant celebration. The war was over and won! A golden future promised to stretch ahead. It seemed almost as though he had brought prospects for that future with him when he fled from the advancing Germans.

But time moved on. Josef never forgot that his 'beloved Rembrandt' had died almost ignored, virtually forgotten. Always a realist, this he grew to envisage philosophically as his own prospect: 'Ninsky, not to worry', with a hug. From the gregarious young artist who lost his heart to Wales – where his memory is enshrined as a legend, part of the folklore, a myth – although through decades in London he remained warmly accessible to one and all who sought him out, by the later seventies he began to withdraw. Time was, he knew, slowly running out. Energy was to be conserved for long hours at the easel, even if these slowly declined from a onetime fourteen a day. A quest for solitude, for all that it went unnoticed, was for work which brought mystical experience in which he sought and found something of salvation and surely of consolation.

In the new edition of this book we can return to Josef again and again to draw hope and courage from a great, unquenchable spirit.

Nini Herman, 2002

Introduction

It is fitting that this new, annotated edition of *Related Twilights* should appear from a Welsh publisher, for Josef Herman has always held a special place in Wales; and Wales always meant something very special to the artist. The moment when he saw the day shift of miners returning to their homes in the village of Ystradgynlais over the bridge and against the sunset has now passed into Welsh art myth.

Certainly, something very profound was felt by the painter – 'For a split second their heads appeared against the full body of the sun, as against a yellow disc – the whole image was not unlike an icon depicting saints with their haloes.' The dark, elemental substantiality of the miners was something that Josef Herman could recognise. The impersonality of the blackened faces, the uniform working clothes, the tired curve of their bodies, all these resonated with his memories of his native communities with their specific working practices and sufferings. The common experiences of men and women and, at the same time, their universality, their iconic force, is what makes much of Josef Herman's work enduringly potent and popular.

When Josef Herman came to Wales in 1944 he found himself, as Turner, Sandby, Piper and Sutherland had found themselves, as an artist who would be moved in response to the communities and landscape of Wales and, in return would contribute to our perception of Wales. Except that, in Herman's case, the visit had much of the accidental about it; and it was to be the people, the miners in particular, who held the artist's attention and whose personalities and working lives Josef Herman was to memorise and memorialise for the next fifty-five years.

But before Ystradgynlais came London, Glasgow, Brussels and Warsaw. Herman's journey westwards across Europe was part necessity, part artistic pilgrimage. In the chapters, 'The Years of the Sun' and 'The Years of the Moon' he describes how, against the odds, he began to learn about art and began to see himself as an artist.

Josef Herman had left his native Poland in 1938. He had left Warsaw and his family, none of whom he would ever see again. And by 1944, settling down to live in Wales, he knew that their numbers had been added to the statistics of horror that we now know as the Holocaust. Those ghosts, a family, a whole community, would re-appear in his art for the rest of his life, but one wonders whether they were ever really exorcised. Nini Herman has written, 'The miners coming out of the darkness of the pit is like his own family coming out of the

horror of the gas chambers. The pigment he uses bringing back to life at its most vibrant and hopeful and intense.'

Josef Herman left a Warsaw of pogroms and constant struggle; that Warsaw was to become a ghetto and a transit camp to mass murder. But before he was to realise the full horror of that, Herman the apprentice painter visited Belgium to absorb the lessons of Constant Permeke and the Expressionists. *Related Twilights* collects memories and impressions of the painters Josef Herman met over the years, but also his thoughts about painting itself. He writes of the Belgian master – 'Permeke's mind was a combination of child-like directness and peasant-like shrewdness, and with these qualities he managed to get to the root of the matter somehow quicker than others... He himself practised a kind of art wonderfully free from any theory.' These Notes from an Artist's Diary are more than that, of course, but are also welcomingly short and direct enough to pull the reader onwards to enjoyment and insight.

One is convinced that Josef Herman is completely committed to the business of painting and drawing: he is focussed and open-minded. Alongside the major painters – Courbet, Millet, Klee, Rivera – are the less lauded – Albert P. Ryder, Marsden Hartley and Henryk Gotlib: paintings Josef Herman had discovered and people he had met. Friends such as Jacob Epstein, who befriended him when he lived in London and who encouraged him to buy and absorb African carvings; and Henryk Gotlib who, accompanying Herman to a Monet exhibition at the Tate, said, 'All his life Monet was what I would call a prose painter, but by the end of his life, already three-quarters blind, with the lily-pond pictures, he became a poet. He struck true art!'

Related Twilights is part autobiography, part travel book, part memoir, part exhibitions review: the whole gives insights into art and a range of artists through an artist's eye. And in this new edition we have included a selection of Herman's own work – the lodestones by which the responses are guided. This book has a clear, arbitrary structure: Autobiography, Places, Artists, but everything is centred on people, for Josef Herman is an artist essentially of the human body and its experiences. There are few unpopulated landscapes in the whole oeuvre; in the later tree drawings and paintings, inspired by, and many executed in, Holland Park, the trees loom, shadowed, as his earlier figures did. They stand as characters. The vases of flowers in the late still-lifes are set by a human hand and occupy human living spaces; so too the late bird pieces, especially the Curwen Press series of lithographs *Song of the Migrant Bird* may be said to have character, personality.

Herman's is an art which recognises and honours the worth of the abstract, but always works towards the body and the land. His nudes, working figures, buildings and hills are all rendered in the drawings by the contours of dark and light. No one in British art in the last fifty years has surpassed Josef Herman in this skilled draughtsmanship. For him, the drawings are not precursors to the paintings, they are multitudinous and finished works. Few are titled on the paper, fewer signed or dated. It is as if the miners and peasants remembered by the

artist in his later years are one and the same with those figures he drew for a decade in Wales and over the decades in Mexico, Spain and France.

Nini Herman confirms that her husband would rise in the early hours and draw until daylight; and, as he says, for him 'Drawing is the most spiritual activity and probably the most revealing... Nothing in a drawing is purely physical. A drawing cannot even suggest the titillating quality of paint, not the material concreteness of sculpture. Its limitations are its strength. It is remote. By distancing itself from all possibilities of sensuality and the physicality of solid matter, it comes closest to the actual working of the mind.'[1]

Josef Herman is in the world most fully when he is drawing and painting: that is what makes artists so distinguished, and what makes them not the easiest of people. 'A drawing is a thing saying things which objects never say.'[2] The act of drawing is not, then, a replication of the real world: it is an intensification of the real world. It touches the essence of things. There are so many Herman drawings, and so many of them are a re-visiting of subject-matter that one comes to realise that the hand holding the pen, pencil or charcoal is plunging deeply into and below the surface of the world.

The paintings are deep and rich, structured by colour – reds and blacks and ochres and blues especially. Josef Herman worked much more slowly and with many more revisions in his paintings. There may be thousands of drawings, but the paintings are numbered in the hundreds. The mature paintings are rich and dark and monumental; the drawings excel in their suggestion of light shaping form. Both are, clearly, by the same hand, but, as it were, working with a different language of seeing.

Nini Herman describes the working circumstances and practice of the artist who was to become her husband and who was already, in the 1950s, a painter of some reputation.

> Three months before, I now recalled, a mutual friend had taken me to meet a memorable man, in his Hampstead studio... The day had hardly awoken yet for all of us were early birds. At a mast-like easel stood a man, fixed like a captain to his bridge, wrapped thickly in a dressing gown that must at one time have been brown. He was entirely absorbed, as little children at their play, and though he signalled to us to be at home, remained oblivious and alone... The light and lofty studio space simply took my breath away. A tree in blossom and in fruit, it harboured treasures that had come from the four ends of the earth, in careless, masterful array... Eventually the man paused from his work and introductions could take place. But is was all too evident the artist's mind stuck to his work and used the small talk as a knack to keep the outer world at bay. Presently, without ado, he pulled some shabby corduroys over pink pyjama pants and added a brown daytime smock. But never once, while part of him was doing this or doing that, or casting quick expressive talk, was one deceived that he had been distracted from the inner glance fixed on the canvas he was working on. It evidently was his all, as he caressed it here and there by adding pigment with his brush, then, taking a few quick steps back, surveyed, head cocked to one side, as will a lover his beloved. Forward and back and to and fro, he moved for it and it alone. It seemed that I was witnessing a sequence from a mystic's dance. A dedication to the source with which no other could compete

or ever hope to be compared. The whole experience was a dream I knew I had longed to emulate in my own life.[3]

The absorption in the work, the apparent chaos of a working studio, the dishevelled dress – 'shabby corduroys over pink pyjama pants... a sequence from a mystic's dance...' describes a man dedicated to the source, his inspiration, the pursuit of truth through image and image-making. It is a pursuit which Josef Herman was to follow throughout his life. Here is Nini describing his working practice in his last decade.

> J. at seventy-seven, grows younger every day. He still starts work at four a.m. as on our first night together, over three decades ago, so that by lunch-time he has covered an entire working day, seven days a week. To be privy to the ways a blank canvas is transformed into glowing images, to a production line which he feels has begun, finally, to represent the truest statement of his heart, almost to his satisfaction, is a joy beyond belief. An earthly privilege, it seems almost an unearthly one.[4]

This is the life of a painter, a life as dedicated to a vision. Josef Herman lost his former life and community in the Nazi Holocaust; his work may be seen as constantly affirming the worth of his survival and, at the same time, stacking images against our ruin. This erasure of his past, his family's and community's heritage, led to several emotional breakdowns. Nini Herman has, with great honesty, dealt with this in *My Kleinian Home* and *A Working Life*. Life seemed to pile hurt, tragedy too, on Josef Herman: the loss of his family, his first wife's miscarriage, the accidental death of his four year old daughter, it is no wonder that he lived increasingly in the world of his art. It is not surprising that he had several emotional and artistic crises. But it is the art which ultimately completes the man and his life. The self-imposed discipline of his working days, the constant drawing, the consistent drawing.

I visited Josef Herman in 1997 when I was editing *Coal*, an anthology of writing about mining.[5] I sought his permission to use some of his drawings in the book. He, of course, generously agreed and showed me collections of his drawings of miners. That was in the Edith Road studio. I had entered the house without realising that the Hermans occupied that and its next-door neighbour. Josef opened the door and led me directly ahead, down a corridor, which had an alcove with his day-bed, and down a precipitous set of stairs to his large studio, situated where the back garden must once have been. He was generous with his permissions for the drawings and with his time. He insisted on taking me to lunch at the Greek café across the busy main road. On our return I noticed more details – an open door into a lounge with glimpses of his African carvings, the Henry Moore, Kathe Kollwitz and many other small works hanging on the walls of the corridor, the thick rope suspended over his day-bed by which he raised himself up. He was in his final years a large man. It was like having an audience with Falstaff. One large black canvas dominated the studio. In the late 1980s he had shown this work, 'Homage to the Women of Greenham Common', at the

Royal Academy Summer Exhibition. Shortly after it returned to his studio the image was obliterated. It had failed his need to express a primacy of feelings, imagination and the spirit.

> Josef felt dissatisfied that the work was pervaded by an element of the didactic, which corrupted pure emotion – the inherent poetry: the desired transformation. And so it was eliminated. Ever since the studio has displayed this statement in that impassive shroud. 'When I am ready,' he confirms the purity of his purpose, 'I will paint it again. Ninsky, there is no hurry' he repeats patiently. Only I am aware that the man is eighty-four.[6]

That act of erasure re-enforces the vision of Josef Herman. He knows too much about the complexities of joy and suffering to produce a direct, political, polemical image. The Greenham Common canvas was covered in black paint because Josef Herman did not want to create a propagandist work. With his specific background, those early experiences of pogroms and Haller's 'Blue Army', and by his natural tendency to rationalise and humanise, Josef Herman would always be a loner rather than a joiner, a visionary rather than a marcher. He would feel awkward about such a public stance, any notion of striking a posture – one thinks of the corduroy trousers at the black-tie Royal Academy dinner[7] and the mis-remembered etiquette at his O.B.E. ceremony.

However, in his chapter 'Mexico's Revolutionary Art' he admires the foundation of 'heritage' in political art over the bombast of 'social realism'.[8] That distinction, those principles, surely underpin Herman's own great 'non-easel' work for the 1951 Festival of Britain, 'Miners'. All his figures, men and women, at work exhibit 'monumental expression' and 'beauty for all'.

Related Twilights is a fascinating book because, as Josef Herman discusses his life and other artists, he is not only illuminating the world he has lived in but also the way in which other painters have shaped and coloured that world. From major figures such as Paul Klee – 'His work is cultured in the same way that precious stones are cultured'[9] – and Courbet, who wanted to 'invest the physical presence of man with moral stature',[10] to lesser-known artists such as Albert P. Ryder, the American whose 'Toilers of the Sea' had such a profound effect on Josef Herman in 1972 when he saw the painting in New York's Metropolitan Museum: 'The pigments here were guided by the luminous strength of his own spirit and this is why the picture has a spiritual rather than a physical effect on us.'[11]

The short, poignant sections on his early life are tantalisingly brief, but one feels that the man has too much pain rooted in those memories. We have enough in what he shares with us to locate his story in the well-rehearsed horrors of the twentieth century's fourth decade. On that platform in Poland in 1938:

> It was a dark, moonless and starry night, and although it was only the beginning of autumn it was very cold; a terrible, noisy wind made it impossible to talk. In the crowd on the platform men held on to their hats and women their skirts.
>
> First my mother, then my father, then my two friends somehow managed to get near my window. Even so, I am sure that they did not hear my last good-bye. I did not hear theirs.[12]

Like a seed drifting and rooting, in Belgium, Scotland, Wales and England, Josef Herman brought his affirmation of life and his strong heart to bear on what he saw and what he remembered. *Related Twilights* is a remarkable book that accompanies the work of a remarkable artist.

Tony Curtis, 2002

Autobiography

The Years of the Sun

Some remember their childhood with terror, some with nostalgia. I view my childhood as the beginning of a dream, simple, though puzzling. I am more drawn towards its fabric, its imagery than to its possible meaning. In spite of what papa Freud says about the symbolic factuality underlying all dreams, I hold on to its magnificent mystery.

My dream begins with walls, tall walls and low walls, all in various shades of white. Then there comes a chaos of things, too many and of too great a variety to distinguish one from the other. The balconies are clear enough, the low stools on which old women are sitting, wheelbarrows on the corner of the street, rags everywhere – what are they doing in my dreams? – goats, dogs, cats, and faces of men, women, children, all radiant with an inner light; they come to the fore rapidly, then, teasingly, disappear into a hollow darkness.

My memories are of moods and atmospheres. The child had no head for facts, order or dates; he walked about in a state of continuous reverie. Not that he was oblivious of what was going on around him – on the contrary, he was nosy and curious about everything, but even so, he responded with his senses, always the most active part of his being. The memory of a thing was stronger than its actuality. Then imagination took over from memory and gave everything its own complexion until not a shred of the actual thing remained.

There it is: my street, the street of my childhood. The whole of it in a blaze of light. A tremendous sun, incredibly bright and sharply contoured – a clear circle of fire sitting above the tallest building. Opposite this building is another, smaller one, the tenancy of a couple of hundred families of which my family is one, totally indistinguishable from the others.

The gutters steamed with a golden mist, and here and there a cloud of thick smoke would rise in a window, and in the smoke there would appear the dim figure of a woman flapping a white towel. In the summer days the kitchen stoves refused to burn and the whole street smelled as though there'd been a fire. That scent I will never get out of my nostrils.

The two pavements were wide, but not wide enough for all the people who always thronged the street; and so the road, with its cobblestones shining like apples, was also thick with people: they stood in groups, talking, quarrelling, or fighting. I cannot recall a single fight on the pavement; it was an unwritten law that if there had to be a fight it must be in the road.

Privacy was a luxury, and quiet possible only in some remote corner; the child

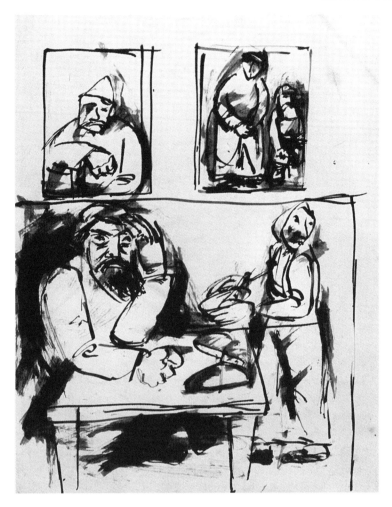

knew all those corners and there he often sat and let his mind wander with the unfettered freedom it craved.

Gas lanterns... A large cube with a red roof – the hospital – whose walls somehow always seemed whiter than those of other buildings. But what stands out in my memory of the hospital more than anything else are the wide crowns of the lilac trees. If you wanted to smell the wondrous perfume, you stood near the hospital wall and breathed in deeply. This was a source of pleasure to many, especially to the women.

There was a police station with a heavy brass bell hanging just above the head of the guard. The rest of the building was narrow and bare.

There were two bordellos with red lamps and red curtains, always drawn; in the evenings the light which came through those curtains was most mysterious, and its centre was as bright as a star. The whores belonged to the street; they provided it with its most vivid colours. To the child they were the most fantastic apparitions; all beautiful in their shawls with huge flowers and their glossy shoes

with the highest heels imaginable. I once told my mother that she too should get a shawl like theirs and that she would look even more beautiful than they were. The child was puzzled: why were those lovely creatures called, by such a dreadful – sounding word – whore? No Jew was ever seen near them, though there was talk that some Jews did steal secretly into the bordellos at dead of night. Only the Poles and the Russians spoke to these women, joked with them, and went with them arm in arm. This sight pleased me immensely.

The street was an uninhibited place where love and hatred were practically indistinguishable – both were expressed by equally chaotic and violent displays of emotion, and the reconciliation scenes were just as noisily vehement as the rows. All quarrels had their spectators; such excitement demanded a keen audience and all ears were keen.

Yells rose from the pavement up to windows high under roofs. Hollow and joyless laughter, the beggar's whining voice, and above all the song of the skivvy soaring into the sky with a defiant sadness:

> My young years have passed in a dark cloud.
> As in a dark cloud was the day of my birth...

From the shops of cobblers and tailors, from the smithy, from every corner of the street came songs... Only the carpenters never sang.

Like something out of a horrific and surreal nightmare crawled the invalids – cripples without legs, gaunt men on crutches, blind men walking slowly, one arm stretched out in front as though in a Roman salute, the others gripping the shoulder of a ragged boy or an old woman. All were in uniforms belonging either to the army of the Tsar, the Kaiser or the Austrians. All had medals pinned to their chests. From time to time they would fight over a cigarette-end or quarrel about battles they had taken part in. But now and again one of them would sing, holding his head up to the sun.

When the horse-thieves arrived, with Shlomo-Hershl riding a newly-stolen horse and his brother Leibish leading a veritable caravan of booty, all the people in the road would move aside in hushed admiration to let them pass to the stables, and after a moment of silence they would begin a guessing game. Where had Shlomo-Hershl stolen from this time? Soon an improbable story would go from mouth to ear all over the street.

There were two Talmudic schools, one for infants and one for training future rabbis. From the open window of the first you heard all day long: 'Kometz alef, oooh, kometz beis, boooh!' From the window of the other came a greater babble of recitations, also in chorus, but of more complicated sounds and words. At sundown all was ended and from both schools emerged a multitude of children, some so crouched that they looked no bigger than mice. They spread through the streets, and ran as though terrified in all directions, small, comic shadows whose little bodies, clad in black, were thin and insignificant. Throughout the day they had been learning that this world was not theirs.

Though with the years I tore myself away, I have never really severed myself from this street. Today I feel it as a part of me still. It was here that my feelings developed. I was no good at games, no sportsman, no Red Indian chief. Days came and went; I waited for twilight. Since the earliest years my memory can summon up, I have known my inner needs. Autumn is my season, twilight is my hour and all my life has been one chain of related twilights.

I do not think that there were many joyless events to spoil my childhood. I found in that street a kaleidoscope of human passions which no later experience belied. Today, it seems to me that all those subjective tremors which began gathering in me so early are probably responsible for the preservation of my attachment to that street, where many of the things that happened might have awakened only hateful memories; but the emotions which gave rise to those happenings were only human, all too human.

My father, David, was a cobbler. Not the best cobbler in the world but one of the tens of thousands of Jewish artisans who just about knew their craft. Small repairs he could somehow manage, but to make a new pair of shoes to fit was beyond his skill. If the shoes he made were too big, he would exclaim in all innocence to the client: 'My, my, what tiny feet you have, even a child has bigger feet than you!' If the shoes were too small, he was equally astounded and would call out to my mother: 'Sarah, have you ever seen such huge feet!'

We lived in a shop, long and narrow and dark. Two paraffin lamps burned day and night, one on the wall over David's square workbench and one at the far end of the shop, over the white-tiled kitchen where my mother spent most her time, even when not cooking; she would sit there darning socks and shirts, or she would stand bent over the nearby oak table, ironing. This was their life; they might as well have been chained to their places. To the rest of the world they were most of the time invisible. Just another husband and wife, just another father and mother. They had only one aspiration, particularly, Sarah: to make their poverty respectable, to give the impression that they had an object in life and that their way of living was it.

The shop also had a gallery in which two beds faced each other. Thus far I was the only child. Later there were to be two others, first Shmiel, and then Zelda, the only girl and the youngest and loveliest member of the family. At this time, however, Sarah was only eighteen and David some ten years older. In the child's eyes David looked an old man, perhaps because of the white streaks in his curly black hair. Sarah never aged – life somehow distorted David but left Sarah untouched. Sarah was the child's joy, David the child's most painful embarrassment – not so much in his father's more miserable moments as during his carefree moods when he tried to amuse his friends. He would stand with a group of cronies and ask a passing youth to pull his index finger. The others would encourage the youth: 'Go on, don't be afraid!' The youth would pull, David would shout: 'Pull harder, as hard as you can!' And when the youth was pulling as hard as he could David would let go a fart as loud as the explosion of a hand-grenade. The youth would go red in the face and run away as fast as he could

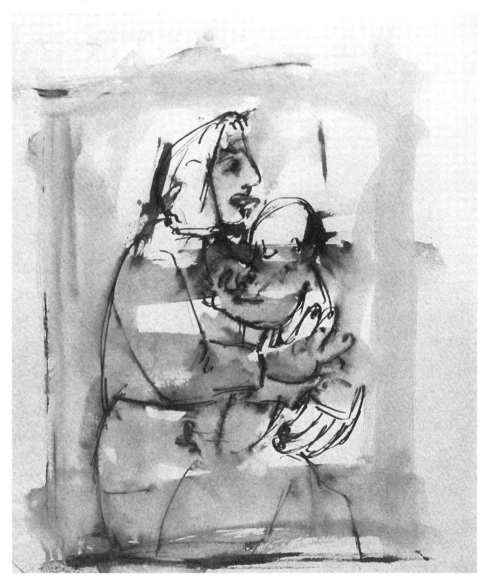

and David and his cronies would yell with laughter and slap their sides. Whenever I saw this coming I, too, would run to some corner and weep. Of my early childhood I cannot recall a single day without the painful sadness David's jokes caused me. When people in the street referred to me as 'David Stinker's son', I wanted to sink into the earth.

But with Sarah I walked the street in pride. She was sensitive, she was subtle, she was gentle, she was rare. And when she saw my pained expression in David's presence, she would take me in her arms and say 'You don't know everything. He was not always like this.'

The years of World War I did not darken our sky. The street remained bright in

the sun's copper glow. The invalids were noisier than ever. They knew this, they knew that. The Germans will win, the Germans cannot win, no, the Germans will never win! But one day the Russians left, and the Germans took over. At first the invalids said it would not be for long, and when the Germans stayed on, the invalids said that they knew from the beginning that the Tsar could not win! The English would betray us, the French would go over to the Kaiser's side. And they talked and people listened to them, for they had been in battles and so they ought to know.

With the Germans prosperity came to the street, to one and all. The bordellos were busier than ever; you could see queues of soldiers – some joking, some laughing, all waiting in perfect order for their turn. The whores were too busy to come out into the street. It was the soldiers who brought all the prosperity. They brought money, they brought food, and the kind of goodies we had previously only dreamed of – cakes, chocolates, tins of milk, tins of meat, fish, herrings, sardines and what not. These they simply gave away – the sheer quantity of it! And the soldiers also bought, and went on buying madly; the shopkeepers didn't know what to do with so much money, so they began ordering things. The cobblers, the tailor, the joiners, the upholsterers, all were so busy that they no longer had time for lounging around. The street was simply teeming with labour, with songs, and with what people call happiness!

The horse-thieves were also busier than ever. You could see Shlomo-Hershl sitting at a table in Lederman's tavern in the company of a German captain, sometimes even a colonel, drinking all sorts of brandies and liqueurs and whispering together with these military dignitaries. The Germans needed horses. Despite all their requisitioning they could not get enough – the peasants were hiding their horses. Shlomo-Hershl laughed at the military's worries and supplied horses. Shlomo-Hershl was now the most important man in the street; he had influence and he had money, and when Shlomo-Hershl had influence he would do you any favour you asked. As for his money, all the tailors and all the cobblers were now working most of the time for him. Thus I heard David saying to Mendel the shopkeeper one day: 'Mendel, you must wait, I can't let Shlomo-Hershl down, can I?' And Mendel agreed. Shlomo-Hershl no longer had time to sit around and tell us children of his more daring exploits, how he sold the same horse twice to the peasant he had stolen it from! Shlomo-Hershl's position was now *legal*; he no longer needed to paint the horses and make them unrecognisable! Peasants no longer showed up with fury in their eyes, ready to kill the two horse-thieving brothers. No, Shlomo-Hershl and his brother Leibish were protected by the highest of the high in the German army, perhaps, went the rumour, even by the Kaiser himself! Oh, Shlomo-Hershl, Shlomo-Hershl...

At that time, two men came to live in our street, both of whom profoundly affected my life. One was the Great Master Xavery Rex, the other was Dr. Zaltzman.

Master Xavery was an elderly gentleman with a ginger beard and a big black bow-tie. He always wore a beret, a wide black beret. He was the greatest artist

that ever lived! He occupied the big shop at the corner of our street, which had a window as large as the hairdresser's. After Master Xavery arrived, my life took on a purpose; I spent my days looking through his wide window and watching the master painting. With all this prosperity around there was plenty for him to do. No generosity is greater than that of poor people who suddenly have money to spare. All at once David needed a sign to hang on the shutter outside his shop – he had never in his life given a thought such a thing, but now he needed one. Likewise the other artisans, and Master Xavery had the right style for them all, which they understood and which satisfied them. Some years later, when the first cinema opened in our neighbourhood, it was Master Xavery who painted all those magnificent and colossal ladies in pink tights and cowboy hats with pistols in their hands. As for letters, surely no one in the whole world could rival his imagination! Not only did they drip blood or stand out from fiery flames or fall together with rocks and the tumbling building of ancient times, but even by themselves they could strike terror into your breast. He liked best the letters R and B, for he could make bayonets and even cannons stick out through their bellies. Master Xavery certainly had imagination. But all this came later; in the meantime he painted in a more restrained, almost stoic way, mostly single objects, a woman's shoe with half a leg in it, and the like. But what pleased everybody most was Master Xavery's passion for flowers and birds and cats. Whatever the picture – whether a gentleman in a top hat or a hunk of meat – somewhere in it there would be a bird or a cat sitting on top of the letters; as for the flowers, they were everywhere.

One day Master Xavery opened the door and said to me in his gentle voice 'What is your name, my boy?'

'Josef,' I answered.

'Well, Josef, go to the hardware shop and buy half a pound of ultramarine in powder and see that the shopkeeper does not cheat.'

He handed me some money, and I went and bought the half-pound of ultramarine, and I watched the scales and returned to Master Xavery, out of breath. He said: 'Come right in.' And I went in and stayed there until nightfall. From that day on I was forever at Master Xavery's. There exists a paradise, I know it, for I have been there.

I was given brushes to wash, and magazines to look at, not just for the fun of it, but with a 'professional' purpose, in order to find a lady in a long dress with an umbrella in her hand, and when I found a lady who pleased Master Xavery he praised me for having a good eye! I was sent on errands and I ate at Master Xavery's table at the same time as he, and consumed the same things: bread and cheese or bread and sausage, and I drank tea with lemon, just like the Master himself. After lunch he usually lay down on his bed, took down the mandolin from the wall and quietly played and sang such beautiful tunes that I could have wept with so much happiness.

After work one day Master Xavery gave me a few pfennigs and said that I had earned them, that I should not blush but take the money and stop thanking him,

for it made him nervous. I ran as fast as my legs could carry me and showed the money to Sarah and told her how I had earned it, and Sarah kissed my head and said: 'I knew that you liked the artist, but I had to go and tell him that if you were too much of a nuisance he should send you home. He said that he likes you very much and that you are a great help to him!'

This was the best thing that ever happened to me. These were my first earnings as an artist! Ultramarine – I will never forget the magic sound of that word.

You don't look for sages; like prophets they suddenly appear. Nobody asked Dr. Zaltzman to come and live in our midst; he came on his own initiative and to begin with he was hardly noticed by anybody. The thing about sages is that they teach you to find a meaning in living and a place in life.

The sun stood still. The earth, too... and as though out of thin air Dr. Zaltzman arrived. From the very first he puzzled everyone. He moved into a two-room flat with a kitchen ('obviously he is well-off – like all doctors'), but he bought himself a second-hand bed and second-hand bedding, a second-hand table, and a few second-hand chairs ('perhaps he is not so well-off after all'), he bought pots and pans and plates and spoons, all of the cheapest quality. It was puzzling, but the most puzzling thing about him was that he did not hang out a brass sign with his name and hours of business as, in our experience, all doctors did from the very first. He had no leather couch and no reception room for his patients. It was all very strange and very puzzling. After meeting Dr. Zaltzman once my uncle Meiloch put things this way: 'He may be a doctor, or he may not be a doctor, but I am telling you – this man is a healer!'

He was always on the spot at the exact moment he was needed. You did not have to send for him, he was already there. A child fell out of the ground-floor window and broke a leg – Dr. Zaltzman was there and did what had to be done. And he never asked for money. He said what was to be said, and off he went – you looked around and there was no sign of Dr. Zaltzman, he had vanished. Dr. Zaltzman was surrounded from the very first with a magnificent unreality.

He was a small, fat man with the shortest legs imaginable; the distance between his pot-belly and his chest was that of a big man, but the distance between his belly and his toes was very short indeed. His head was also unusually big; the bowler sat firmly on it but rode high above his ears. His face was round and his skin radiant. His eyes were two prominent shining, dark dots; his nose was typically Slav, round like a radish (the 'typically' Jewish nose has long ago disappeared from the face of the majority of Jews, though anti-Semitic caricaturists have failed to notice this), and his mouth was round and small, always moist and deep red. He wore a black suit shiny with age and I never saw him without his leather medical bag, also worn with age.

So much for his physical appearance. But spiritually he was a wonder. He healed more people with words than other doctors with medicine. The most amazing thing was that he had time for everything and for everybody. He considered no one beneath him and no one above him: nobody felt ridiculous in his

presence. The words which gained him the confidence of everyone were: 'You were not born to be slighted, you were not born to be hurt.' Dr. Zaltzman repeated them so often that today they still ring in my ears. When my uncle Meiloch took up socialism he often quoted these words, and when in later years I myself began to think of a better life I imagined a world inhabited by a race of men like Dr. Zaltzman.

At the glorious age of five I saw the power of a gentle heart and I will never forget it. I saw goodness in action and I will never forget it.

While the Russians were in Warsaw the free-thinkers had been unable to have a club of their own. Now, under the Germans, the free-thinkers got their club, but children were not permitted to enter their shrine. It became an ambition of mine to see the inside of this holy-of-holies. Ryvka, the elder of my two aunts, was the char who once a week washed the floor of the free-thinkers' club. I promised to help her and carry buckets of water for her. She, simple soul, suspected no perfidy in such a tiny fellow. Thus I saw the inside of the club and I was very

impressed. It was a large room containing at least twenty long wooden benches, and bookshelves that took up a whole wall, crammed with books! I had never seen so many books!

But it was the other walls that took my breath away. They were hung with portraits. On the main wall above the speaker's table was a face of absolute seriousness such as I had never seen in my life: this was Charles Darwin, about whom I had heard my uncle Meiloch talk. On the wall between the two windows was another portrait, but this time benign eyes looked out from under the eyeglasses. This man was called Grigori Plekhanov, and facing him on the opposite wall was yet another portrait, of a man called Dr. Max Nordau. There was nothing else in the room – but it was enough. So this was the place where the free-thinkers gathered and shook their fists at an empty heaven!

On the Day of Atonement, the most sacred Fast Day in the Jewish calendar, the free-thinkers' club was at its most active, almost as active as the synagogues! Not only were there free lectures, but also free food from an improvised buffet. It was for these feasts on the Day of Atonement that the free-thinkers' club was most famous. It also had other activities. Its members published thin little books in which they proved that God did not exist – the left-wing members quoting Bakunin's dictum that if God did exist it would be necessary to abolish him, and so forth. My uncle Meiloch once said to Fishl Seligman, the most orthodox Jew of all, who wanted to set fire to the free-thinkers' club: 'We have not been doing so well with your God around, let's see whether we cannot do better without him.' I will not attempt to describe the look that Fishl gave him. It was to this same Fishl that Dr. Zaltzman once said: 'Why does your God make you feel so angry about those of your fellow men who happen to think differently from you?'

But nothing could shame Fishl.

When I first went to see my grandmother she was busy chasing rats. Within minutes she had four of them dead while the others ran for their lives! Her name was Feigl. She was a small, thin woman of incredible determination. When Feigl wanted something she got it. She ruled the lives of everyone in her family. If she met any opposition she simply wore her opponent down with talk, with tears and more talk until she got things her way. It was her doing that my mother Sarah, Feigl's eldest daughter, married David, and this is an epic worth telling.

At the time, by the standards of our street, David was a rich man. He was a partner in a small shoe factory and had a gold watch – and Feigl could not resist the shine of gold. Each morning on the way to his factory David would see a young girl of such beauty that she seemed to be from another world: the sheen of her long red hair could blind a man! Every morning he got the same feeling. she was not real. For a while she would walk his way and then turn a corner so that he could see her no longer.

This went on day after day. David knew of no way to approach the girl, but one morning he followed her and thus found out where she worked. Another day he took time off from the factory and waited for her and then followed her, and

thus learned where she lived. He talked with the neighbours and found out all there was to know about her mother, father, her two sisters and her two brothers. Then one day he could wait no longer, and he put on his best suit and went to see the girl's mother. She was alone and this David thought was a good omen.

When the girl's mother saw such a well-dressed stranger she knew at once what it was all about and addressed him in this way: 'I hear that you have been asking my neighbours all about me and my family and my daughter Sarah. This can mean only one thing.'

David stood stupefied. She had taken the wind out of his sails. He had never expected that it would be so easy. This woman was magnificent – he was thankful for the way she laid her cards on the table. He said: 'Yes, all this is true, I want to marry your daughter Sarah.'

That was all Feigl needed. 'You know that we are poor and there can be no talk of a dowry or any such thing?'

David was disarmed. In fact, he *had* thought of a dowry, but he heard himself saying: 'Not even a room with furniture, as is the custom?'

Feigl laughed in his face: 'Look around, look at this basement, it hasn't even got a floor – and you are talking about a palace with furniture! Where would I get money for that kind of thing?' Then she asked him whether he would like a glass of tea and without waiting for his answer brought him some tea and cakes, and said: 'Now you know where *we* stand, what about *your* parents, can't they give something? After all, it is their son's wedding.'

David told her that he had no parents, no family whatsoever, that he was alone in the world. Feigl interrupted him: 'This is all very sad so let's not talk about it. But I can see that you are well-off.'

'Yes,' said David, 'life has been good to me. I am now a partner in a shoe factory.' Feigl again interrupted him.

'So my old eyes did not deceive me. You will not regret it. We are a poor but decent family and all my daughters are virgins, not just hussies. Leave the rest to me, I will see to it that the girl is yours – provided, of course, that you won't forget what I am doing for you and that you will help me when needs be. Not now, thank God! We can talk about that later, another day.'

That very evening, when the family was at the table having their evening meal, Feigl told them about David's visit. She was a true master when it came to the use of bright colours and glowing descriptions, and they were all amazed at the great luck that had come their way. But Sarah, instead of showing gratitude, began to cry, first silently then bitterly and loudly. She had good reason. She was secretly in love with a revolutionary who had been arrested the previous year and was now in Siberia; she had given her word (to no one but herself) that she would wait for him no matter what.

In fairness to Feigl it must be said that she knew nothing about this revolutionary and her daughter's love for him – not that it would have meant anything to her if she had. She looked at Sarah and thought to herself that every girl wept at first, and that all Sarah needed was gentle breaking in like a young horse which

at first resists a harness and then carries it for the rest of its life without a mur-mur. And Feigl was good at breaking in. She said nothing more that evening and winked at my grandfather Yankev not to say a word – not that he would, he never talked. Needless to say, after a few weeks of breaking in Feigl had her own way and within a year Sarah and David were married.

That was in 1910. I came into this world a year later, in a 'luxury' flat of three rooms and a kitchen which Feigl herself furnished – with David's money, sparing no expense. The flat was in the better district of the more prosperous middle class. Feigl was proud of herself! What an achievement! And David proved not only to be a good husband but also a generous son-in-law. Whenever Feigl was in need David was there to help! Before the wedding Feigl had already got from him a silk dress, a black silk shawl and an overcoat – the first she'd ever possessed. But then something happened, something that destroyed David.

He was illiterate, and at his factory he was often given papers to sign by his partner, Emanuel Friedman. Below Friedman's elegant signature David would put three crosses. He never asked questions: he took it for granted that Friedman looked after the papers, while he managed and worked together with the twenty or so workers. One day David was given some more documents to sign and he put his three crosses at the exact spot where Friedman's index finger pointed. Friedman took a few days off, as he had done on several occasions before, and David suspected nothing. But one day he learned the worst: Friedman had sold the factory and was already well on his way to America!

'How could he,' cried David, 'he never told me a word.'

'But you gave consent,' said the new owner, 'here are the documents and here are the signatures, Friedman's and yours. The three crosses are yours, aren't they?' David had to admit that they were his. He could not understand, and began to behave like a crazed animal, shouting that he had been swindled and that the factory was still his. The new owner tried to reason with him and when this had no effect he asked a few workers to throw him out. And that was that. David sank into hopeless despair from which it took him years to recover. He was now without energy, he no longer knew what to do next. Apparently he sat for days on the edge of his bed in absolute silence. He had to be fed like a baby. Sarah saw that David was no longer the man he had been – there was hardly any life left in him at all – so she took over. First she sold all the furniture, all the best clothing and the few bits of jewellery she had, and it was she who found the shop into which we moved, on the street where grandma Feigl lived. I was exactly one year old.

Feigl now despised David and showed him as much contempt as her poetic tongue could master, but David never answered her; he was beyond feeling the insults she heaped on him. Sarah stood by David and she was his strength. She was patient with him. And after a year or so David regained some life, enough to work and more or less function. But even then he still walked this earth as though he were poisoned but could not die.

A war has its own logic and its own ways. The First World War went on and on. The longer it went on the more people thought that it would never end. And they carried on living. But something did change. People began talking about an Independent Poland.

The first time I heard the words I did not quite know what they meant, but Master Xavery explained to me about patriotism. Master Xavery was in ecstasy as he talked and his words were choked with tears. I thought at once that an Independent Poland meant more sunlight and still more glorious twilights. I thought so particularly when Master Xavery sang songs of battle and of freedom! He now kept the doors open and put breadcrumbs on the floor and the room was soon full of pigeons and sparrows. Master Xavery was overjoyed and so was I. Long live Independent Poland!

The talk about Poland's freedom began to spread like wildfire. The Kaiser was just so much shit, people said, and who wanted to talk German all their life? The Tsar had never been anything else but shit. My two uncles, Meiloch, whom I have already mentioned, and his elder brother Moishe, were also for Poland's Independence. Uncle Meiloch was a Bundist and he had his reasons for wanting Poland free: in a free Poland the Jews, under the leadership of the Jewish workers, would get national autonomy, they would have their own schools with Yiddish as their main language. But Poland's independence came first. Uncle Moishe wanted all Jews to go to Palestine, but he knew that many Jews would not want to leave Poland, the place of their birth, and a free Poland would guarantee their safety.

On the walls I saw posters showing a strong Polish worker with a red banner in his hands proclaiming: 'To arms, Poles! To arms, Citizens! The Polish Socialist Party calls you!'

Everybody I knew was in favour of Poland's liberation. I knew that one day soon, Poland would be independent and free and there would be one radiant beam of light for ever and ever.

One day Master Xavery disappeared. Some said that he went to join the Polish legionaries already fighting for a free Poland.

The first soldiers of free Poland that I saw chilled my every nerve. Instead of feeling happy and gay I felt terror. They were in the bright blue uniform of General Haller's[13] army and they were chasing bearded Jews in the same way and with the same terrible determination as grandma Feigl chased her rats! As soon as these soldiers in bright blue uniforms came into the street everybody began running and shouting: 'The Hallertschicks are coming!'

One day my grandfather came to our shop, his head wrapped in bandages thick with crusts of dried blood. The Hallertschicks had pulled his beard from his face and naturally they pulled with it large pieces of flesh. I saw many Jewish faces looking like plucked chickens. All over Warsaw you could see Jews with bandaged heads. They walked in terror.

Uncle Meiloch, who up till now had had no good word for the bearded Jews,

spoke of a planned pogrom in which every Jew would be hurt or killed. He became very busy. I saw him talking to the street porters, some of them shrivelled and small but most of them real giants. He talked to the artisans, to his Polish friends the socialists. New faces were to be seen in the street, all Uncle Meiloch's friends. I saw him talking even to the 'lumpen-proletariat', the horse-thieves and the pimps. He wanted everybody. My uncle Moishe also brought friends, he too went round and talked and talked and talked. And something came out of this talk. Uncle Meiloch had his sources of information and as soon as he knew the Hallertschicks had been seen in the neighbourhood he told everybody to arm themselves with whatever they could find, sticks, hammers, hatchets, axes – anything – and took them all into the courtyard and closed the front gate. The street had never been so empty as on that day. Uncle Meiloch's strange 'army' looked pathetic and desperate. Then a young boy hammered with his fists on the gates and yelled: 'They are coming! They are here!'

At once the gates were opened and like a fury all the men ran into the street. It was exactly as Uncle Meiloch had said it would be. Until now the Hallertschicks' raids had been on helpless bearded Jews – how many bearded men who were not Jews had fallen victim to them is difficult to say – but now they were awaited by Jews both bearded and clean-shaven, Jews who were no longer helpless, and this was another story. The street porters were the first into the street and at the very sight of these terrifying giants the Hallertschicks halted in their tracks, at first stupefied, not knowing what to do; then, when they had recovered their wits, they took to their heels and ran as though chased by hell-fire. Nobody went after them. Their humiliation was complete. The Jews stood for a while like a solid wall, then broke up in a chaos of talk and laughter, and later each went his own way. There was no bloodshed that day. But for days nobody laughed and nobody felt secure. It somehow slipped our minds to cheer the Independence of Poland. We just forgot all about it.

The sun, like an autumn leaf, gradually withered away and disappeared behind bulging clouds. The clouds came to stay.

Typhus and dysentery swept the street. The children's hospital was full and there was no more room, not even floor space, for any child. The two Talmudic schools became hospitals and soon they were full. Mothers hugged dead children till they themselves collapsed and the little corpses fell from their arms. No one showed surprise at a man or woman or a child sliding from the pavements into the gutter and dying.

Hunger... Typhus... And death.

Dr. Zaltzman now really needed wings to be everywhere that his warm heart wished him to be. One day typhus killed him, too. There were still some tears left to mourn him, but not many; he was taken from the street with many others, to be buried in a common grave. Everybody had his own pain; it was difficult to share the anguish of others. People no longer stood beside each other. No one philosophised any more: it was a matter of indifference whether life had a

meaning or was a mere banality. Unhappiness no longer mattered, death lost all its terror and in a way it became easy to die.

Vans arrived with men in white smocks with copper tanks on their backs who sprayed carbolic disinfectant over everything and this was now the most natural smell of the street. Many of the invalids died or disappeared and nobody gave them a thought.

All this lasted an eternity. The rich, who were also in fear of the epidemic, wrote to the papers that the slums should be fenced off with barbed wire so that nobody could get out. 'It is there that all the evil is,' they cried.

Eventually the epidemic was halted and it came as a surprise to see that so many had managed to survive. The Americans and the Red Cross sent over field kitchens and we were given soup and milk and bread.

The street was safe once more.

But the heavenly brightness had gone. The street was now a place of calm resignation.

Thus ended my years of the sun.

The Years of the Moon

On a warm evening in July I lay on the sandy banks of the Vistula, Warsaw's great river and Poland's 'queen of all rivers'. My tongue was playing with a cherry stone I had in my mouth.

I looked up at the moon; its body was full, rose in colour and perfectly round.

A barge floated by, leaving white ripples on the surface of the water.

The bargee shouted obscenities at his wife who was busy emptying a bucket. She straightened up and shouted back a few obscenities of her own. I sat up and wished them a good evening and they returned the greeting.

'A beautiful moon,' cried the bargee.

'A beautiful night,' said I.

The passing of the barge felt like a mild adventure. Then it was quiet again.

In the distance, the silhouette of the city, flat and black. The palace of past kings with its round, turnip-like tower, the tall, slender column with its tiny king holding a thin cross, and the iron girders of the bridge. In the shadowy city the bells of St. John's Cathedral chimed carefully, without hurry.

I looked at the river and thought of the pleasure of diving, of coming up to the surface and swimming on. But I did not move from my place; thinking of the pleasure was pleasure enough. I was only half awake, the condition I like best to be in, I felt drunk with the moon's light.

For five years I was dead. I came back to life for one year and then I was dead again.

The years between seven and thirteen, the years I spent at school, were the dullest years of my life. Not that I did not like going to school – I found the subjects quite absorbing and they presented me with no difficulties. Nor did I have any trouble in making friends with other children. The problem was the teachers – today I know this for a fact. They were dull men and women, quite uninterested in teaching – shining examples of ignorance and chauvinism. The shortage of teachers was so great that no head of school dared look too closely at the qualifications of his staff. Some of my teachers would have made good wardens in prisons: they were all great disciplinarians. Oh, they were good at discipline; fanatical about sitting upright, with head high, chest out and so on. During a lesson no child dared budge or even cough.

Although almost all my teachers are now faint ectoplasm in my mind, one – just one – stands out sharply and well-defined, both as a physiognomy and as a

person. She is the only bright spot in this stark universe of my memory: Miss Rose Dickstein. She was big, the eternal mother figure, although a spinster in her middle fifties. Her head was large, with large features and large blue eyes, yet, there was nothing overpowering about her. In spite of her size she gave the impression of being delicate and soft; she was truly of the 'angelic order'. As a teacher of Polish language and literature she had to do a lot of reading to us and the quality of her lovely voice is with me still. She transformed each lesson into a dream. She made Polish poets and writers our personal friends. At some moments we actually felt the loneliness and desolation of a particular poet entering our inner selves. There were also moments when she made our spirits rise and we felt like dancing and singing for joy. She was never matter-of-fact not even when she got down to the harder backbone of thought and ideas, not even when she attempted to simplify the content for us. Everything she said was expressed with passion and love.

All the other teachers left our heads as empty as they found them; this woman alone filled us with things memorable. I still cannot read a map, still cannot find my way with the help of a magnetic needle. Algebra, physics, and chemistry still put me in a state of panic. But the love of the Polish tongue remains with me. When some years later I fell in love with Yiddish it was in the same spirit of enchantment that I learnt from this woman.

This was about the only good thing my school gave me. It is perhaps a lot, but it does not outweigh the long, dull pain the other teachers inflicted on us. The worst of all was Mr. Cybulski, who taught history – a subject, by the way, for which I had some passion. He was a middle-sized brute with a face as empty as the surface of an egg; the eyes, the nose, the mouth barely registered. But he had enormous hands which I have good reason to remember.

He would come into the classroom, place himself in the corner between the blackboard and the window, look up at the ceiling and recite in a monotonous colourless voice a litany in praise of the military and the rulers of Poland, past and present. No child could really be blamed for dozing off, particularly when most or us had empty stomachs and little energy to resist sleep. One day this Cybulski noticed out of the corner of his eye that my head was drooping with sleep. He swooped, and began to beat the life out of me. Then, hearing a movement behind him, he just as swiftly turned and beat the next boy, and then the next. A real massacre followed.

During my fifth year at school a miracle happened. A new headmaster was appointed, a man full of energy and ideas. As if by magic, all the Cybulskis disappeared and were replaced by advanced students from Warsaw University and by older men and women long forgotten in the teaching profession. The new head, Gedali Schorr, also did something else. He went about with a begging bowl to get free lunches for us, and managed to obtain the help of some American charitable organisation which supplied free lunches for other schools. Gedali Schorr called us 'My children.'

The school was now a lively place. With all this new idealism and with our

stomachs no longer empty, it became a veritable paradise; but alas, too late for me. I had only one year of it.

In accordance with the unwritten law of our street, the thirteenth year of a boy's life was the year of his transition to 'manhood' of a sort. The boy was taken away from school and was told that he was no longer a child, that he was now to take a job and become a man 'like everybody else'. Having no purpose in life, nor ambition for which further education was needed, I put up no opposition to that law when it was applied to me; thus there was no friction at home as there was in some cases where the child wanted the moon and the parents needed bread.

In my home things were pretty bad and there was no time to 'think ahead'. Any job which would pay, no matter how little, was the job I took. I did not mind. I had no ambition. I abhorred all work.

My first employment was in a small factory which manufactured cardboard boxes and my job was to carry a mound of boxes, roped to my back, from one end of Warsaw to the other, or so it seemed. Before the week was over I was sacked. My back proved too weak, and one day as I was loaded up I fell flat on my face. This happened to me again several times in the street, and the boxes spilled around me like confetti. Some got filthy; some got run over by tramcars, or trodden down by horses, and though everybody in the street helped, there was nevertheless a lot of damage. Complaints began to pour in and by Thursday my boss had had enough and told me that I was of no use to him 'nor to God', though how he knew this was – is still – beyond me. That I was of no use to him I could understand. However, while handing me my money he gave me some fatherly advice: 'Tell your mother to feed you better. Lots of meat – that's what you need.'

Thus began a cycle of getting jobs and losing jobs. Within the first few months of leaving school I went through more jobs than most do in a lifetime.

On that evening in July when I lay in the moonlight, it was only a few hours after my latest sacking. I was in no hurry to go home. I quickly forgot my troubles – such was the magic of the atmosphere – and I thought of different things altogether. Somehow I never felt humiliated at being told that I was no good at this or that, and that I would have to go. In fact, I felt relieved. What did I want? I wished I knew. What grieved me was the hardship my parents had to endure. They so badly needed my help.

Lying on the sandy bank I rejoiced in the cool peace of the night.

I thought how vital this peace was to my life.

And I felt. And I forgot. And I remembered.

As I looked around I saw the great change in the sky, in the river, everywhere. Whereas before there was only a lone moon, now the sky was studded with stars, big stars. And the river, too, was studded with stars. I seemed to be surrounded by huge stars, their light was everywhere, like lamps at a feast, a strange heavenly feast.

For days, for weeks, I floated without any purpose. Even my zest for finding another job lessened. I was nearing my fourteenth birthday. Nature has its own

course to follow and follows it without the slightest concern for man's situation. Before the autumn came I felt strange emotions and physical tremors. To call this 'torture' would be a puritanical exaggeration. There was in those tremors a strange urgency, to be sure, but there was also a promise of pleasure. I followed each passing woman and thought that this one or that one, or the other – any of them – all of them might generate the comfort I wanted, I needed. I was now inhabiting the land of sexual fantasy. I was ravenously hungry.

I had a close friend, a Polish boy called Stephan. We had much in common; he, too, had been taken out of school before he could finish his studies; he, too, could not stick at any job; he, too, felt happier when out of work, and his widowed mother was just as much in need of his help as my parents were of mine.

One day that early autumn Stephan said to me: 'Josef, I have an uncle who is a coal merchant, and I can always lay my hands on some money from his cashbox. I took some today; he's so stupid that he suspects nothing. Let's leave Warsaw and go to the country. We can tramp from village to village and see something of life. Let's follow the "wild music of the wind".'

'Yes Stephan,' I agreed, 'let's do just that. We can beg for food if need be. Let's do what you suggest.'

I lied at home. I told Sarah that just outside Warsaw I had a friend who wanted me to work for him for a time and that I would like to do this, I don't think Sarah believed a word. She merely looked into my face with those big, tearful eyes of hers but said nothing.

Stephan and I went to the market where the peasants came to sell their goods. We asked for a lift from a peasant and his wife, who shared their bread and cheese with us but said nothing all through the journey. Nonetheless it felt good being with them. Freedom is the absence of anxious moments, and rocking in the wagon I felt blissfully free. We travelled thus for about four hours, then said goodbye to the peasant couple and thanked them for the lift. They did not answer, nor did they look at us.

It was as hot that afternoon as any summer's day.

We walked for a while and at dusk we began looking for field of haystacks in which to sleep.

I never saw such colours as those around us. I looked and thought that all this was so beautiful and free from violence, a complete affirmation of peace and beauty. Too much of this could drive one crazy! This was the first time I'd seen such a grand spectacle of 'nature'. The meadows on the outskirts of Warsaw were hardly nature – they were a part of the city – but here... My eyes danced from colour to colour, from ochres to orange yellows to gold! And in the distance a radiance of fine, rose vapours and on the horizon, in its last glow, a huge red sun. The nearby fields had the texture of satin and the whole vast sky shone like burnished brass. Only the solemn trees were dark and they alone suggested firmness and strength.

Here and there at a distance, peasants were gathering their tools. Followed by brown and white horses, they then walked along the narrow tracks which lay in the shadows. Their day's work was done.

Then I felt the resignation of the world before the night set in.

The darkness of the night descended slowly. A crescent moon the colour of butter appeared in the sky. Sitting deep in the haystack, we talked in lowered voices; the air was heavy with scents which heightened the sensuousness of the atmosphere. Thus we lay in silence for a long while. I closed my eyes and dared not open them again. I was too happy to move.

Young sex does not seek enjoyment, only fulfilment. Every part of my body was hypersensitive, even to the touch of my own hands. Every bit of my flesh below the belly felt separate from myself, with drastic demands over which I had no say.

Sex is cataclysmic and explosive and, like hunger, wants only one thing – and this was the first time in my life that I had hungered this way.

I moved nearer to Stephan. He whispered: 'It's very warm – let's undress!' We undressed and became at once entangled in our passions. We caressed each other and gripped each other's penis so tight it almost hurt. Then everything became chaotic, confused and engulfed in a spontaneous St. Vitus' dance of pleasure. The ejaculation came with a tremendous force. Then we lay still for a while, numbed and wet, and drifted away from each other. I got dressed again for the night's sleep. Later Stephan dressed too.

By the morning all was forgotten and for the remaining days we slept at a short distance from each other, without repeating the experience.

One midday, we were sitting in a field of poppies having our meal – each peasant woman at whose door we knocked had given us big slices of bread and told

us to take tomatoes, radishes, even fruit – when Stephan said: 'What do you say we look for a girl or two?'

'I think about that every night,' I replied.

So, like two hunters we set out, with one idea in mind. We walked and sang at the top of our voices! The world around us was ablaze with light! Our spirits, too, were full of light! There would never again be any darkness! The light would go on for ever!

This was the light of our hope

This was the heavenly light! Hurray for freedom, for girls and for light!

When I first fell in love the idea of love was out of fashion. The boys and girls I knew refused to be 'sentimental drips' or 'mooners'. The poets of the time told them to be at one with the machine age and 'to have hearts of steel – and hearts of steel they had. The greatest influence was a book by the Russian woman Aleksandra Kolontay, *Three Generations of Love*.[14] We piously read this book and quoted it at each other; copies went from hand to hand, and sex became as emotionless as 'drinking a glass of water'. Those with a talent for sex never had it better. Those with a talent for love fared badly. Techniques in copulation were the be-all and end-all; the exploits of Casanova provoked hilarious laughter but were also the model for active sex. This was considered being true to nature; *nature* wanted nothing else... Love? *Love?* Oh no, not for us – forget it! Ours was the mechanical age, the age of science and revolution! There had to be a technique for perfect love-making. 'I have read about a new way, let's meet about nine this evening and we will try it out.' As cool as that...

It was in such an atmosphere that I discovered that my talent for sex was rather less than average, while my talent for love was perhaps greater.

While I find nothing wrong with a healthy appetite for sex, I am certain that love is the greater of the two as an experience. As far as sex is concerned, the other person is an abstraction, an instrument, and apart from the mutual seeking of pleasure there is no other involvement. Where love is involved, the other person is a reality.

Montaigne explained friendship thus: 'Because it was you, because it was I.' This, I think, can also be said of love. In love, as in friendship, the person comes first, love itself comes first, the metaphysical connection comes first, the togetherness comes first. That is why lovers are able to die for each other. The spectrum of love with its hypnotic antidote to the eventual dreariness of sex is also the spectrum of joy for the two people who have found each other. Love, too, is nature! And the awakening of this feeling in a life dark with chance, the rare moment of experiencing this feeling, by far outshines the most perfect orgasm.

That was how I felt on my first day of loving.

All the troubadours through all the ages had sung of my love – of this I was certain. All the poets had written of my love, for there was never any other love to write about.

The sky has many moons, says the scientist, and the poet adds to each moon a pair of lovers. There was also, in this vast heaven, a moon for me and my love. Since time immemorial the years of love have been the years of the Moon.

Her name was ordinary enough: Dora. She was a silent girl. Instead of words she used the language of her eyes which I soon learned to know and understand. Quiet suited her physique: she was tall and brown with shining black hair which fell down to her breasts; her presence brought to mind primitive peoples and savage landscapes. But I was to see her against the more realistic open plains of Warsaw's suburbs, where there was grass and shrubs and where, at its zenith, our moon was. There we were alone and alone we wanted to be all the time. We filled the emptiness around us with our passions. Their sources were inexhaustible – because it was *she* and because it was *I*. And when we were tangled up in love it was love's own joy that brought the rhythm of life into us. Just being with her brought a gleam of unique loveliness... because we had found each other, because it was *she* and because it was *I*. And there could be no one else.

But our love was not to last.

Her father was a forger of passports and other documents. I knew him for only a short time. He was unfortunate in that he had a personal 'style' and the authorities had no difficulty in recognising any 'job' of his. He was therefore more often away 'on holiday' than at home. Her mother was an idiot; most of the time she was either in tears or laughing out loud, suddenly and for no reason. Trying to talk sensibly with her was a Sisyphean labour.

That winter, Dora caught a cold... then pleurisy, then tuberculosis, at the time a killer. The doctor and I tried as hard as we could to explain to her mother that Dora must be sent to a sanatorium, but no, the mother wept and laughed and said that Dora must die at home.

Dora's father was inside at the time – on one of his 'holidays'.

And Dora never saw the coming spring.

I was then not much older than Romeo when he took his poison...

It is only after you have endured the anguish, the suffering and the death of someone precious to you that you get the first whiff of the bitchiness of life...

Eli Adler was a type-setter in one of the largest printing establishments in Warsaw. He was also a tuba player in the Printers' Union brass band. You always knew when Eli had a day off from work; all day long you could hear the oompah, oompah, oompah. Printers were the highest-paid workers and Eli was well-off. He was short and fat and his round head lay on his chest as though he had no neck. He was good-natured, always ready to help others; and he was a good friend of my uncle Meiloch. Eli's wife Ethel was of a different breed; she was fanatical about cleanliness and considered herself a cut above the rest.

One day Eli called me from his window, 'Come up Josef, I want to talk to you.'

I went up and the moment I opened the door I heard Ethel's voice: 'Wipe your feet!!!'

Eli stood in the small passage. He put his index finger to his fat lips as though to say 'Don't mind Ethel,' but he dared not take me into his sitting-room and we remained standing in the passage.

'Josef, your uncle Meiloch told me how you can't keep a job and he asked me if I can help. Perhaps I can – and perhaps I can't – it all depends on you. First, tell me what you would like to do. We all have to do something.'

'Honestly, Eli, I don't know. I've asked myself the same question a thousand times. I'm willing to do anything.'

'Perhaps you did not find the right kind of job? Now, listen to me. You know how difficult it is to get into printing. Let me tell you, it is very difficult. People are prepared to pay hundreds and hundreds... Now, I am not without influence in the printing world – playing the tuba helps. People like musicians. I have spoken to Felix Yacubowitch and he is willing to take you on. You know he does fine work and is highly regarded. You can have a good life, you can be apprenticed to the machinist or learn to be a type-setter. What do you say to that?'

'I say yes, *yes*, to every word you say. Eli, I'm very grateful.'

'All right, that's all I wanted to know. Now, wait here a moment while I get my jacket and we can go at once!'

Felix Yacubowitch was an unusual man. I heard many stories about him and they all illustrated one thing: his great originality. In his younger days he was quite a well-known figure in the anarchist movement. He knew Kropotkin[15] and from his years abroad he also knew the legendary Rudolf Rocker,[16] the non-Jew who learnt Yiddish in order to spread propaganda among Jewish workers. He had spent a term in Siberia and he knew the inside of many prisons. But something had happened to him during one prison sentence, and when he came out he was a changed man though still an anarchist at heart. But he often behaved a little oddly. That he was no longer a young man when I began my apprenticeship I knew, but I could never have guessed that he was over seventy. There was a perfectly true story in circulation that every time a union called its members out on strike, Felix asked his own employees (six in all) to strike too and thus show 'what the solidarity of the working man is capable of'.

'But Felix,' his workers would argue, 'our union is not involved in this strike.'

'Then shame on them!'

Efraim, the old machinist, told me that this happened every time there was a strike somewhere. 'If Felix had his way and we came out on strike every time some other union had a conflict, we would never do any work!'

Felix Yacubowitch was the warmest and kindest human being I ever set eyes on. To work for him would be a joy, I thought, and it was. The three years under Felix's tutorship were the great experience of my life. Besides being a good man he was also a great teacher. He spoke with a voice full of light and I knew that following him I would not be lost. Every word he said brought new ecstasy and work became for the first time an adventure! The nights seemed too long and the working day too short. Never before had I longed for the day's work to begin or felt sorry when it was over.

'My boy, my dear boy,' Felix would say, 'type-setting is an art, an aesthetic act. Selecting types for, let's say, a letter-heading, demands a decision involving taste and imagination. A well laid-out few lines are the expression of a sensibility towards graphic shapes and graphic space. The type-setter's aim is to make something exquisite which will give pleasure to the eye. Have you thought of this? Think about it. Type-setting is not a mere job, it is an applied art. What I noticed in you, my boy, is that you have taste and imagination, so I'm pinning my hopes on your turning out to be a true type-setter. A *true one*, I say.'

It is not always easy to pinpoint the moment at which one's inborn gifts begin to show. In my case I can say that my sense of art began to reveal itself during my apprenticeship as a type-setter. And I would have remained a type-setter for the rest of my life and been perfectly content but for a practical joke played on me by one of my workmates which changed the whole course of my life.

The day was meant to be a day of celebration. Felix stopped everyone from working and announced that with the coming week my apprenticeship ended: 'Let us welcome a new type-setter, and a good one at that. Josef has a special gift for fine work and he has shown that he loves his work.' Everybody applauded and shook my hand.

During the lunch break I was ceremoniously handed my sandwiches. Someone had put pieces of filthy type full of ink and dust between my bread and sausage so carefully that I swallowed several bits of the poisonous lead before my teeth bit on something unusually hard... Seeing the contorted expression on my face they all fell about in hysterics of laughter and cried in chorus 'Congratulations, Josef! Now you have tasted type and you know what it is to be a type-setter! Welcome to the fraternity!'

A few hours later I grew dizzy and began to vomit. I became so faint and life-less that Felix insisted on taking me to the nearest hospital, where I remained for a few days under observation. Finally I was told I had severe lead poisoning and that further working with lead was out of the question. I will never forget Felix's eyes when I told him. I think he suffered more from the shock than I.

Two significant things happened to me during those years, about which I have to write at some length.

After I had been working only a few weeks I became a member of the Printers' Union. For the young, the unions at the time were a sort of university: most unions had study circles and there you could hear some of the country's finest lecturers giving talks on a wide variety of subjects. The library was the union's pride and it was in this large room, against the rows and rows of books, that dis-cussions went on till all hours of the night. The topics varied from sociology and history to philosophy and literature. At poetry readings we had actors or the poets themselves. Some of the talks were in Polish but most were in Yiddish.

I have good reason to recall here one of the lecturers, a young man from the Yiddish Seminar for Teachers at Vilno. His name was Zalmann Gurfinkel. His complexion resembled more that of a corpse than a living person. His cheek bones were high and his eyes lay in violet hollows. But what fiery eyes they were!

His Yiddish was so beautiful that I often listened to him with closed eyes, as one listens to music.

I detested the Yiddish I had heard as a child and wanted nothing to do with it. Its vocabulary comprised utility words with no beauty, no lyricism, no music. Even the shouts were flat, without vigour or passion. As for tenderness, the vocabulary seemed so poor that even the great Yiddish writer Peretz had to admit: 'It is impossible to love in Yiddish'. There were only basic words at the lover's service; these lacked sensuality, elasticity, variety, intensity and tones which could blend the emotional quality of the situation with the longing for expressions of love. Until the age of seventeen I preferred Polish. In any case, as most of my childhood friends were Polish, my Yiddish was very basic.

I became friendly with Zalman and he introduced me to a group of young Jews who called themselves 'The Children of Peretz'. Politically they were at logger-heads, but they had one thing in common: they all spoke Yiddish with pride. They trained their minds in Yiddish and their Yiddish speech suggested a refinement and a force I had never thought the language capable of. There may have been

an element of youthful posturing in their insistence on Yiddish being 'one of the great European languages', but one thing is certain, they loved Yiddish. Their aim was to give Yiddish an urban quality, to free it from its parochial status, its village narrowness and village witticisms. 'Our Yiddish needs the rhythm of the big city', they said, and this was why they were so keen to support the younger poets who experimented with words and forms in the fashion of European Futurism, Constructivism and Expressionism; they loved the works of Markish, and Brodersohn, Kwitko, and the new plastic lyricism of Kulbak. All this was to me a revelation, and not only as regards the quality of the language, but also the new concept of Jewish *identity*. I often heard Peretz's famous lines quoted:

> ...and thus we stride,
> We proud Jews!

And with my progress in Yiddish I too began feeling proud of my Jewish identity.

It was now clear to me that Yiddish was not what the Zionists or the assimilationists said it was – 'a ghetto jargon', an expression of 'downheartedness' and 'spiritlessness'. On the contrary, it was a language of rebirth, pride and self-discovery.

The second significant thing that happened to me during those years was of a more artistic nature. Felix Yacubowitch was very anxious that I should become familiar with the 'new taste' in graphic arts. He gave me foreign journals concerned with 'modern typography' and 'modern design'; he would look into my eyes and in his clear voice say: 'Things are happening in the world of which very few in Poland have any idea. There are new ways of using letters and you must learn these ways. There are new ways of using printing ink and you must think of these. I will hand over to you only special jobs, for clients who are not afraid of new things.'

From these journals I first learnt that what was going on in the applied arts was a part of a greater thing called 'modern art'. Without knowing yet why, I began to buy art publications and to feed my mind with lengthy and difficult articles. This was the age of artists' manifestoes, and I began to read with great earnestness all the manifestoes they printed. I also began visiting exhibitions – usually held in the basement of some great store – of avant-garde artists, and tried to recognise the styles they worked in: this is a Cubist picture, and this Futurist or Constructivist, and so on. Heaven only knows what I was trying to get out of this guessing game! Perhaps this was a way of feeling my way towards art – after all, much of the art of the twentieth century was a matter of reasoning. I recall that many many years later, I talked to Gino Severini about the early days of Italian Futurism; he was present at its birth so he should know about it. He said: 'Ah, those were odd times. You must remember that in those early days we were all logicians more than artists; we asked questions and *painted* answers!'

Of all the slogans, I remember being most impressed with that of the Russians who called themselves 'Suprematists':[17] 'A chair is more beautiful than the Mona Lisa!' This sounded to my ears a challenging and tough statement! It took me

some time to discover the confusion underlying it. With my inner eye I could see the Mona Lisa sitting on a chair! A chair is for the bottom and art is for the head, I thought to myself, or for the heart or wherever feeling resides! Painting a picture and designing a chair are two different functions and one is no substitute for the other! The Suprematists also proclaimed that painting was dead but this I did not want to hear. Nevertheless I went on liking what the Suprematists and the Constructivists[18] were doing with letters, their devotion to a flat graphic surface, their ideas about lay-out and so on. I also liked their basic colours, the reds, pale greys, browns and blacks. I particularly liked the graphic works of Lyssitzki.

I am saying all this to indicate my dour, almost monastic intellectual beginnings, for soon afterwards I wanted nothing of this.

During my work as a type-setter it became clear to me that I had some talent in the field of graphic design. Now that I had more time on my hands I wanted very badly to become a graphic artist; in their attempts to link fine art with applied arts the moderns gave the applied arts a particular prestige, and to design for definite products, book jackets, posters and so on, seemed the very thing I could do. I needed no extra schooling for that.

I was fired with a new purpose, my senses were in state of excitement. Here once again two men helped me in my first steps to get commissions – the beloved Yacubowitch, and Oscar Stern, a man well known in Warsaw's artistic circles whom I had once worked for as an office boy and at whose place I saw the first 'originals' of modern art. Through these two men I obtained my first introductions to some commercial firms which used graphic designs to further the prestige of their products, and also to one or two publishers. I came to know some of the leading designers in this sphere – later, when I had started to paint, I earned a living by giving them a hand.

For a time things went well. But then my enthusiasm for this kind of work turned sour on me; soon it became little more than a boring routine.

Oscar Stern was sympathetic to my new mood. He said: 'I knew this would not last. I may be wrong, but I flatter myself as being something of a psychologist! The hunger in your eyes when you look at pictures tells the whole story. You may well be a natural painter.' These words I found encouraging. Now Oscar Stern asked me to his Thursday evening gatherings at which I met some of the finest writers, artists, and actors. The things I heard on these Thursday evenings made me more restless than I was already but they also filled me with an eagerness and a will to change my way of life dramatically. I stopped fearing poverty; this was a thorn in my flesh I had to get rid of! Children of poor parents suffer a double handicap: not only the poverty they inherit but also fear of the continuing threat of poverty. That fear has eaten up more talent than the world will ever know. I was a wounded bird trying to fly.

One Thursday evening, when we were walking back to our respective homes, the painter Felix Friedman said to me: 'Oscar told me that you want to be a painter. What do you think, have you got enough talent for this? Do you think Warsaw is a beautiful city? I think it is. Look at the moon over the white tin roofs. Does this soften your

heart? Nowhere have I seen such green light effects – now, where was I and what was I talking about? Ah, yes. I was asking you what makes a painter. Do not bother to answer, I know and I will tell you. Is it his desire for expression? Yes, but this is common to all creative people. The painter shares even his sense of colour with others, even with the woman arranging flowers. His sense of form he shares with sculptors and his sense of shape with designers and architects. The painter also shares many things with poets and musicians, for instance, the sense of unity and composition. The only thing which is true of the painter alone is his sense of pigment, yes, his sense of pigment is his sole domain, it is instinctive. So my dear, if you have an itch in your fingertips to handle this bit of muck, that bit of pigment, then you are a painter. If you have not got it, you may still be an artist of sorts but take it from me, you are not a painter. Now I must turn here. Good night.'

When I was left alone; I looked at my finger-tips. I knew that they held a deep secret. I thought I felt the itch this older painter was talking about. I had always felt something prickly about the word 'art' and something down-to-earth about the word 'painting.' I suddenly saw myself in the role of the village idiot in Anatole France's lovely tale, *The Lady's Juggler*, who knew only one way to pray and that was to stand before the statue of the Lady and juggle three plates.

One day at an exhibition, a tall old man with a long white beard approached me and introduced himself as the painter Professor S. He said that he was painting

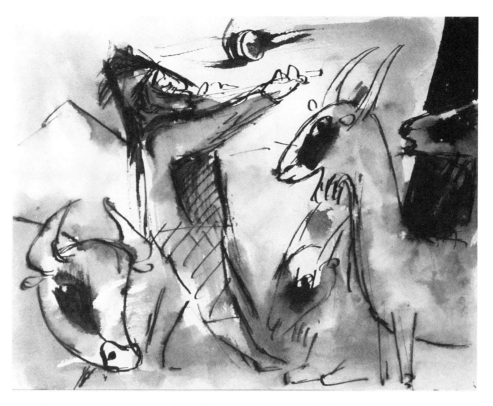

an allegory on the theme of the Young Orpheus and that seeing me it occurred to him that I would make the right model. Had I ever modelled? No. Was I interested in art? Yes. In exchange for posing the old man offered me free tuition at his evening school. The posing was a chore: I stood naked with a fig leaf under my belly and laurels on my head and lyre in my hands; to make the image more ridiculous, Professor S. made me stand in front of an *eighteenth-century French tapestry*! Nor was his tuition much better. All his talk about 'truth to life' and 'the science of composition' was a trap to get me into some routine from which I would never get out again. Whenever he mentioned Raphael he really meant the academic painting of the nineteenth-century School of Munich in which he was trained! He recited passages from Alberti,[19] first in Italian, then in Polish, on how to make a composition interesting: 'Avoid backs!'

One day during a rest from posing he made me look at his monstrous canvas; it was so high that even this tall man had to use steps when painting at the top. (That morning before coming to model I had read in a leading paper an anti-Semitic call to restrict the entry of Jews to learning; it was signed by some of the better-known anti-Semites, and by Professor S.) Now, standing before his picture I remarked: 'With that silver fig leaf covering my sex nobody will ever guess that yours is the first circumcised Orpheus in the history of art!'

That was the end of my career as a model. A few months later I entered the School of Art and Decoration.

It is a fact that the school of art is a poor substitute for the medieval workshop. The only person from whom you can really learn something is the one with whom you have a kinship of temperament, otherwise you are really on your own. No school can put you on your lonely way, and all the time I was at this school I felt as though I were nailed in one place. I saw clearly my direction but could not move towards it. After eighteen months I left, and felt better for it. The modern artist suffers from a high degree of amateurism. He is self-made at a price. The problem for him is: from whom to learn the craft?

I was lucky. I knew one fine painter at whose door I could knock whenever I wanted him to tell me something about my work. From him alone I finally learned something. He was in many ways an extraordinary man, in his late forties, robust, but of an ascetic disposition. I called him by his initials, J.C. He liked it that way. He had lived in France for years and there had got into the habit of theorising, but now thought all 'intellectualising' a waste of time. He was wonderfully articulate in a poetic sort of way: when he could not find expressive enough words he preferred to keep his thoughts locked up and sit quietly. He was an attractive man and women loved him, but he saw sex as the enemy of 'creation'. One day I found him in unusually high spirits with a glass of vodka in one hand and the bottle in the other.

'Ah, glad you came. Now I have company to celebrate. Take a glass.'

I took a glass and asked: 'What are we celebrating?'

'You may well ask. I have freed myself from my greatest physical bother. I am one step nearer to the ultimate freedom! My young friend, I am impotent, sexually I mean. As impotent as if I'd been castrated! I have prayed for this day!'

'J.C., why do you hate women so much?'

'You don't understand a thing. Me, hate women? No! I hate the sex in *me*, not the sex in them. Now women will be still dearer to me. They will be my sisters. Let me tell you a story about some Jewish – or is he a Christian? – mystic. It does not matter. Anyway, this mystic once had an important conversation with God! Suddenly he doubled up over his knees and cried out: "Forgive me, God! I must interrupt our conversation, I must go into a corner and shit!" Now, my dear Josef, do you get it? The further we get from our physical needs the nearer we get to the spiritual wholesomeness of the truly artistic being. No more sexual shitting for me! Isn't that something to celebrate?'

He laughed, I laughed, and we got drunk. I need only add that J.C. meant everything he said... he was not joking.

That day I had come to tell him how a simple phrase from Edvard Munch[20] had changed the whole purpose of my work. He said: 'Yes, that often happens. One wise line can do what a lifetime's struggle in the dark cannot.'

I quoted: 'No more paintings of interiors with men reading and women knitting!... I will paint a series of pictures in which people will have to recognise the holy element and bare their heads before it, as though in church.'

J.C. said: 'Unless we paint in our modern day as seriously as religious painters painted in their times, we are lost and no amount of "experimentation" will save us.'

But more often J.C. talked to me about matters of technique and things basic to the craft of painting and drawing. He would look at a drawing of mine and would turn it upside down and then bring it back to the right position. Then he would point out to me a line and say: 'It is weak', or 'It is not like the rest, it is superfluous, it adds nothing to the rest of the design', or 'This line is without expression, it is merely decorative'. I would look, and try as I might I could not see the differences. But sometime later I would bring another batch of drawings and J.C. would smile with satisfaction.

'It has sunk in... You've got it. This is it. It is not what you understand of what I am saying that matters but what sinks into you. Yes, it has sunk in...'

And under those encouraging smiles of his I felt my work getting somewhere. I began spending days with a sketchbook in the industrial suburbs of Warsaw. I felt drawn to the motifs I could find there and nowhere else. And I needed J.C. to tell me how far or how near I came to making of these motifs a work of art. Still today I am not quite sure of myself and I often wish for another J.C. to tell me where I succeed and where I fail. I always yearned for the all-absorbing still-ness, and this I tried to paint. I always longed for a space as soft and luminous as the inside of a rose, and this I tried to paint. I always desired the timeless moment when life stands still and is endless, and this endlessness I tried to paint. But being drawn from my earliest beginnings to social motifs made me feel uncertain about the shining ideas with metaphysical centres I was truly after.

In 1932 I had my first exhibition in Warsaw in a small shop belonging to a frame-maker named Koterba, who also had a gallery adjoining his workshop. I hung my pictures and did nothing else. In fact, I hardly went to the gallery for the rest of the fortnight. Some friends and a few colleagues – young painters – saw the exhi-bition and told me pleasant though not very illuminating things. And so I went on painting, only occasionally sending a picture to the annual salon; sometimes it was accepted and hung, sometimes it was rejected. I was not totally unknown in some art student and even artistic circles. I was particularly active among a group of painters whose link was political rather than artistic; politically they were to the left, artistically they were as varied as the nature of individual tem-peraments can be. To underline our political commitment we called ourselves 'The Frigian Bonnet'. Such a group could only have come into existence in the

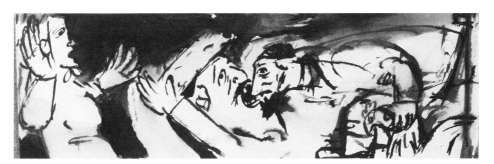

political atmosphere of the thirties. To be socially aware was then inevitable and no one with a drop of social compassion could be otherwise.

My motherland, since ever I could remember, had been governed by a military dictatorship. Anti-Semitism was part of State policies, at times applied discreetly but later quite openly and consistently. Although many writers and artists were radicals of varying degrees, they were unanimous only in their opposition to fascism. To the police they were all communists or agents of Bolshevism. During one of my arrests I was told by an interrogator: 'We have no patience with subtleties', although he knew very well that I did not belong to any political party, legal or illegal. In 1936, when the first concentration camps on the Nazi model were established, many of my friends were its first victims. Like many others, for well over a year I never slept twice under the same roof. New anti-Semitic laws had been pronounced: in schools and universities Poles and Jews now had to sit on different sides of the classroom. In the anti-Semitic propaganda Jews were identified with 'international banking' and with 'international Bolshevism' at one and the same time. In the streets, armed with sticks and knives, nationalistic students with green ribbons in their lapels attacked Jews and smashed the windows of Jewish shopkeepers. They shouted 'Jews to Madagascar!' Once again fear filled the Jewish quarters. There was no protection from the police. On the contrary, the police often accused Jews of 'provoking street disorders'.

In 1938 I decided to leave Poland and within a short time I had in my hands a false passport which my friends got hold of through the services of shady lawyer.

On the platform to see me off, besides my mother and father, there were only two of my closest friends – the painter Zygmunt Bobowski, and the art historian Joseph Sandler. It was a dark, moonless and starless night, and although it was only the beginning of autumn it was very cold; a terrible, noisy wind made it impossible to talk. In the crowd on the platform men held on to their hands and women to their skirts.

First my mother, then my father, then my two friends somehow managed to get near my window. Even so, I am sure that they did not hear my last good-bye. I did not hear theirs.

The Years of the War:
Brussels 1938-40

Like all European artists, modern Polish artists were drawn towards Paris, just as an earlier generation was drawn towards Rome. Polish painters were convinced that in Paris they would find the examples of the modern attitudes they sought. They certainly found them there. And what they brought back to Warsaw gave one an indication of what to expect from Paris – Bonnard and colour, a bit of Fauvism and bit of Cubism.

Frankly I was not overwhelmed by all this even though I was at the time a mere beginner. My own thoughts turned towards Holland and the Flemish. I thought of the country of Rembrandt and of the country of Breughel, the Peasant Breughel – though he was not so much a peasant, but rather a highly erudite man for whom the peasants represented a doorway to humanism. Indeed, peasants were not his only subject; in 'Landscape with the Fall of Icarus', for instance, Breughel painted one of the most poetic and philosophic pictures ever attempted.

But though I felt drawn towards the Low Countries, I knew nothing of the modern Flemish or Dutch artists – after all, the French influence was the most dominant in Europe. France's greatest period was the nineteenth and twentieth centuries; like all aspiring young painters I made a point of knowing all about that period, but I did little to familiarise myself with the work of other countries.

At the same time, I was rather uneasy about the French genius, for it seemed to me that although it reached a certain pinnacle, it did not attain the peaks of the Italians nor the depths of the Dutch and the Flemish. Through the ages French art has staked its all on what Delacroix called 'le charme et le goût', on refinement and sophistication, on intellectuality and sensuality, but it has never approached the serenity of the Italians nor the intensity and the simplicity of the Dutch and the Flemish. A great French painting makes my mouth water, a great Northern painting makes my head spin.

Thus, when I decided to leave Poland I thought of Belgium, and not Paris. With the sole exception of Ensor I had never heard the names of contemporary Belgian artists – Servaes, Permeke, van den Berghe and their contemporaries.

I knew something of the flat fields and low horizons of Belgium's countryside, I knew something of the big peasants and the low farms and the dark skies of Flanders; I had heard about them from da Costa's writings and Verhaeren's poetry.

In choosing Belgium I followed a dream not a reality.

I arrived in Brussels about ten in the morning and a dear friend of mine was

waiting for me at the Gare du Nord with her sister. We went straight to her place. As she had to attend some classes – she was studying history at the university – and as her sister had to go back to her home outside Brussels, I found myself alone, and was glad. I decided to make a tour of the museums without delay. I also decided to make my way on foot and see something of the city.

The first impact was overwhelming.

I could not help comparing the streets of Brussels and all I saw there with the streets of Warsaw which I had left only twenty-four hours before. I was breathing a new air, the air of the free.

Earlier that morning, when I stopped at the offices of the Ixelles Commune to register, I had been struck by the ease with which things were done. In Warsaw a visit to a municipal place strained the nerves to the utmost: the long hours of waiting, being called, being told to wait again, presenting papers, more waiting, nothing but hanging round and waiting, and if you dared to ask how much longer you had to wait, you were shouted down by a petty official, a little tin god behind a window. In Brussels I was flabbergasted by the readiness to help, by the courtesy and the speed. And as I walked the streets I looked around me, admiring the city's astonishing physical beauty, observing the way people talked, or simply greeted one another, or walked – yes, the very way they walked spoke volumes about freedom, for an enslaved people walk with a different gait. They carry with them the burden of insecurity, the burden of fear and of darkness. Even when off-duty a Polish policeman breathed fire through his nostrils: his very presence frightened the life out of you – that was his job. Here the policemen actually saluted before he answered my query in a civilised leisurely manner. It was lovely to see that everybody took this for granted. For the sheer fun of it I stopped every policeman I saw just to hear his soft, polite voice, just to watch his courteous manner. Now, I said to myself, this one looks like a brute, I'll stop him and see... But no, he was no brute, he simply had an unfortunate face and his behaviour was that of a civilised human being! 'A free man, whoever he is, is more beautiful than marble' – these lines of Baudelaire suddenly came into my mind. Yes, it was quite an experience. It left me weak at the knees and I had to sit down on a bench in the Botanic Gardens to regain some strength. Like a film flashback, the freedom-loving Julio Jurenito[21] appeared before me. I could see him exactly as his biographer Ilya Ehrenburg described him, I could see him, intoxicated, shouting at the top of his voice: 'Hip, hip, hurray for the Free West to which I am now returning. Hurray, hip, hip, hurray!' I must have been raving, for I became aware that people were looking a me. Raving or not, I was out of my senses, happy beyond words.

I was in no mood for museums. I had lunch on the terrace of some tavern, then I made my way back to the room in Ixelles. I threw myself on the bed and soon fell asleep.

No sooner did I open my eyes than I felt an urge to be once again out in the streets – just to be there, to walk, to look.

I was now much calmer. The streets, the avenues the squares, the corners – all

was now familiar, even the spirit of freedom in the street. Nevertheless, I felt a tenderness within, as though I was stroking a child's head. I walked slowly, leisurely, not the least bit excited, but reassured.

It was now dusk and the half-light suited the city. When I came to the square of the Palais du Justice – in daylight an overpowering building, not without its share of the pomposity which usually accompanies this kind of pseudo-classical building – I could take in even this monster; the soft light subdued it and made its scale more manageable for the human eye. But it was the view below me which swept me off my feet. I stood in the shadow of the Palais du Justice at the foot of its steps, as though overlooking the wall of a garden. But far below, as though in a valley, lay not a garden but Old Brussels. A world all its own. An even line of brown roofs, and in their midst Gothic spires, tall, slim, green, rising like sulphurous flames. At first all looked like a newly discovered city, a wonderland. Uniform narrow strips of buildings all pink and wine-brown – the kind of brown Breughel used in order to make his walls more fantastical than real. A white church stood out, shining like ivory. The trees were reduced to black blobs here and there. Over everything lay the spell of the Middle Ages, the silence of a pre-machine age, the overpowering loveliness of long-past times. A nostalgic view, which poured peace around me like an eastern fountain. A city in which to seek salvation.

And the sky that evening was made for the Old City. I saw the same view at other times under different skies, but this sky remained memorable. There was no variation in all its wide stretch, just delicate textures of cool, luminous greys... Only in the mountains, before rain, have I seen such a sky. Strange soothing gleams – an ethereal vision, yet an integral part of the walls, of the roofs and of the spires. Against just such a setting Ensor put the lunacy of man's horrific gaiety, and his own commitment to the grotesque... I could almost hear the laughter and the screams of his crazed humanity.

Thus I stood hunched over the low wall. There was not a soul around. When the evening darkness fell, and a slow drizzle became a heavy shower, I decided to make my way back to the room.

That evening B. came back from the university with some of her colleagues, all Belgians. She made coffee and at first everyone was friendly. Then I was asked how I had spent my first day, and when I explained my intoxication with the things I had experienced I caused a real commotion. First, my feeling of freedom and then the matter of the smiling police. I was really bawled out. I was told to ask the coloured peoples of the Congo Belge what they thought of imperialist freedom, then to ask the Belgian workers whether the police smiled at them when these same police on their horses rode them down at demonstrations for peace. One girl threw into my face Engels's words: 'Freedom is the recognition of necessity!' I was handed a real pudding of mixed arguments! When, to ease the atmosphere and bring a smile to their faces I said to them, 'Say cheese,' they became really furious with me.

One of the great blunders of the Left of the thirties was its inability to distinguish between bourgeois democracy and fascism, and still more catastrophic was Stalin's 'theory' of 'social-fascism' which was meant to discredit the social democrat throughout the world. In each case fascism came out the stronger.

I had my own ideas about freedom, which I always believed to be basic to individual life. Engels's definition is purely philosophic and speculative and could be just as useful to a fascist as to a Marxist. A Mussolini and a Hitler could with equal logic prove that they 'recognised necessity; just as Stalin could, when establishing his state of permanent terror. In historical terms, freedom as part of state policy was brought about by liberal capitalists – to be sure, for their own ends – but it has since become essential to every human being. And although contemporary communists can show many practical victories, social democracies the world over may still have the last laugh precisely because of their will to succeed with freedom on their side.

The next day was again significant for other reasons. It was a day to remember.

I was outside the doors of the Museé des Beaux Arts – where the Flemish moderns can be found – just as the gallery opened, and I was the first to enter. The public does not rush to museums, it visits them at its own convenience. For the public, the museum is a place of entertainment. For me it is an extension of my workshop. I usually work hard in a museum and when I leave I am exhausted. I say this to explain why I was glad that I had all the rooms to myself for nearly an hour, and I walked quickly from picture to picture and from room to room to get a general idea, an all-round feel of the totality. Then came my second tour, when I looked more selectively at single pictures. I devoted the rest of the time to those important to me.

De Braekeleer impressed me, so did de Groux, though much less than Laermans and Evenpoel; Servaes, Ensor, Permeke, van den Berghe, de Smet more than impressed me – they brought my feelings to the boil! Within seconds their work transformed me from an onlooker to a lover. They had a quality which I think is rarer than originality; there was in each of them an independent spirituality, traditional yet unique to the temperament of each personality. Nationally defiant, individually assertive. I loved this spirit. I loved this refusal to bow to the demands of fashion, of French fashion or any other. What is more, in their work the quality of the pigments is at one with the feeling content. I thought this quality had been lost in modern painting, but the Flemish had kept it alive: their pictures carry the iconography to a moral depth, and this is more than painting for aesthetic ends, more than painting just for taste and for pleasure. Was this the kind of painting that Munch had in mind when he wrote the lines which impressed me so much: 'I will paint a series of pictures before which people will bare their heads as though in church'? 'Modern painting, if it is to have any significance at all, must be in as serious a mould as religious painting was in former times.' – I kept hearing J.C.'s voice. On a purely personal level, this was the most important discovery I made that day in the example of the modern Flemish painters. I felt that these artists combined the right painting quality with a great popular style.

Thus began my life in Belgium. After some time I had a small exhibition in an artistic café in Brussels, arranged by the lawyer and art critic Robert de Bender. He introduced me to the painter Arnold Stern who came one day to the exhibition with a short, powerfully-built man whom I took for a peasant. The two looked first at the pictures then they sat down at a table and ordered beer for themselves. They sat drinking and laughing and talking, then Arnold called me over and introduced the solid 'peasant': he was Constant Permeke.[22] I was asked to sit with them and we talked and talked till dusk. After that encounter I saw the great painter quite often, though not regularly. Permeke was an easy man to love and I loved him not only for the many kindnesses he showed me but above all for his great humanity. I have written about him and his art at greater length elsewhere in this book.

This was not a time without anxiety, fear and uncertainty, however. I had much on my mind, all to do with papers, permits to stay on in the country, and such like. These were things of which I had no experience and I had to be led by the hand like a child.

To give my student passport a semblance of legitimacy I was advised – when still in Poland – to enrol at the Brussels Academy of Fine Arts. I had sent over a portfolio of my work and had been accepted. Nevertheless, I was still on a temporary visitor's visa which was due to expire in a fortnight. On the day that I registered at the Ixelles Commune, this was prolonged without any fuss to a three month permit. I attended the painting classes run by a large Flem, Professor Alfred Bastien, with whom I got on wonderfully well. He invited me several times to his studio – in his private quarters he had a large collection of paintings among which I remember an excellent tiger by Delacroix and a still life with apples by Courbet. On the walls of his studio hung his own works – battle scenes in the style of large academic paintings, but his still lifes were quite solid. He told me of his days in Paris, of his friendship with Toulouse-Lautrec, Monet, and some of the lesser Impressionists long since forgotten. Bastien was a generous soul; he would laugh at the slightest joke till tears came to his eyes, but he could also be serious and feel for another's predicament. Most of the times I went to him were not just social occasions – I often had to seek his help, for after the three months were up my troubles really began. The Belgian government was under constant pressure from the Degrelist fascists, and the laws against foreigners were pretty severe. Bastien said to me, 'Ah, what do you expect, our times are no joke. Years ago you could come to this country and settle and nobody would say a word. Now it is different.' But he did not spare himself, and wrote on my behalf yet another letter to the Immigration Authorities. Each time he had some degree of success, winning for me a few more months' reprieve. So it was until the Nazis attacked Poland. Ironically this spelt an end to the fears of the Polish 'refugees' in Belgium. We were no longer bothered with little papers telling us that our stay had come to an end. Then the Nazis attacked Belgium, and along with two million Belgians I found myself on the road to France.

On my way I met a young American woman with the extraordinary name of June Peach July. Far from fleeing the Nazis, she was touring France! She had a small car and asked me where I was making for. I said I did not know. She was going to Toulouse – was it all right with me? I said yes, perfectly all right. But at the village Villefranche de Rouergue, a short distance from Toulouse, I saw a large group of Belgians and learnt from them that holders of Belgian Identity Cards were being told to stop here.

June said: 'I see that you've found your own people. OK. Well, I'll leave you now and go on. I may come over to see how you're getting on. See you sometime – God bless!'

I thanked her for the lift and for her confidences – the way she had told me about her family, herself, her broken marriage and why she was now 'doing' Europe.

This was the first of many such encounters with strangers; we would become friends for a short while and then part, never to see each other again. These were unpredictable times. But June always seemed to be there when I needed her most! Why? How? I do not know – but there she was and I was grateful.

One day I was told by the local gendarmerie that I had to go to somewhere – I have forgotten the name – because this was where all the Polish refugees were. That was the last thing I wanted! When I left Poland I swore to have nothing more to do with the country in which I had never felt at home! None the less, I had to go to the designated place. It took me well over a week because one day there would be a train, the next day there would be none, or there would be a train for a few kilometres only and so on. When I eventually reached my destination I was relieved to hear that the Poles had already left. Nobody knew where. But I also heard that the Germans were on the outskirts of Paris and this news hit me hard.

What now? Where now?

Anywhere – the nearest port – Bordeaux. All right, I decided, Bordeaux it should be. When I arrived there I made my way to the port. It was on fire after a Nazi raid – nothing but smoke and flickering cinders. There were no people around, no firemen, no onlookers – only smoke. Everything before me was enveloped in a thick white pall. But in the nearby streets I saw people running, weeping, in panic, in an impotent rage.

In the centre of the city all was normal. In the distance one could see thin white vapours rising in the sky, but they might have been bonfires for all anybody cared. I sat down on the terrace of a café to rest and to get my bearings. I even heard laughter in the interior of the café. Well, well...

A few Poles – civilians – sat at a nearby table and I overheard them saying something about La Rochelle. One Pole spoke quite loudly, so sure was he that no one else but his friends could understand him. He had heard from a captain that at La Rochelle there was a Greek ship which could take all the Poles to Canada.

In times like these you act on the thinnest of information. You take a chance

on things you cannot be sure of. I was sad beyond measure. I thought of Paris in Nazi hands. I behaved as crazily as everyone else. I planned. Like everyone else, I wanted a spot without danger, where my brain would not be reeling with fatigue. La Rochelle. I could think of nothing else. La Rochelle. La Rochelle. I went into the café's gloomy interior. I enquired the best way to get to La Rochelle. Nobody was suspicious. Nobody cared. In fact they were rather friendly, but the information I got was confused. This way was impossible, that way was already in Nazi hands. I went back to the terrace – and there it stood in front of my very eyes: the little car, *June's little car*. June, my sister, my friend! Late in the evening, when all was black, she appeared and got into the car where I had been sitting waiting for her. She cried out: 'Hi Joe! You here?'

'June, you are a miracle! I never dreamt I'd see you again. Let me kiss you,' I said.

In a few seconds she had explained everything. She had met a sailor with a shattered soul: all he wanted was to get to Bordeaux to kiss his wife and children before being sent to Africa; he had a night to spare, but he was lost and could find no help to get him to his loved ones. So June had driven him to Bordeaux in her car. I knew that she was all goodness, so I was not surprised. Now she was thinking of going to Spain, but when I told her of my dilemma she said with characteristic casualness, 'La Rochelle it is. Spain can wait.'

We decided to spend the rest of the night in Bordeaux in the hotel across the square. Early the next morning we set out for La Rochelle.

Here I must digress for a moment. When I had left Brussels, of the two coats I had, I chose to bring my black leather one as being more useful. I also thought my beret would be more convenient than my hat. Little did I know that this choice of outfit would make all the difference to my destiny. Once again the unexpected, the unpredictable would take a hand in my salvation.

The port of La Rochelle was full of people and their possessions, possessions they were ready to abandon if this would enable them to get onto a ship – any ship. The shouts and the weeping, crazy and comprehensible, informed one loud, continuous, insane noise. While I was trying to explain to June that there was no hope of us ever getting onto a ship, I felt two hands grip my arms. I wheeled round. On my left and right were two huge Polish military policemen. I asked them what they wanted and they laughed 'So you want to desert, eh? Running away, eh? You know that we can shoot you on the spot, so you'd better come quietly and join your comrades, quietly please.' I looked frantically for June, but she was being swept away by the crowd.

At the best of times you could never argue with a Polish policeman. And with military policemen there was even less possibility of explaining sensibly. Without listening to a word, they dragged me to a queue of several hundred men, many of them dressed in black leather coats and berets, all slowly walking up the steps of a huge ship. These were men of the Polish Air Force: was the black leather coat and beret their uniform? The two policemen marched me onto the ship and on the deck handed me over to another military policeman and told him to keep an

eye on me, for I was dangerous. From the deck I scanned the crowd, hoping to see June somewhere. But I could not see her.

It took the ship ten days to reach the British coast. Why it did not go to Canada, I have no idea. But that is how I came to Britain, amidst strangers, a stranger in the night.

The Years of the War:
Glasgow 1940-43

Glasgow was the first city I settled in. In the summer of 1940 it was not unlike other cities in wartime Britain. Although the streets were sunny and golden, they had a forbidding look. Strange shapes like aluminium whales swayed above the roofs of the city and in the evenings criss-cross beams of searchlights swept the sky.

On the pavements only a few walked at a leisurely pace. Most were in a secretive hurry. Young women in ATS khaki, wardens in blue.

A variety of incantations from a variety of throats: hard Norwegian, rapid French, soft Polish and scarcely audible German, coming as though from ashamed voices.

The sporadic wail of a tramcar made everybody stop, look around, look up at the sky. No one knew what a sound might bring. These were times when everybody listened to the sky.

In times like this every personal consideration seems a luxury or self-indulgence. But my life at the time was far from self-indulgent. True, I had been freed from the Polish Army, but I had volunteered for the British Army and was now waiting to be called to the forces or to industry. Waiting. In the meantime, there were twenty-four hours which had to be filled in some way. That I succeeded in giving them any sort of shape was mainly due to some Scottish friends who made my needs their concern. To them my gratitude.

It began with a chance meeting with a journalist at the Gorbals public library – seeing the piles of books around me, he was curious to know what kind of research I was doing. He may have thought that there was a story for him. He came over and addressed me in English; then, seeing from my face that I did not know the language, he tried French. During our conversation I told him that I was a painter, that this was my first day in Glasgow, that I would like to meet other artists. He said that there was an Art Club and that people there might be of some assistance. Then he changed his mind: 'No, better still, go and see Professor Benno Schotz; he is our leading sculptor'.

He wrote down Professor Schotz's address on a piece of paper. We shook hands. And I never saw him again. In my excitement I forgot to ask his name.

On my way to Benno's, I stopped at a café for a cup of tea. I sat down at a table opposite an extraordinary little woman. Her French was poor, but nevertheless, within a few minutes, she succeeded in awakening in me a strong feeling of brotherly love and in this spirit we remained friends until her death years later.

She was unusual to look at and very ornamental. Because of a childhood accident, the lower part of her body had stopped growing at the age of ten and on the upper part a formidable hunch had developed. But she knew how to make of her deformity the aesthetic best. She dressed herself in a short smock, so loose that the hunch, encased in a square of green velvet, was hardly noticeable. Loose trousers hid the child-size legs. She carried her head high and proud and looked as mysterious as one of those Egyptian monuments in which the head sits on a block. She was the sculptress, Helen Biggar. It would take pages to speak of the innate goodness in her.

We met every day and walked the streets of Glasgow hand in hand. One day, without saying a word to me, she found me a studio for the glorious rent of seven shillings weekly! She also found an easel for me and arranged for it to be transported to my studio. The story of this transportation deserves to be told in some detail...

One afternoon I was in the studio, which was empty but for a mattress and blankets, when I heard a noise of banging on the stairs. Opening the door and looking down, I saw two girls dragging an awkward, heavy Victorian easel. One of the girls was very big with a dark complexion. Though it was a warm day she wore a thick grey pullover, the kind usually worn by sailors or fishermen. The other girl was tiny, blonde and sweating, I shouted down to them to stop and wait for me. Then we all three carried the easel. In the studio the smaller girl was the more forthcoming. She introduced herself, and then her friend: Joan Eardley. Both were students at the Glasgow School of Art. Joan, though unbelievably shy – she could not utter a word without going red in the face – came frequently to my studio after this first meeting. She used to bring a home-made sketchbook, very large and awkward to handle. From her early efforts it was difficult to foresee the fine artist she was to become, just as from her strong physique one could not foresee that she was to die so young.[23]

Let me now return to Benno Schotz.[24] That first day in Glasgow when I knocked at his door, he told me something which surprised and cheered me: 'There's another Polish painter here. He's been living in Glasgow now for some months. He was discharged from the army because of some heart condition; his name is Jankel Adler.'[25]

'Unbelievable!' said I in a low voice. 'Incredible.'

'Do you know him?' asked Benno.

'Yes, of course. Where does he live?'

'He had a studio in Regent Street. I'll write down his address and tell you how to get there.'

I had first met Jankel Adler in Warsaw, in 1935-36 where he arrived after escaping from Nazi Germany. Right from our first meeting we became friends, though Jankel was my senior by about seventeen years. His gift for making friends was prodigious. This is not to say that he was easy to understand. His Nietzschean mode of expression needed much comprehension as it also often needed clarification, and this Jankel was unwilling to give. Yet he was a joy to be

with. His conversation ranged wide: art linked with philosophy, philosophy linked with folklore; a Chasidic tale or a quotation from the Jewish book of mysticism, the *Zohar*, led to present-day trends in science, literature, the theatre and the cinema. But he liked conversation to have an air of mystery. 'I am no explainer,' he would say when pressed to clarify a point. He would groan like a bear and twist his green eyebrows upwards as though they were a moustache, and remain silent. His ability to create atmosphere stemmed more from his frequent silences than from his conversation. Silence was meaningful for him. His favourite story about his friend Paul Klee was the one about Klee at a party: 'Among all the clatter and noise, you heard only Klee's silence. All present knew that this was the only thing worth listening to.'

I think he modelled himself very much on Klee.[26] He believed in the existence of a technique for greatness and that all one had to do was to apply oneself to it. Incidentally, the best short essay on Klee is by Adler, published in *Horizon* and later quite justly included by Cyril Connolly in the anthology *The Golden Horizon.*

Just as Jankel's mind was a world's library, so his mode of painting was built upon the traditions of many countries and many peoples. In this lay his sophistication. Whether the source was some ornamental design from a Jewish ritualistic object, or colours from Coptic materials, decorative shapes from Persian pottery or medieval manuscripts, he assimilated and made use of everything that stimulated his taste on which he could improvise. But he was not a mere plagiarist. He had an unquenchable thirst for rich and complex styles. When the formal recognisable bits and pieces are sorted out they can be set aside; the final colour scheme of a picture, the total image, is recognisably Adler. Jankel's inborn gifts were rich enough to command for him both respect and admiration. His *will* and his *taste* were the natural machinery of his gift and he used them both conscientiously. He wrote to me once: 'Taste is the key to an artist's spirituality.' On another occasion: 'In the twentieth century a new aristocracy came into being, an "aristocracy of the spirit". It is here that the modern artist belongs.'

It was Jankel's notion that I should meet J.D. Fergusson 'very soon.'[27] Indeed, within two days Jankel had arranged our meeting. He prepared a dinner for the three of us in his studio. His month's rations must have gone into it. He was an excellent cook and proud of his dishes. The smells from the pans on the gas stove promised a gourmet's feast, and a feast it was. With his great instinct for ritual he had arranged his studio for the occasion, and the room had a festive look. One half of the table was covered with a prayer shawl for a table-cloth, and two large beer bottles served as candlesticks. The candles were lit, although it was still daylight. All his brushes and tubes of paint had been pushed to the other half of the table.

J.D. Fergusson was good-looking and immaculately dressed. His light grey suit, white shirt and deep blue tie were all in the right degree of tonality and beautifully matched. You could see that they were the result of a deliberate choice. His face was all pink as though he had just got out of a hot bath; his white

hair had a pearl-like gleam and lay smoothly on his head. Elegance suited him and was the introduction to his gentle manner. There was soberness about him which permitted no exhibitionism of any kind. 'Artists are like everybody else, only what they do is different.' Jankel growled but said nothing.

J.D.'s speech was tentative, unhurried, at times so slow it was as if he were try-ing to hide a stammer. At that period, his brain-child, The New Art Club meant much to him. 'Scotland is at a new beginning, talent will come, is bound to come... The Scots are artistic only they are ashamed of it. What is important at this stage is to prepare an atmosphere of freedom in art, uninhibited by jury or selection committee. More or less talent, or even no talent at all matters little at the moment. Talent will come, is bound to come... The international style is not opposed to national expression. That the two should flourish we need the right kind of atmosphere. Talent will come, is bound to come...' and so on. One could see that behind the organisational concern there was a visionary hope.

I never heard J.D. talk about himself, his family, or even his work. Sometimes during a conversation there would appear some warm light from the South of France in a memory of a meeting with some French painters, but this was cut short and his mind would turn to Scotland's present and to the future: 'Talent will come, is bound to come.'

But more, perhaps, in his talks at the New Art Club than in private conversa-tions, J.D. showed the kind of aesthetics that underlay his work. Naturally, most so in his talks about Cézanne. He would talk without plan, without order, without a definite point, as the words came to his mind: 'Yes, mmm, oh yes, Cézanne... he is the father of us all... (Long pause) As Giotto was the father, at another time in history... Cézanne never knew how to begin a picture... Each beginning was tor-ture to him, but once begun, he knew how to conclude it... This he knew...'

Then, casually, J.D. would turn to something else: 'With Delacroix we have all tension and contrast... Yes, tension and contrast. Not so with Cézanne, and his surfaces are not the least bit dramatic... Cézanne's tensions lie in setting plains together, making each plain fit with the other. No light acting against the shadow, no, what we see eventually is a pattern of well-fitted planes. Yes, this is what it is all about...'

J.D. would let his head drop and would mumble something totally inaudible, then, as though waking from sleep he would open his eyes and look around: 'Cézanne had a violent temperament, but in his work he avoided violence, cos-mic collisions and the like... Inch by inch he set forth the great union of things... And when your eye follows the pattern of that great union of things your soul will get a tranquil pleasure.'

Now J.D. would become meditative: 'A tranquil pleasure, the same as from the works of Piero della Francesca... What went on in Cézanne's imagination? I know... when he was young there were sinister dreams. With the years of work he made constant discoveries, mainly of the laws of nature; he became concerned with nature's rough structure. He wanted no embellishment, no illusion, only truth...'

Then J.D. would talk of the direction of the brushwork in a Cézanne picture,

of the role of the flat brush: 'Each stroke, by the use of a flat brush, was already geometric; so precise were the brush strokes that on some pictures you can count them individually.' He would talk of the 'miracles of small accents,' declaring that 'Cézanne took the greatest care with them; they must be in the right place; only thus could he make clear the nature of a mass.' He would tell us how Cézanne in his later pictures abandoned all concern for background and foreground and went after 'the unity of space and object', and then, unexpectedly, all the flatness would disappear from his voice, which rose almost to a singing pitch: 'The last version of the Mont St.Victoire Cézanne painted the year he was to die. This painting is a final victory of a lifetime's striving. Ladies and gentlemen, with this picture a new structure in painting was born... To me at any rate, this is the first cubist painting, perhaps also the first abstract painting. Nature leads to abstract consideration and to a metaphysical ideal.'

He would stand quietly for a moment. Then he would sit down, perhaps tired, his face flushed.

It was not a lecture in the university sense of the word. It was rather a guided tour through Cézanne's workshop or perhaps J.D.'s workshop. After all, J.D. was Scotland's leading Cézannist. Who can tell how much self-revelation lay in such talk?

J.D. Fergusson and Jankel Adler, these two men gave Glasgow a rare atmosphere at that time. In their presence one felt as though art was at the centre of the city's life.

The more I got to know Benno Schotz the better I liked him. It did not take long for us to become friends. During the years in Glasgow I went to his home more often than to any other. Because of this I find it impossible to write about him without mentioning his immediate surroundings. He lived in West Campbell Street. The Schotzes' was a little house: battleship grey on the outside, inside all rose and warmth. Adjoining the living-room and the bedroom was the studio, tidy with a shining floor. There were, of course, all the things which told of the continuous work that was going on: a stand with an unfinished wood-carving, an immense stone waiting to be tackled, stands against the walls with finished heads in clay or busts covered with wet rags. On the walls of the living-room hung pictures by friends of Benno's younger days and over the mantelpiece a still-life by Leslie Hunter. It was in this room that the Schotzes entertained. The evenings were seldom free of visitors; a list of these would make quite an absorbing *Who's Who*. But there were also evenings when Schotz could be found alone. On one such evening in the autumn of 1942, the two of us were in the studio chatting leisurely about a thousand and one things. Then, probably provoked by something I said, Schotz spoke out in his more than usually forthright way: 'I never had great ambitions. All I wanted was to work, like everybody but... better.' And, as though he had said something too lofty, he added in a more self-effacing way: 'I must reckon with the kind of talent I have... Sometimes I too try to fly – even high – but when I get back to the human norm, I feel more at home.'

From his very beginning his direction was singularly consistent. Predominant in his output were the portraits. Schotz has never seen himself as bigger than his sitters, nor has it ever mattered to him whether his sitter is a penniless poet or a prime minister, a captain of industry or an actor. For him it is *man* that matters. Each physique may indicate a separate existence in psychological and social terms, but as an *image* it reflects Schotz's *conceptual idealism*. Each head is unmistakably set in the mood of resolute integrity and tender feelings, as though each of the sitters was habitually given to thinking of things serene. He is a gentle humanitarian. And much of this gets into his work. Taken individually, few of the heads summarise this complex attitude, but taken together they add up to a sort of ethos of the average, or, as Schotz has put it, to an ethos of 'the human norm'.

Once I had the easel, I considered my studio furnished. There were of course, other basic things I needed, but these I thought I would get gradually.

When still in Belgium, I had had an idea of painting an autobiography in pictures. Now this idea came back to me with greater urgency. I walked the streets of Glasgow, that gaunt Scottish city, and all I could see was what memory wanted me to see: a fabric of distant life which was none the less part of me; men and women in the refinement of a unique spirit. Most of them were poor, certainly, but I saw them in an aura which I can only describe as enchantment. I could not touch them, but I could follow them with my inner eye and a certain line; I would draw a characteristic detail of their clothing, a characteristic expression of their faces, a characteristic gesture of their hands. I was obsessed with hands.

There were other memories, too. Memories of singing voices, abstract memories, memories of the splendour of the Yiddish theatre (that theatre, more than anything, was my strongest influence) and memories of early readings. Sometimes a folk-song would set the whole pattern for an image. At other times I would take a paragraph from a story by a Yiddish writer, the paragraph I remembered best and, without attempting to illustrate it, I would freely interpret the text.

The drawings themselves would follow a free course. Like a tight-rope walker, I put my trust in my instinct for balance, and drawing lines was a hazardous way of getting to the depth of a memory. But my drawings were not of lines alone. It was in those days that I used for the first time ink washes. They were meant to add to the lines not only a variety of tones but also an accidental play of light, not unlike the broken reflections of a moon on dark waters. Thus the sentiment in the line was extended into a suggestive atmosphere.

Today, after so many years, I look at these drawings and paintings as though they were done by someone else. But deep down I know that they are part of me, a memory of memories, my childhood, people, theatre, stories, life; they all evoke nostalgia; and this nostalgia is the background to all my work in Glasgow in 1940-43. For me these were primarily years of drawing. Even for the paintings of that time I used a technique very much akin to drawing.

A trip to the outer isles of Scotland nourished me with a new sense of form.

And if, being now my own critic, my guess is right, the last picture in Glasgow, 'The Wise Man and the Fools', has the beginning of an attitude which consolidated itself later in Wales in an atmosphere not all that different from the Scottish highlands.

In 1942 I had my first exhibition in Glasgow at Connell's Gallery and Dr. T. Honeyman wrote the introduction to the catalogue. Some time later at the Royal Theatre, The Celtic Ballet Club performed my surrealistic *Ballet of the Palette*.[28] Though the choreography was by the late Betty Simpson, it was Margaret Morris who pulled the whole thing together.

The Years of the War:
London 1943-44

While still in Scotland, I had arranged with Reid and Lefevre for an exhibition at their London gallery in King Street. I was to share the exhibition with a painter little known at the time: L.S. Lowry,[29] who had had only one previous exhibition, just before the war.

The late Duncan MacDonald, partner of Alex Reid, took me aside one day and told me in a confidential voice loaded with emotion that he had made an extraordinary discovery in Lowry: 'The first English naïve painter on a level with the Douanier'. He began placing one canvas after another against the walls and like a midwife who had just accomplished a perfect delivery, stood in front of them, bursting with pride. And I must say he had good reason to be proud of his discovery.

I left Glasgow some two or three months before the exhibition was due to open. I was not surprised that there was no dearth of studios in London at the time: it was just a question of choosing which was best for your requirements and for your pocket. I took one of the Alma Studios in Stratford Road, and having delivered the pictures in good time, I began to organise my life.

Not until after my first exhibition at Lefevre did it become clear to me that I was in a state of spiritual crisis as well as artistic. The nostalgia for my childhood years had burnt itself out and nothing had taken its place except a vague feeling for big forms and a cry within me for a new belief in man's serenity. Wartime reality was not the best of times to solve personal crises, but I was going through a crisis and this I had to face. From time to time my mind was activated by a notion that art and morality should not be too far apart, but as to visualizing such art – my capacity for it was as dead as ashes.

What momentarily relieved my despair was meeting people, making new acquaintances and friends. I soon discovered that many other painters were facing a similar sort of crisis. Many were showing a deep dissatisfaction with things they had hitherto done, and no one knew exactly where to turn next. But there were two painters who knew where they were going, war or no war; it was therefore refreshing to listen to their excited outpourings. Ludwig Meidner,[30] that phenomenal draughtsman of expressionistic portraits and painter of explosive landscapes and cityscapes, believed strongly in his prophetic powers and would talk to anyone ready to listen to his somewhat raucous voice: 'As far back as 1913, it came to me that the essence of the art to come is in painting big-city life.

This will produce an art absolutely true to our times, and to the spirit of revolution and to individualism!'

He would half-close his small eyes and his reddish eyelashes would gleam as though they were gold. He would wave his little red fists: 'Our century is the century of the big city! We must avoid at all costs the Impressionists' example, for they painted bourgeois self-satisfaction and the pleasures of the senses! They were weather reporters, nothing else! We need to paint the *truth*! The city's savagery, its chaos, and the dark passions pent up in man! We need to paint the truth! United in such a collective activity, we will put an end to the painter's alienation, and through our example mankind, too, will rid itself of its alienation!

His animation would become terrifying. One tended to concentrate, on his swaying fists for fear that they would fall on one's head. But the blows never came. Meidner was, in fact, a mild, well-meaning and kind man. There was also an unconscious humour in these wild performances of his. He was a fanatical Judaist, suffering perhaps from religious mania. He could not bring himself to say the word God without first covering his head, as all orthodox Jews do. He kept a deep-blue skull-cap in his pocket and every time he had to use the word God, he became silent for a moment, took out his little skull-cap, covered his head, said 'God', and then put the skull-cap back into his pocket. One was thankful for the pause this performance produced: it cooled the air – though not for long; the flood of heated words soon roared out gain.

David Bomberg[31] was the other painter who seemed certain of his direction. Once, in my studio, I translated Meidner's rich German into the sort of English I knew, for David's benefit. Now David had a temperament not much quieter than that of Meidner. He would perk up in his chair and cry out: 'It's all right... it's all right to paint the city – I have done many paintings of the city. But why should *everybody* paint the city? Josef, tell Mr. Meidner that now I like to paint mountains! Ask Mr Meidner whether he has ever painted mountains.' Without waiting for me to do so, he went on: 'Even flowers can be painted so as to remind us of all the terror in the human breast! Painting reaches its artistic momentum on its own terms no matter what subject one paints! Josef, tell Mr. Meidner that I like the way he talks and cares about painting, but he is crazy! Ask him also what revolution he has in mind! I was a member of the International Association of Revolutionary Artists. We, too, talked a lot about *the Revolution*! But look what happened to Soviet art. Spinster painting! That is what happened!

I translated all this for Meidner and his face convulsed: 'No, no... I don't mean that kind of revolution. The Bolshevik revolution was a materialist revolution, and was of the devil! I supported the German revolution and I know. Their kind of revolution is of the devil! I mean, the only revolution which matters is the revolution of the human spirit! Mr. Herman, tell Mr. Bomberg that painting mountains belongs to the past; the ancient Chinese said all there is to be said about mountains.'

It was a different Meidner when he spoke – almost chantingly – of his love for the inner power and boldness of drawing, or of his love for the plebeian character

of Michelangelo's drawing and sculpture; here David applauded, he clapped his hands like a child and demonstrated his approval, shouting: 'Hear, hear!' These word seemed to worry Meidner and he looked suspiciously at David. I explained to Meidner that David was expressing his approval in an English way. Meidner was reassured, and smiled benignly.

It was late afternoon by this time and the sirens sounded the warning of approaching German planes.

I will not catalogue here all the other colourful men and women who contributed to the vitality of life in London, not withstanding the fires, the sirens and the bombs which were meant to shatter the spirit of that great city. To everyone who lived in London at the time it was obvious that the Nazis were losing this battle of psychological warfare. One got this feeling when walking the streets after a raid. Fires were dealt with within seconds of the raid. The debris was neatly piled up and the sign 'Business as usual' went up on the board where before there had been glass. Even today that sign has a symbolic and heroic ring.

Of the 'colony' of foreign painters in London I must mention Martin Bloch,[32] if only for the fact that he loved this city and has painted its streets more often than anyone else. Before becoming a painter Martin studied architecture and the history of art under Wölffling. It may well be that to those early beginnings he owes his interest in buildings, streets and the cityscape in general. In art he was a student of Lovis Corinth but from Martin's paintings no one could guess this. Matisse was his true master, Matisse translated into German systematism. A canvas for him was no hazardous field; once started no change was permissible, only continuous realisation. His colour scheme revived in his memory emotional associations and nature's harmonies. He belonged to the generation of artists who believed that nature's patterns are benign and peaceful and that nature's laws should be made into artistic laws. His was not an alarming temperament, but rather tender and lyrical. What always astonished me was that in spite of his strong bent towards 'the method', so much of his lyricism came through in his pictures and never more movingly than in his London street scenes. Today, many of his pictures and drawings seem to have a documentary quality about them.

At that time I heard a lot about a revival of English Romanticism; the names of Samuel Palmer and Blake were often bandied about and generally were talked of as though they were neighbours from around the corner. Kenneth Clark was the main inspiration and propagandist-in-chief of this movement. Moore, Sutherland and Piper were the front-liners and behind them the younger painters Keith Vaughan, John Minton, Michael Ayrton and one or two others, and in close proximity to these were two Scottish painters whom I got to know quite well. This is how it happened: one day the Lefevre gallery had an exhibition which impressed me very much. While the gentle McNeil Reid was telling me about the painter, the doors opened and in came two very handsome men. Robert Colquhoun, the painter of the pictures here, and Robert MacBride, introducing them.[33] I was to see them often, and the more I saw them the more

I came to understand their complex personalities and their tender relationship. Both knew their human worth and Colquhoun had a gentle way of standing up for his dignity.

One evening, in Finch's pub in Fulham, a few of us were having a drink. Before long, some disagreeable fellow, perhaps drunk, an acquaintance of the two Roberts, came over and began insulting them because of their close relationship. MacBride was ready to punch him in the face but Colquhoun stopped him and turned to the drunk: I am as nature made me' – (a pause while Colquhoun looked the drunk in the eyes) – 'and so, unfortunately, are you. Now shove off!!!' His voice had so much authority that the fellow disappeared as though through the floor.

Much has been written about the influence Jankel Adler exercised on Colquhoun. Some of it is true, but not to the extent that it could be detrimental to Colquhoun's own worth. The basic feeling from which Colquhoun made his imagery is so drastically different from Adler's that the word 'influence' loses its significance. The influence is marked only in the borrowing of a few textures and some other painterly luxuries such as a taste for rich colours, etc. Colquhoun carried with himself much of the Scottish twilight and Scottish lore and his final images are out of his own imagination. In essence, his talent belongs to that group of Scottish painters who, like Gillies, Maxwell, McTaggart and Philips, are singular for their Scottishness. Colquhoun is undeservedly underrated.

I must also mention the war artists and their exhibitions; they too reflected the mood of the time. What impressed me in their exhibitions was the spirit of belonging. Much of the Frenchness had gone from English painting and in many ways the forties may one day be considered as one of the most independent decades in English art. Moore's 'Sleepers' and other shelter drawings had a terse beauty, an elegiac power and a heroic structure which few paintings of the thirties had. The works of Sutherland, Piper and Stanley Spencer (another underrated figure!) were also highly individual and obviously English.

Altogether, we who were not of this soil but wartime newcomers had much admiration for what we called English Art. Of course, there had also been minor paintings, mere boosters of patriotic morale, but their importance receded with time and they were quickly forgotten.

Moore's 'Sleepers,' with their Masaccio-like solidity, worked particularly strongly on my mind and probably gave me the incentive I needed to start work again. But neither the scenes of destruction nor the scenes from the undergrounds were exactly what I wanted.

Soon after the first refugees from the Continent arrived in London, two philanthropists, the brothers Alexander and Benjamin Margulies, organised a club for Jewish intellectuals in Gower Street, which they named 'Ohel'. A small number of us used to gather there every Friday afternoon to hold discussions and give lectures. Of the more permanent 'members' I recall the two folklorists, Dr. J. Maitlis and Dr. Olshwanger, the essayist Leo Koening, the short-story writer

Leo Füchs, the writer Joseph Leftwich, and the artists Jankel Adler, Marek Schwartz, Bloch, Meidner, Bomberg, and myself. There was also in our midst the Yiddish poet Itzik Manger[34] – a man of obvious genius.

I first met Manger in 1935 or thereabouts in Warsaw; then chance brought us together again in 1940 in a refugee camp in Norwood, London. His clothes hung loosely from his emaciated body, no shirt had a small enough collar to fit his thin neck. His face was green, his black eyes shone out from red eyelids. But his nervous vitality was undiminished. He could be offensive, tender, spiteful, amusing and exciting, but never as lovable as his poetry suggests him to be.

Manger was born to sing, and he sang. Even reading other poets was with him a way of singing, and what he could not sing bored him. He thought of himself as a folk-singer, one of the primitive band of the proverbial 'Broder Singers'. He imagined himself in their company, travelling from one market-place to another, going from one tavern to another, jollifying an evening with recitations and songs in between drinks. Similarly, his feeling for the theatre made him wish that he'd lived in the times of Goldfaden, the founder of the first Yiddish theatre in Eastern Europe. Manger was steeped in Yiddish folklore and he mastered the folk-song form as no one else before him. With him this form reached a state of classical perfection and his own ballads had a charm and depth similar to those of François Villon, his great master. As with Chagall, Manger's images have a naïve but also sophisticated flavour. Only Garcia Lorca equals Manger in achieving textures akin to the greatest folk-songs.

Manger was also a natural clown and when in high spirits there was no pleasanter company than his.

At that time Manger used to carry a small leather suitcase in which he kept all his worldly possessions – his manuscripts. During heavy bombardments he would hug it to his breast. In any other language he would have been known throughout the world, but writing in Yiddish he was isolated and he felt his isolation strongly. Some years later, with the help of his friend Arthur Waley, he tried to compose in English, but without results. 'I am doomed to remain a Yiddish scribe,' he once said to me. 'No one is as lonely as a Yiddish poet.' Then he added quietly, as though to himself: 'My God, but how lovely our Yiddish can be!'

I kept myself fairly busy. I was ready to start painting but my instincts told me that for this I needed a different kind of environment.

I began to think of leaving London, of returning, perhaps, to the highlands of Scotland, but then a friend just back from the Welsh mining valleys spoke to me of them with such enthusiasm that I decided to go there for a short vacation before returning to Scotland. I had no inkling that once in Wales I would make my home there for eleven years.

The Years of the War:
Ystradgynlais 1944-55

My wife and I set out in exuberant spirits (I had married Catriona MacLeod in Glasgow in 1942), and we were overwhelmed by our first sight of Ystradgynlais, the Welsh mining village we came to through a chance meeting with Dai Alexander Williams, a carpenter who worked in the mines and who was also a gifted short-story writer.

Elsewhere in this book I have described in detail the quality of life in Ystradgynlais. Here, I will set down my first impressions and the images which were crucial to my decision to remain there.

It was in 1944, either a June or July day, I can no longer remember, but I vividly recall the heat of that afternoon and how deeply I was struck by the quiet of the village around me. There was hardly a soul to be seen. In the distance, low hills like sleeping dogs and above the hills a copper-coloured sky – how often I later returned to the colour and mood of that sky! Its light reddened the stone walls of the cottages and the outlines of the stark trees. The railings and the cement blocks of the bridge had golden contours. Under the bridge, out of a cold shadow, trickled a pool of water which got thinner and thinner as it ran on amidst the dry stones and glittering pebbles. Then, unexpectedly, as though from nowhere, a group of miners stepped onto the bridge. For a split second their heads appeared against the full body of the sun, as against a yellow disc – the whole image was not unlike an icon depicting the saints with their haloes. With the light around them, the silhouettes of the miners were almost black. With rapid steps they crossed the bridge and like frightened cats tore themselves away from one another, each going his own way. The magnificence of this scene overwhelmed me.

Every artist knows when he experiences something new, something he has never experienced before. What he may not know is the effect the experience may have on his whole life, or how it may shape the course of his destiny.

This image of the miners on the bridge against that glowing sky mystified me for years with its mixture of sadness and grandeur, and it became the source of my work for years to come.

The image filled me, too, with certainty that this village was the right place for me. I felt my inner emptiness filling.

Here I began working from scratch, as though I had never drawn or painted before. I worked on the spot, assimilating those experiences which struck me not

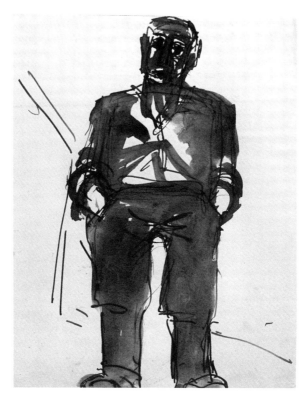

so much by their actuality as by their symbolism, by the idealism which they rep-
resented. In computer terms, reality fed memory and memory fed imagination.
I also made large charcoal drawings, studies of single heads; with these I once
again began with reality, but aimed at a wider synthesis, both of form and of
expression. I turned to a medium I had never used before: pastels – probably
because pastels are the most direct medium of drawing with colour. With these
pastels as well as with the pen and ink drawings of that time, I got nearer to the
sculptor's approach to form than at any time before, to such a degree, indeed,
that even today I am asked whether I am doing a sculpture. Because such results
in pastels are difficult I must say a few words about the nature of the medium.

Although the eighteenth century was the great age of pastel painting, Degas
was the first to achieve the full potential of this medium. Without trespassing on
his style, I took to studying his results with great care. The eighteenth-century
artists used pastels in a straightforward way mostly on greyish-blue paper. They
achieved gradation in tone by rubbing the colour with their fingers to create the
paleness they were after. Belonging to an age which was highly conscious of cos-
metics and powders, they also gave the surfaces of their pastels a powdery and
indecisive effect. Degas wanted something different from his pastels; he wanted
an exactness of texture and a richness of colour that painters hitherto had got
from oil painting and thought impossible to obtain from pastels. Degas was
obsessed with the technical problems and would try everything to overcome the

difficulties: he prepared his papers with water-colour, gouache, even with thick but lean oil paint; in fact he very often painted a whole image and only then began applying pastels. These various methods gave him results no other pastel painter had achieved. And this seemed to me the technique I had to master – but for other ends than those of Degas. Degas, sharing his colour ideas with the Impressionists, believed that colour gets its maximum intensity through the right juxtaposition of its neighbouring colours. His favourite phrase was: 'We have to surround a brown with neutral colours so that it will gleam like red!' It seemed to me that it ought to be possible to get from each colour a richness in itself, independent of its neighbouring colours. Thus I used Degas' method of under-painting in a different way: for instance, for a full-blooded cadmium red I would underpaint with a burnt sienna, and for a vermilion, with a yellow. In this way I could get from pastel a red as luminous as a flame. Sometimes I would even underpaint cold colours with warmer tones and let them come through the thin-ly applied pastel. Thus cool colours, too, achieved a gleaming effect. I also found out that a good effect could be achieved by underpainting the same colour as the colour of the pastel I intended to use: thus black pastel over black water-colour produced a new kind of black never seen before except in velvet.

I do not want to suggest that technique *per se* is an objective quality which once learnt can be applied mechanically with the same results; technique must always bend to the subjective needs of feeling and expression, above all to the mood required. In fact, technique and the state of mind is one.

During my exhibition at the Lefevre gallery in 1943, a man dressed in the navy blue overcoat of a firewatcher came and bought a drawing, and as I happened to be in the gallery he came over and introduced himself as Gustave Delbanco. He told me that together with a partner he dealt in pictures, mostly old masters, from a private office. Some years later, while in London for a few days, I saw a sign in Cork Street: 'Roland, Browse and Delbanco Gallery'. I wondered whether it was the same Mr. Delbanco I had talked to at my exhibition, so I went in. It was. He recognised me and introduced me to his partners. One of them, Miss Browse, had an air of unapproachability; she looked elegant but forbidding (later I found out that this was only an innate shyness and that she had an immense sense of loyalty and was capable of great friendship). Henry Roland, on the other hand, was very much an out-going character, though not as self-assured then as he is today.[35] We chatted for a few minutes, and the positive outcome of our talk was a common agreement for an exhibition to be held at their gallery. During the past four years I had made about a hundred pastels, and from these in 1946 were selected a number for my first exhibition at Roland, Browse and Delbanco. Thus began a working friendship with the gallery lasting for the next twenty-eight years. Although it was Gustave Delbanco who first took me into the gallery, it was Roland who first warmed to my work. In time his enthusiasm became a strong link between us; he has often shown more belief in and fewer doubts about my work than I myself had or have. I need only add that

my friendship with all three partners goes beyond our business association. My ties with Roland are particularly close.

It was not until 1946 that I returned to painting in oils. Here I owe a debt to the examples of the modern Flemish Expressionists. Until that year I had given them no thought. During the four years of struggle with the pastel medium they were as far from my thoughts as a strange galaxy in the universe. Now they were in the forefront of my mind. What seemed so particular about their work was the combination of the painting lessons each of them had inherited from their own Breughel and the Dutch Rembrandt, and their talent for imbuing it with a spirit which was completely modern, completely of our time. For the same reason I also turned to Rouault and the early works of Gromaire. They all seemed to me to be the soil for my 'family tree'. I had always believed that only mastery in paint gives significance to freedom and originality. All the 'psychological' considerations about freedom and originality in this or that youngster are so much empty bunkum. 'To be a poet at seventeen is nature's gift, to be a poet at seventy is a human achievement' – thus spoke Goethe, and so be it!

In 1948 we bought a derelict pop factory and converted it into a studio with living quarters (until then we had lived at the Pen-y-Bont Inn). In 1951, having finished the mural 'Miners' for the Festival of Britain, I fell ill and for the next two years travelled extensively in sunnier lands. From about 1953 I spent more time abroad and in London than in Wales, but even in 1955 I was still thinking of returning to the incredible mining village which had become my home. I never did.

During my years in Wales I noticed a gradual awakening of interest in painting and sculpture. This was particularly noticeable in the immediate post-war years. A younger generation grew up, eager to take up painting, not in the hitherto amateurish way, but with the idea of becoming professionals. Many a beginner came to my workroom to 'talk things over'. Of course, the improved economic situation in the Welsh valleys had much to do with it, but credit must also go to two institutions – The Contemporary Art Society for Wales and the Welsh Arts Council – which did much to make painting and sculpture popular.[36]

If I had to name one single individual who did most of the post-war pioneering work, it would be David Bell. When I first met him he was the Assistant Director of the Welsh Arts Council. Some years later he became keeper of the Glynn Vivian Art Gallery in Swansea. David was a sick man. Though his ill health was immediately visible, it was also what one least associated with him. He was a gifted poet and painter, but perhaps even more than this he was an administrator of great vision. He was clear-headed about the difficulties, but he was all enthusiasm and hope. 'The Welsh,' he used to say, 'are naturally gifted and drawn to music and literature, but I am sure that they also have a talent for painting, only they don't know it yet.' And until his untimely death he made it his job to make his countrymen aware of this dormant gift.

There were other things that marked the changed situation. Large-scale exhibitions from the Arts Council of Great Britain were taken to Wales and shown in remote places where hitherto no works of art had been seen at all. The standard

of the paintings and sculpture submitted to the annual National Eisteddfod went up. A new class of collectors appeared, and some years later two commercial galleries established themselves. The two main public galleries, the National Museum in Cardiff and the Glynn Vivian in Swansea, underwent a great change. In short, where at the end of the Second World War there had been literally nothing, something was now beginning to germinate.

In August 1967 in his introduction to the Gold Medallist Exhibition, Dr. Roger Webster paid me the compliment of saying that I had had something to do with the creation of a universal symbolism out of the Welsh theme, and that this was of some significance to the Welsh. I hope that this is true, even if only in some small degree. It would please me to think that I was not only a taker but that I have also given something in return.

In 1955 Catriona and I parted and divorced. Two years later I married a woman I had met at the time of my divorce, with whom I fell in love. We have two children – David, aged sixteen, and Rebekah, aged six. For the first four years after our marriage we lived in London, then in 1961 we moved to Suffolk. This move was characteristic of my new situation: it no longer mattered to my work where I lived. I continued in the mood which had obsessed me since my years in Wales. From the beginning I always thought of painting as an unhurried, life-long discipline. True creativeness calls for repetition, in technique as well as in style; thus we achieve the intuitive familiarity with our restricted imagery, our inner world.

Realism has always irritated me; it is so much less than reality. It lacks what nature has in abundance: the power to move our feelings to such a degree that we rush to our brushes for relief! Realistic painting never does this to me. There is more to a miner or a peasant standing and doing nothing than meets the eye. Many, many years ago, an old Scottish fisherman from Stornoway said to me: 'I am more afraid of living than of dying', and these words made me resolve to look only at paintings purged of all trivia and inessentials. I told myself: the pain of living must never be too far from artistic expression.

I am never satisfied with putting nature or social life on record. When I look at things I see them like everyone else does; but when I close my eyes and try to recall them from memory, a great change occurs. Nature is so many fragments. What I see with my closed eyes is a simplified image, deep, synthetic, and in form it has the grandeur of a symbol; in that final symbol I also recognise the unity of my direction. This is why I make only notes from nature, and draw and paint from memory; the subject is then a lost world that I recover. In this way one can get an approximation of reality without becoming realistic.

Reading poetry I found stimulating and helpful to my work, but at no time more so than during my years in Wales. Here I must mention Walt Whitman, whose *Leaves of Grass* I read over and over again. Also, folk epics such as the Welsh saga *Mabinogion* or the Scandinavian epic *Fritiof* interested me.

At that time music also played a part, and I frequently listened to Beethoven's 'Ninth' and Wagner's *Ring*. Wales is renowned for its singing and I found the rehearsals of some of the male choirs of the district most absorbing.

My love for African primitives and icon painting comes from these days, too.[37]

All this defines my attitude to painting both before I went to live in Suffolk and during the time I spent there. Although my life in Suffolk was the nearest to bliss I ever came, in another place and under different conditions I know that I would have carried on in the same way and painted the same things – as I still do now, in my sixty-second year and back once again in London.

Places

A Welsh Mining Village

This mining village differs from others I know first of all in its colour.

The collieries are on the outskirts of the village, and the air is therefore clear. A friend of mine who knows the French landscapes by heart, compares the place, when bright-lighted, with Brittany.

Violet roofs at the foot of green hills. Pyramids of black tips surrounded by cloud-like trees the colour of dark bottles.

When the sun appears and gilds the air, the streets, otherwise uniform grey, become copper brown. This happens usually in the evenings, for the days are mostly behind a screen of slow rains, cold and blue like steel dust; the kind of rains which never promise to stop, and awaken in you a feeling as hopeless as that arising when you are faced with many roads on a lost track. To be truthful, I must add that only at the beginning did they awaken in me a feeling of impatient anger. Afterwards I discovered, to my own surprise, that the rains here are more than part of the general atmosphere. It is the rain that weaves the strange tapestry of mood in which here finds its order.

While the air becomes oily, the roofs and roads glossy, the river fuller and noisier, men bite their pipes, and finding cover in the entrances of the shops, enjoy, as always, a talk for talk's sake. Only dogs disappear from the streets, for the heavy doors of street philosophy are closed to them.

On the square of the village blue and red buses appear and disappear. A colourful little cart with the standing figure of the milkman inside; in the twittering noise of the rain the tapping steps of the tiny brown pony.

A woman walking over the bridge at the end of the street, the wind blowing against her, the white shawl rising from her shoulders and spreading like two huge wings

A brown bus with miners returning from work.

Singly or in groups of two or three, short silhouettes with logs of wood under their arms fill up the square. The black statue of the policeman gleams like silk.

'Shwmai Wyn!' 'Shwmai, Sid!' 'Shwmai, shwmai!'[38]

Some turn left, others turn right.

Some remain and talk awhile under the awning with red and gold letters – 'Fish and Chips Restaurant'; others walk forward to the bridge.

But even the glossy rainy hours are numbered. A sunlit evening glazes the village.

The River Tawe which always has two colours more than the sky – black of

coal and yellow of clay – is now red.

White stones in the river.

Gilded cows walk over the stones.

Children in pink shirts hang on the trees near the bridge.

The hills are bright blue. Over them lie brassy yellow clouds.

'There you are,' said a man with the soft voice of secrecy to me, 'such is life here; mostly grey, but there is also a drop of gold in it.'

For weeks I wandered here on the hills, in the little streets, looking at the landscape, looking at walls and at men, at pits from far and near, sketching and talking to miners on the surface and underground, at work and at rest, studying their movements and their appearance.

This was a way of exercising my faculties of concentration, of clearing my mind; a way of piercing the thick cloud of insignificant incident which enshrouds every new reality.

There is a tradition among artists, particularly among writers, when they come to a small place, to look for the so-called 'characters', and to represent them and their acts as the colour of the village. Yet a less easily satisfied observer will soon find out that the so-called 'characters' are lamentably alike everywhere. They rather remind one of exotic spots in a landscape which may awaken curiosity but do not satisfy a longer interest. There is no real depth in them; and therefore they surely do not typify any place. They only have connected anecdotes, which do not possess a big enough form to embrace a full-blooded living man, nourished by tradition, formed by labour and moved by aspiration.

The miner is the man of Ystradgynlais.

In his appearance, although at first sight like other workers, the miner is more impressive and singular.

Sometimes I thought of old Egyptian carvings walking between sky and earth, or of dark rocks fashioned into glorious human shapes, or of heavy logs in which a primitive hand had tried to synthesise the pride of human labour and the calm force which promises to guard its dignity.

It would be true to say that the miner is the walking monument to labour.

By this singularity of appearance, amid the clean figures of the shop-keepers, the tall and thin figures of the town councillors, the robust figures of the insurance agents, the respectable figures of the ministers, and the fatigued figures of the schoolmasters, the miners form, like trees among vegetables, a solid group. But what makes the group so singular outside is but the strong similarity within the group.

Like the houses with doors smaller than men, like the two china dogs on the mantelpieces, like the taste of the blackberry tart, they are similar in each house.

The kind of mauve scarf and the way they wear it; the manner of nodding their heads sideways in greeting, the feelings of relief and comfort they express as they stride down the middle of the road, their way of sitting near a wall and supporting their bodies with the heel of the foot.

Also similar are their troubles and joys.

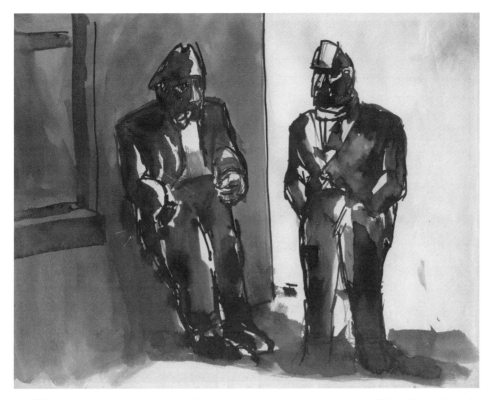

What happens today to one happens tomorrow to another. Therefore there is a sincere concern for each other's lives, and duties become habits.

Men must give each other a hand.

Familiarity breaks the ice of strangeness.

'You're no stranger here,' I was told the very day I arrived. A day later I was addressed as Joe, and soon I was nick-named Joe-bach.

If someone more individualistically-tempered does not like the familiarity, people here will easily find out, and even the dogs won't bark after him.

Men need each other if only to talk to – or just to make the heart easier. Thus men listen with heavy concentration, and share feelings, laughter, tears.

Birth and death are faced as matters of fact, the first without too much fuss, the other without too much gloom. But the unexpected is encountered with gravity.

One afternoon a little street was empty but for a few dogs walking here and there. The two rows of houses and the black road between them were bathed in a peaceful light.

An old man, bent like a walking-stick, with his head hanging down on his chest, was knocking at every door, one after another, all the way down the street. At every door he spent just a moment.

A woman or man or the two together would come to the open door and listen to the old man; some would take their apron to their eyes, others just nod sadly.

When he came nearer to me, I thought that evening that Welsh must be the only language of music of sorrow.

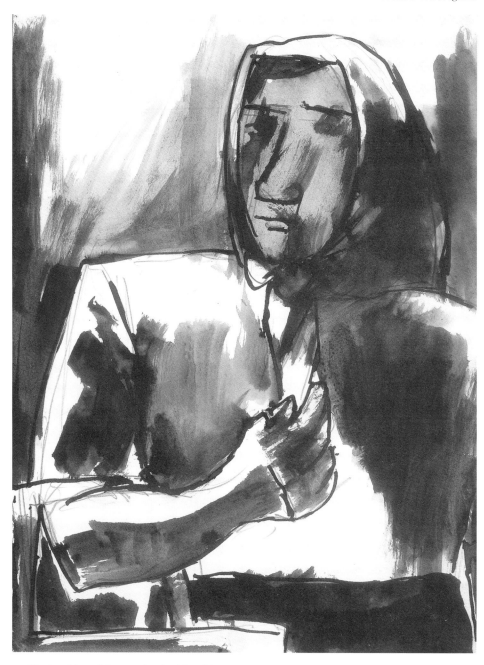

He had lost his son in the Far East.

Then, on the Teddy Bear bridge, I met three pregnant women. Their shapes were enormous and of earthy beauty. Next to them all Venuses would look but pale girls. Looking at them, Walt Whitman would have repeated his psalm-sounding phrase: 'And I say there is nothing greater than mother of man'.

The three mothers of man talked of death.

The whole village talked of death.

As in most small places, time and energy do not find their expression in movement, but rather in density. In passionate calm, rather, that brings out not so much the vivid as the heroic, not so much the ornamental as the dignifying simplicity.

This fashions primarily the form of speech. Emotion replaces sentimentality, the quality of voice replaces the choice of smart words. Not all music is expressed in the songs and instrumental compositions of people. Music lives first of all in the everyday modelling of the language, in the way of pressing our feelings into sounds for which words are but natural tails.

Here tradition gives its lead. The most admired is the man able to speak in the tradition of the Welsh preacher.

How does an old Welsh preacher speak? His voice knows only two colours: the bright yellow of a peaceful sun, and the threatening red of hell. Only two sounds: the whisper of a branch moved by the wind, and the thundering of an empty barrel falling downstairs. His hands know only two movements: the gentle movement of reaching for a flower, and the whirling of mill-sails in a storm. Only two expressions on his face – eyebrows, eyes, nostrils and mouth working simultaneously; first, that of comfort from looking into a garden; second, that of surprise from facing the dark mysteries of a forest.

As his voice goes higher, his body rises up in the air.

As his voice sinks, his body falls across the pulpit rail, and to make sure that now he is in earnest, that he is now on the earth, he hammers a closed fist on the open palm of his hand.

Even underground I saw men falling naturally into oratory.

Even fireside conversations are seldom 'clever' or dispassionate, although there are quite a few who have learnt the art of working out a case and swiftly proving a point; but the will to carry us closer to the object at the end of their vision keeps passion alive. It is this passion that brings even to the loud unordered life of the local pubs a nostalgic atmosphere half dreamy and half joyful. It is this passion which lights up their aspirations, and makes some of them read heavy volumes of economics, sociology and philosophy, and prepare themselves for the task of leadership. It is this passion which makes others sing, or write. It is this traditional passion, this monumental appearance, that broadens the local and incidental, and makes the individual become typical and symbolic.

But there are others who have no more passion left.

They are waiting for death.

Victims of silica dust.

You can pick them out with your finger.

They will say with a sad smile: 'A bit short of breath.'

This is Ystradgynlais, a Welsh mining village.

A Strange Son of the Valley

Yiddish he had forgotten. Bony and hard, with blue scars on his face and hands, his appearance was not unlike that of the other old miners. He shared with the other inhabitants of the rocky mining village the way of smoking his pipe and spitting through his teeth, the way of expressing himself through the kind of maxims akin to all beer drinkers, and through his enthusiasm for life: 'A man who drinks beer because he is thirsty should never waste the stuff!' Looking me straight in the eyes he would say, 'I'll tell you, heredity never typifies a man to the extent that his job does'.

Now he is alone. His wife was a Welsh woman called Mary.

'I am really sorry you could not have met her. Only five years since I buried her. She was the only woman in the valley who took great care to pronounce the 'i' in Moishe. Others out of sheer carelessness – you know how people are – called me Moshe. Of course, you can't be angry about such trifles; they just could not understand that it is precisely the 'i' that makes my name so folk-Yiddish. This subtlety escaped them. Not so with Mary. Do you know, she used to hum Jewish tunes when I had forgotten them already! She was a great girl, Mary. She nearly killed herself with longing for a child, but no, she couldn't have any.'

He was born about sixty-eight years ago, somewhere in Russia, or was it Poland? In any case at that time it was all Russia. What was the name of the village? He had forgotten. It was a wee name and had got lost in a dark corner of his memory.

'But I still have the air in my nostrils. One remembers smells longer than names. It was a quiet village. If you stood on a roof or between the branches of an oak tree you could see how small it was; you could encompass it with your eyes. The surrounding fields were vast. On those fields our village must have looked like a pimple on the palm of your hand'.

Their home was quite an ordinary Jewish home where the physical was veiled with the melancholy wings of the spiritual and where prayer lived longest. Nevertheless there were six children, of whom death took away two. His father, though he knew even the remotest districts of heaven, here on earth knew only the way to the synagogue and back. Thus his mother was the pillar of the every-day. His sister Git'l was the eldest and the apple of his mother's eye. She was engaged and her fiancé lived somewhere far, far away in a strange kingdom called England. Though a marriage in a strange country without parents and relatives

was not quite the thing, it was still better than to be left, God forbid, to the terrible uncertainty of spinsterhood.

'Her fiancé Ber'l wanted her to come... that is to say to leave... I really can't remember what he wanted; but it was his advice that I, who had yet to learn a trade, should join Git'l in her journey to England.'

Thus he came to Manchester, at the end of the last century, where Ber'l was weaving, tailoring, peddling and what not. 'I was not then twelve.'

Now imagine Manchester through the eyes of a young Jewish boy, transplanted from idyllic scenery, full of surrealistic fears, with a consciousness formed of cycles of dreams, haunted with images of poor sinners carrying barrels of tar on their little finger to be burnt alive in the fires of hell. Imagine Manchester through the eyes of a boy for whom the four seasons whitening, greening, watering and drying, blueing and gilding that tiny fraction of life which he could encircle with his eyes, had only a symbolic meaning.

'Every city and all I saw on my way to England was fearful and terrifying, but most of all Manchester, where I had to live. This was hell to the letter! All those fires, showing through open-jawed factories, the huge chimneys like threatening fingers, the heavy breath of smoky clouds and the crush on the dark grey streets, full of damned and gall-eaten men with submissive faces and angry eyes. Why, they could murder and just run away! Only a fly caught in a spider's web could feel as I felt! I remember how I held on to my fringe-garment and begged God not to leave me at the mercy of Ashmeda the devil. Yet, Manchester was my school of life. Later, I just laughed at my earlier fears. Until I was eighteen I worked along with Ber'l as a weaver. I liked weaving. Weaving is a job with a heart. What I mean to say is that it is a kind of art. You became familiar with the woolly air and the machines' clatter, and you just loved the activity of your fingers.'

When there was nothing to weave, he took to tailoring like Ber'l.

'You won't believe it, but tailoring is also a job with a heart. I simply loved it. No, not the life we had to live, but the doing; it was the doing that played on my imagination and refreshed my curiosity. Was it unrest? Or was it just that we Jews, I mean my generation, were so hungry for labour?'

He worked later in a huge metal factory and learned engineering, and this he loved no less.

'Man's heart is really big; it can take communion with any material.'

One day when he looked into the mirror he could not tear himself away. A strange face looked back at him: Could it be he, Moishe? The girl-like complexion had gone; the cheekbones had now become prominent; the eyes were black and sharp; the mist, the blue mist where Ashmeda in the form of a huge cockerel or flying goat stood out real and distinct against the background of a dimly perceived world, had vanished from his eyes. He closed them for a moment and could not even imagine Ashmeda. How long was it since he had last been to synagogue? He looked at his hands, they were heavy and big. He thought: Fabians, unions, strikes for wages, engineering – could all this have induced this physical change?

'You see, I was no longer a boy of twelve. A new man, dormant in me, had awakened. Though I remained a Jew, and there is no reason in life why I should not end my days a Jew, I was no longer a Judaist. I could no longer accept religious laws as laws of conduct and human relationships. When I told Ber'l that Jewishness means tradition in growth and change, but that Judaism had lost its meaning for me, he jumped in the air and cried that we couldn't share the same table any more. Git'l shed tears and I left them for good. No, it was no child's play. No child's play at all.'

He puffed his pipe and spat into the fire. His eyes were pensive, and this moment of reflection was strangely saddened with a heart-touching nostalgia.

'They just could not stomach a man above religion. So I had to go my way. Many years later in a little debating society, I met Ber'l once again. The same old Ber'l. He said to me "So you didn't get baptised after all!" I laughed... Talking of the debating society reminds me – wait a moment...' He stalked to the bookshelves. 'See this book? This is my youth... My mind and my heart... It's over forty years since I read it, and today I couldn't even if I wanted to. It's all in Yiddish. Every page of it. See here, the stamp: "Jewish Debating Society, Swansea, 1904." I was a founder member.'

For a moment I stopped listening. I opened the black covers. It was not one book, but several booklets bound together Philip Kranz – 'God, Religion and Morality'; Dr. Max Nordau – 'The Lies about Marriage'; Prince Peter Kropotkin – 'The Philosophy of Anarchism'; Karl Marx – 'Surplus Value and Wages'; an anonymously written lesson on Darwinism and three pages of Vinchevsky's poetry.[39] The pages of cheap paper were yellowish and smelled like wet chalk, yet they breathed as if alive, sounded alive like an echo of times which though past, never really disappear, for they are layers in the mountain of our history.

'At that time I was already settled here for good and working in the mines. Thirty-six years through thick and thin on different coal seams in the length and breadth of these valleys. These were my happiest years... People don't know how much art there is in mining! You sit, sit and think in front of that black mystery. And then you hit and nature gives way! It's no daydream, believe me. Yes, it was not easy to leave the mine. Once you get used to an art you don't leave it just for a caprice. The chest became troublesome... Yes, it was the chest all right.'

Thus about eleven years ago he had opened up this little fish and chip shop.

'It was Mary's idea. Mary was a wise woman. You can't work yourself to death. She was always right. And now I'm not sorry, not sorry at all. To fry fish properly – crisp, with a nice bronze-golden surface – is, let me remind you, also an art!' His eyes glittered once again with enthusiasm. 'The potatoes are from my own garden. I do some gardening, of course. If you want to taste the fish and chips, stay here for supper. Be my guest. It will be a pleasure – a rare pleasure.'

And before I managed to answer he had stretched for his apron.

A Mexican Village

Mural painting is inseparable from walls and buildings and the only way to discover how modern mural painting worked was to go and see the walls for myself. This was one reason why I decided to go to Mexico.[40] The other was the country itself. Unlike other countries I had been to, Mexico was the only place about which I had read quite widely. And what I read about it set my imagination aflame.

But the journey turned out to be a failure. It was the wrong time to go to anywhere; I was ill without knowing it – how much so I discovered later on my return to England. In the meantime, the nine weeks in Mexico were not the happiest I have known. I was restless, depressed and in a state of continuous anxiety; I could not concentrate. But not all days were desperate. There were times when I was alive to the life around me, especially in the remote Indian villages, high up in the mountains. I became friendly with an American anthropologist who proved of immense help to me. We travelled in his jeep for several days into areas little visited except by scholars, writers and the more adventurous tourists. We slept in the jeep; though it was warm in the daytime the nights were freezing. My state of mind scarcely improved even on my travels with him. I was in a state of such indifference that I did not even bother to write down the names of any of the villages nor the regions of the mountains. Now, as I remember some of the places I went to, they are more vivid to me than they were then. One village in particular stands out clearly in my present state of reverie. I was particularly happy from the moment I set foot there. Yet I could not say that it was so very different from other villages I had seen. It did me good just to be there. The village was set in a vast and hungry landscape, framed with mountains tall and stark. The plain between the mountains and the houses was covered with grass from which the sun drained all colour; the intermittent patches of earth were red. On this plain a large number of goats were grazing and in their midst was the small figure of a shepherd wrapped in a brown blanket with a guitar on his back.

The village itself consisted of two rows of white-painted cubes, one in shadow and the other in the light. The roofs were of corrugated iron – the only sign that here, too, modern times had arrived. They had no doors, only a blanket hung in an oblong opening. They had no windows. There was not much life in the village. In a crouching position a woman in a pink skirt with a bright blue shawl over her head and shoulders was blowing into a white basin. She was trying to get the

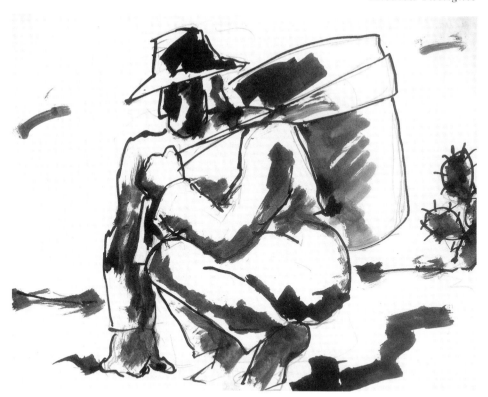

charcoal alight; this seemed an arduous task, and as she puffed and panted, glowing cinders rose into the air. A peasant loaded colourful rags onto the back of the tiniest donkey I had ever seen. Here and there a child played, shining clean. The sky was bright but without a visible centre of light – the sky was one wide blare of light.

The Mexican Indians are a race of short people. 'They work hard and eat little,' the American anthropologist said, then he corrected himself. 'They have little to eat.' In the distance men look like boys and boys look like old men. From the moment the sun comes up groups of people gather in the shadow of a wall and sit in a row like figures in a frieze. They seldom talk. Sometimes they pass a cigarette from mouth to mouth, each taking no more than a puff at it. 'This village is lucky,' the American went on. 'A trickle of a stream runs down from one of the mountain slopes and this is enough for them to grow their own maize. On feast days a few goats are killed and divided among the families The goats belong to all, even to the shepherd. Will you stay here till the afternoon? If so, I could take you to another village, where they are better off. They make pottery and sell it in the markets to the tourists. They even have a small hotel there. It is about thirty miles from here, high up. The women make fine lace. No one ever stops in this village for more than a few hours. But it is good place for scholars. Their patois is very interesting. It is an invention all their own. I cannot trace it to any of the more familiar groups of dialects. But then, language is

not what interests me most. See you later, Joe.'

It was ten o'clock in the morning and the heat was already like that from a fur-nace. I looked around and made a few notes in my sketchbook. I decided to go over to the shepherd. It was unbelievable! I thought it was a mirage! It could not be... But it was a man I had befriended only a few days before in the market square at Patzquaro.

'Roberto,' I shouted. 'How on earth do you come to be here, and a goatherd at that? You told me that you were a musician.'

'It is here, Señor Joe, that I live. Here I am a goatherd. In Patzquaro and in other market towns I am a musician. Will you stay here, Señor Joe? Look, it is beautiful all around.'

Indeed, from this point the landscape was totally different. The mountains divided and a narrow creek between them was visible, opening into a vast plain studded with a variety of wild cactus, all dark and green, and tall cactus trees of a kind I had never seen before. In no other place have I felt so much a stranger, no other place I has ever seemed to me so impenetrable and so mysterious. The sheer immensity was terrifying. Now the sun was one circle of fire. A rider was moving in our direction across the plain with the sun behind him. The horse trotted at such a slow pace that for a while I thought it was standing still. In the plain the rider looked small and insignificant but when he came nearer he was majestic. He was dressed for the sun, a white shirt and white trousers in thin cotton, bare feet and a hat of fine felt as wide as his shoulders. He had a calm face, only his eyes spoke. He looked at me, and I felt sad. I returned his greet-ing. He exchanged a few words with Roberto in that strange-sounding patois and went on his way.

Roberto said, 'I could tell you much about this man,' and he laughed. 'Oh, very much!'

I knew that Roberto was a fine guitarist and soon I was to learn that he was also a good story-teller. We sat down on large stones and Roberto began. From the very first words I knew that I would enjoy listening to him. He linked the words carefully as though he was making a precious chain. His tale contained the light of Mexico's sky and the sharp shadows of Mexico's mountains. It had also the smell of the sea and the rhythm of the wind, but most of all it had the still-ness of noon. It was a tale of savagery and humiliation, and from Roberto's face I could see how much he pitied the man in his story. He hugged the guitar to his chest and at the more dramatic moments he unleashed the fury of his fingers on the strings and the strings cried out.

This was Roberto's story: 'I lived at the time in a fishing village – I was then a fisherman myself. And Diego, whom you just met, was a cobbler, the only cob-bler around. On the horse just now, he looked big, eh? But he is as short as any of us. Now he is old, eh? But at that time he was young, though the colour of his face has not changed – it was just as it is now, green, eh? The moustache which now droops over his lips was then a thin line between his nose and lips. O, the women liked him, they liked him a lot. He walked about from door to door with

his wooden box of tools hanging from his shoulder, doing a repair here and a repair there. He had no wife of his own but he did not need one; women every-where were his wives.

'O Diego, Diego! the sheer incarnation of the devil! And with a voice so sweet it could charm the moon to lie down with him. I think he was stealing too, some of the time, but this no one knew for the things he had he may have been given by the women. But people talked. The fishermen did not like him and never returned his greeting. And Diego was the sort of man who was friendly to one and all. Of all the people, I was the only one to speak to him, to listen to him, and I was the only one who shook hands with him. He always had pesos but no one, not even I, knew how he got them, for the folk whose sandals and boots he repaired had no money – they paid with a vegetable or a bit of maize. But it was during the nights when the fishermen were out on the sea that Diego worked hardest. O Diego, Diego! It was then that he loitered and enlarged many a fisher-man's family! O Diego!

'It got so bad that the fishermen beat him up, dragged him to his own shack and beat him again, and there they also recognised things – a shirt which belonged to one, a pullover that belonged to another, even children's toys. Diego swore that he had stolen nothing, and beat him as hard they might he would not say how he had come by those things and told on no woman. But the fishermen knew; oh, how they knew. They told Diego to pack his things, to go and never come back. Would you believe it, Señor Joe, that as he was leaving, women, many women stood in the doorways, hugging little bastards to their breasts and weep-ing and their own men saw this! O Diego, Diego! He went away. Nobody saw him for a year or even more. Then his shadow began to show. People saw him here, saw him there, and women, possessed creatures that they are, went crazy looking for him. The priest was called and was told of this strange thing. To bring back some sort of peace, he exorcised the village. All went down on their knees and prayed. But it did not help. O Diego, Diego!

'One midday, it was no longer the shadow but the real Diego who came back to the village, but it was no longer the same Diego. The fire, the self-assurance had gone from his eyes. He threw himself at the feet of the fishermen and begged for pity. What had happened to Diego? Nobody was in a mood to forgive. This time they threw stones at him but Diego did not move from his place. He cried aloud so that even God in heaven could hear him: "Forgive me, brothers, forgive!" For a moment it was very quiet. The proud Diego was no longer proud. He whined: "My conscience, brothers, burns me like hell fire." Women now despised him. Rosita, with a child at her breast, went over to Diego and cried in his face: "So, woman is your bad conscience!" And she spat at him; others did the same. Then José Manuel and his two sons went over to Diego; not a word, not a word did José Manuel say, but with his eyes he ordered his sons to lift Diego. José Manuel could speak with a tender voice, oh, he could, and with his tender voice he said to Diego: "Follow us and all will be forgiven." And Diego followed, and they passed through the crowd and they went on and on to a distant shack and all the way

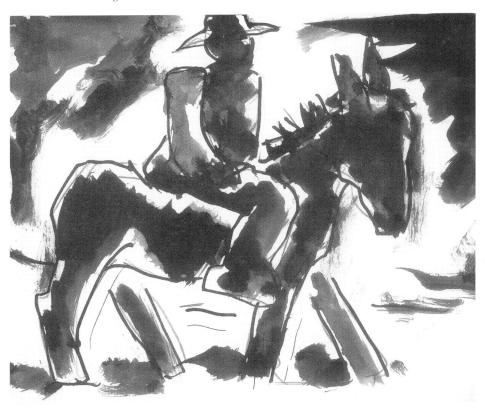

José Manuel spoke tender words to Diego: "We forgive you, Diego, we do."

'But once in the shack Victorio and Miguel, the two sons of José Manuel, caught Diego by the arms and held him fast, and placed their feet on Diego's feet and Diego could not move and José Manuel pushed a rag into Diego's mouth, and then he took out his knife and cut Diego's penis in half. Diego fainted. Then Victorio and Miguel carried Diego's half-dead body on their shoulders, and the blood dripped from Diego's crutch all the way. They carried him to the steps of the church, threw him on the ground and left him there. O Diego, Diego...

'If it had not been for the priest, Diego would have died there and then. What happened to Diego after that no one knows. For as soon as the wounds healed he left and was no longer seen. Then he appeared on a horse in places far away from the fishing village. He lives now on people's pity. Everywhere he goes people give him food, but he stays nowhere long. He rides in his humiliation all over Mexico. He eats, goes on his way, and nobody knows where he sleeps. Look up, Señor Joe, and see that range of mountains. He passed just now and has gone on his way again. O Diego, Diego...'

Roberto finished his strange tale with a loud chord on the guitar. And when I looked up and followed his pointing finger, I saw the silhouette of a man on a horse on top of the mountain.

Roberto asked me for some wine and I gave him some. Then he said that he must go back to his herd of goats and that he would see me, if not here, then in

some market town. 'Goodbye, Señor Joe.'

'Goodbye, Señor Roberto.'

I could not get the story out of my mind. When my American friend returned it was nearly sundown. I told him Roberto's tale. He smiled. 'Oh that, yes, I've heard it too. I have written a paper about the Diego legend.'

'What do you mean, the Diego legend? I saw him with my own eyes – Roberto exchanged words with him.'

'All you know is that you saw a man on a horse saying something to Roberto. There have been many ballads about this Diego. And of course there are many variants. Like most popular heroes, Diego is part truth, part fiction. For instance, during a civil war Diego's torturers become the hated soldiers. I could never trace the date nor the place of origin. Fishermen I have interviewed in villages miles away from each other swore that it was in their village that all this happened, and that they knew Diego, just like your Roberto. Traditionally the person telling the story claims that he alone knew Diego. The Mexicans are a credulous people and like all simple people, good at heart. Any passing vagabond on a horse is believed to be Diego. They feed him but never inquire about him: but woe betide the vagabond who departs from tradition and stays the night in the village or makes love to a woman; he is usually killed on the spot. He must be constantly on the move. He must never touch a woman. Then people believe him to be Diego. A strange legend, but it has all that appeals to the Mexican imagination: terror and pity. Nothing is more humiliating to a Mexican than no longer being a man. Nothing awakes in him greater pity.'

All red now, the enormous sun lay on the rim of earth. The village glowed like a geranium.

La Rochepot

The fog came down suddenly and grew worse every minute. It became so bad that we could go on no longer. Looking ahead was like looking into a lump of cotton wool. We did not know this part of France and could not even make a rough guess as to what was in front of us. Even looking for a flat bit of ground was an undertaking in itself. I walked in front of the Dormobile and C. steered the wheel. Each step was a victory over the unknown, with each hesitant step we felt as though we had discovered a new land. At last we achieved the necessary few yards distance from the road and stopped. The fog seemed to be creeping after us. In vain I looked around – there was nothing to be seen. Perhaps this was what the end of the world would be like. It was not until we were inside the Dormobile and had stopped talking in whispers that we felt free from fear. We lit the calor-gas lamp and in the green light, seeing the familiar things, we regained our sense of security. We were out of danger.

At eight in the morning we were awakened by footsteps on asphalt, by the clatter of heavy wheels and the trotting of a horse. Outside the window nothing had changed; the same white fog. I opened the window and leant out; the clatter and the sound of voices came nearer and nearer, and when at last I could make out the silhouettes of people and of a horse and cart behind them, I shouted a greeting and asked where we were. A voice called 'Hola!' and the horse stopped. An old peasant couple appeared at the window. Now I could see their rugged faces. The peasant said that we were above La Rochepot and that the village was a few hundred yards down the valley. Then he and the woman retreated into the fog and within seconds were swallowed up.

By the time we had breakfasted the fog had lifted. A yellow beam of light came through the window, spread itself across the length and breadth of the table, burnt down on to the floor and rose up the further wall of the Dormobile. This unexpected appearance of the sun cheered us. The world was visible once again, and a heavenly world it was!

There were hills, all pink and red; trees, tall with golden leaves in autumnal splendour; and high, high in a shining blue sky the glittering walls of a castle. As a rule I do not care much for castles, even beautiful ones, but in this scene, in this place, and in this light any building would have seemed magical.

Along the road came a procession of ultramarine carts each pulled by a giant of a horse and followed by a peasant couple, the man dressed in faded blue – almost lilac – and the woman covered from head to foot in black.

Their voices had a fairy-tale ring and their laughter floated over the valley on invisible wings.

I stared hard at everything. It was a festive sight. To think that if it had not been for the fog I would have missed all this!

The village of La Rochepot lies in permanent shadow in the basin of the hills. Its tallish grey houses, with their brown tiled roofs on which patches of green moss grow here and there, have an air of severity and give a strong impression of age. The trees which surround most of the buildings are stark, and the leaves deep brown, almost black.

I stood for a while near an old water pump and then made my way to the vineyards. It was very warm and as bright as a summer's day. The only indication that it was autumn lay in the colours of the trees, and the faded grass, so pale that it had not even a semblance of green. The whole panorama was coloured in various shades of copper, but on closer inspection one could see the presence of other hues. The vast fields were the colour of a biscuit, and the symmetrical, long, low rows of twisted bushes were either dark grey, or black as charcoal: no sign of a leaf on any of them. Behind lay the vague outline of the hills, smooth in texture, their colours ranging from ochre to vermilion. And beyond them rose the hard walls of the mountains, as hard as the figures of the peasants who bent over the vines. Others stood upright, motionless... The whole scene was immensely beautiful, and deeply moving.

My day's work had begun.

La Rochepot, like other agricultural communities, still preserves a high degree of collectivity, yet the personal and private is more distinguishable than in big cities or in industrial centres. Perhaps this is why I like peasant communities so much; the peasant is a type, but also an individual. From their very postures one can sense a world of silent expression. But more important than their shapes or their faces, their whole bodies express a kind of transcendental declaration of human independence. With the greater mechanisation of agriculture, depersonalisation will spread here too: but it has not yet done so, and many worthwhile values remain. Here man is not a lost boy nor woman a painted doll. Living and working is common to both sexes. Both men and women dress for the job. On Sundays, for a few hours, they change into shining, clean, traditional black costumes which are neither decorative nor comfortable. They look clumsy in their Sunday best. After church and after eating they change back into their every-day clothing which sits more easily on their bodies.

There are no communal lavatories which make so many small French places smelly.

For a few short hours radios screech away, loudly and with little concern for the type of programme – a wild anarchy of spoken words, music and song... Then all noise stops. Siesta time... Silence... Then back into the fields or vineyards. It is now the season for turning up the earth and pruning the vines.

I found so much to do that we decided to stay on for another few days, perhaps weeks.

The landscape changed... Or had my eyes changed it? Many hidden colours merged together into one warm brown. And this brown gave me the ambiance of the place which comes only after prolonged and intense looking... Seeing is also a spiritual process... After each hour of drawing I felt as though I had come from a different planet. After each hour of drawing I felt myself nearer my familiar definition of nature and of man. Silent night, silent peace, the silent strength of it all.

A woman called out from a distance 'André-e-eh!'

Monsieur Laval's horse had died. He had enough money to buy another, everybody said. But M. Laval told me that his horse had immense distinction. It takes a long time for a man to understand a horse. It takes a long time for a horse to understand a man. Hence the death of the horse was like the death of a friend. M. Laval had locked himself in the stable with his dead horse, and outside a crowd had gathered.

Nowhere have I seen such deliciously rich earth as in the fields around La Rochepot. It radiates as though it were alight on the inside. With such earth at their base the vines look like works of art and the vineyards spectacular. I have seen vineyards which resemble abandoned graveyards! But here, everything which germinates from this soil, the high trees and the low vegetables in the gardens, is potent with superbly rich juices. To look at the vegetation made the head spin. It was so unreal and poetic. To dream unreality in front of things real!

Watching a figure bent over the low vines, noting the rhythm of his hands –

one holding shears, the other the twig to be cut – reminds me of some sacred ritual. There are many such figures in the vineyards, day in and day out. But I am concentrating on one such figure and in the drawing of it, I am trying to imbue it with the essence of all... I am aware that I am drawing a perfectly ordinary incident, one that is part of everyday life here. But should I succeed in synthesising its grandeur, I could call it justly 'Pruning the Vine' and be certain that it is a poetic record of all such incidents, that I have captured the universal in the particular. The true interest lies in the form. It is a hazard guessing when it will be right.

In all my travels I have never looked for a 'promised land', and for me, to leave a place requires no earth-shaking decision. Like a seasonal labourer, the work done I move on. With gratitude I say goodbye to friends of short standing and take with me different degrees of nostalgia and the usual pain of saying adieu. Every human being possesses something of value that is worth sharing. And so do places. Patience is needed to discover it, that is all. For the last few years I have had a strong desire to stay away from big cities and the art accumulated in museums. I have wished to be with people who work with their hands and who use their brains to direct their hands to give them purpose; I have wanted to talk with such people about ordinary things and understand why and in what way such things matter. In all my travels it was always the small places which nourished my soul.

It was a fortnight of bright autumn days, and nights lit by a red moon. Just to walk in this magnificence was sheer enchantment, and afterwards to draw the

things I saw was an added joy. During our last night in La Rochepot I could not sleep. I decided to dress and walk through the silent little streets. To my surprise old Madame Laval was sitting on a bench against a garden wall, lit by the moon. She spoke to me in whispers. For the past few years she had prayed each night for sleep but sleep never came. The doctor had given her pills but to no avail. Each night she walked about for a few hours. And so, sitting alone she thought of this and that, but most often about death which she was so frightened of. 'I sometimes think that God is vengeful. To pay with an everlasting death for the few years he gives us to live is a heavy price. Perhaps all living is his way of punishing us. Everything dies, why punish poor animals or plants? Do you understand it?'

From the way she spoke I knew that she was suffering. She looked at me but I could not see her eyes; above her cheeks were two deep cavities so dark they looked quite hollow. 'I know I should not talk like this... But these thoughts will come to me and then nothing makes sense. Monsieur, you had better go on, why waste your time with a silly old woman who is afraid of dying?' To distract her I asked about some of the people in the village – this awoke her love of gossip and I was rewarded with a chain of stories. At about two, Monsieur Laval came out to take his wife back to bed. He said with rare tenderness: 'Come back, Marie, perhaps you will fall asleep now...' Then he turned his head towards me: 'She has put the fear of death into me, too. But I lose no sleep over it.'

I watched them both walking along the moonlit road towards their house. They looked so pathetic and so forlorn.

It rained very hard all morning and when by midday the rain had not stopped we decided to leave anyway. I was frozen with anguish while waving adieu to all those people sheltering beneath dark, wet sacks and umbrellas, who had come out to see us off. The Lavals brought us a bottle of cognac and a bottle of liqueur, and proudly said that it was home-made.

Then the car bore us away. Within seconds we were on a wide road, alone.

Andalusia

From the first moment I set foot in Spain soon after the war, I knew I was both in Europe and outside Europe. Spain's present and its past have a surprising quality. Each time I go there I have the feeling that I am stepping on a new planet. At the same time everything feels close to my skin. Each time I leave Spain I know I will go back.

In 1958, N. and I decided to spend some months there; six, seven, eight – who knows. For a variety of reasons we chose Torremolinos. I have been to Torremolinos several times, and I have watched its gradual transformation from humble fishing village to tourist hell. In 1971, when we passed through on our way to Gibraltar, we could not believe our eyes. The village had been obliterated from the face of the earth. Tall skyscraper-style hotels were everywhere. The streets were crowded with zombies. In 1958 it was nothing like this, though the approaching future was writ large. All the signs were there. But not yet the reality.

As in all the villages between Malaga and Gibraltar, in Torremolinos the peasants and the workers live at the foot of the mountains and near the fields; nearer the sea are the dwellings of the fishermen. Their boats lie on the sand.

Of the windmills which stood on the hills, stark against the sky, and which gave the place its name, there remains only the ruins of one; sail-less, roofless, only bits of walls to remind one of its original cylindrical shape. The ruin is looked after as though it were a shrine; the whitewash always looks new.

The round hills of Torremolinos have a hard outline as though they have been drawn with a compass. Beyond them is a range of blue mountains, and miles away in the distance is the even taller range of the Sierra Nevada, sharp as crystal, cold, grey, capped always with white.

The sun was made for Torremolinos. Torremolinos needs it most – not so much for its warmth as for its light. Every building, even the hovels in which the poorest live, has the most luxurious look. The eucalyptus trees, the olive trees, the palm trees, and the spread of the red hills all look festive and radiate a tranquil prosperity. Just to stand still and to look at the miracle this light has performed lifts the spirit. Nowhere have I seen anything so pathetic as Torremolinos in the rain. The social wounds, the physical disintegration exposed by the rain can only be compared to a poor, neglected graveyard. Nothing is left of the illusion of wealth, nor of nature's breathtaking abundance. But most degraded-looking of all are the men and women of Torremolinos. Now they stand before you virtually in rags. But the sun is never away for long

– not even in the winter, and when it returns the great poise comes back first of all to the Andalusian, the poise he has preserved against all odds. And this poise fits him as though by right. He once again has physical integrity and proudly walks this bit of earth. There is form to his body, there is style to his personality, from the brilliance of the surroundings he stands out in his own brilliance. This great poise is the Andalusians' other sun. To live among such people warmed my heart. With these poor but proud neighbours of mine I felt safe.

The Spaniard is a man with an inward look. He does not reveal himself in terms of reason, but he makes himself felt through his unique presence, a presence embodying many traditions at once, Western as well as Middle Eastern. He is not of the daylight like the French, he is not of the soft twilight like the English, he is of the night, when thoughts and passions collide; and the Spaniard finds his most emphatic and definite self-expression in painting. Spanish painting is the most stern warning to those who take it for granted that bright weather produces bright, cheerful art; it mocks the theory that climate influences the nature of a people's art.

The Spanish painters lived in a sun as blistering as anywhere on earth and had around them a landscape as bright as anywhere on earth, yet they produced the most tragic paintings in the darkest of colour, Spain became the home of one of the most sombre spirits in the story of painting – El Greco; and from its own people Spain gave us a painter with a mind as dark as that of Beethoven or of Michelangelo – Goya. Nor are Zurbaran's few great pictures a song of cheer to the sun of Spain. Perhaps Spain, to suit the theoreticians, should have gone on multiplying objective geniuses like Velásquez, or impressionists as soft and woolly as Murillo, but it did not, and the weight of darkness pulls Spanish painting down to earth and displays the recklessness of human passions with pride and trust.

The Greeks' disposition towards sculpture is still today often explained as being due to the clarity of the light. Yet Spain has a similar quality of light and has produced no sculpture whatever except for its great Romanesque works, and these are generally thought to owe more to the religious climate than to the meteorological.

Spanish painting has always been close to my own obsession with passions and nocturnal ideas. And so I found it the most natural thing to do – on my way South – to stop in Madrid for a few days and spend the time in the Prado or just walking the streets of this lovely city.

I find the Prado one of the most intimate and endearing of all museums, not only because of its collection, but for its general atmosphere. In which other museums do you see a peasant woman hugging a child to her breast as she walks from room to room? In which other museums do you find the poorest of all Spaniards, the ordinary soldiers, on leave probably, standing open-mouthed before their beloved Goya?

As for the pictures of the Prado, well, I must confess to being very subjective in my choice, and I only look at few painters at a time. Looking at pictures is a serious business; it is a strenuous activity of the spirit. As with pain, as with joy, with pictures you are alone, no matter who is beside you. The picture which has

chosen you demands this isolation. I went deeply into Zurbaran's self-portrait,[41] and Goya's black pictures,[42] and that I found enough for the day.

The next day was for El Greco, Rubens and Breughel. The following two were for the streets of Madrid, and then we left for the South.

II

Getting out of some cities can be agony. For instance, London drags on endlessly, an eternity of ugliness upon ugliness. Your nerves are deadened, your mind numbed. By the time you realise that you have at last left the city you are beyond caring.

To get out of Madrid is a different story. Not that its proletarian suburbs are the world's seventh wonder – in fact there is nothing there that is beautiful in itself. On the contrary, there are stinking dumps and tips, large areas buried under debris and filth. The concrete surfaces of the tall 'modern' houses already look covered with a thousand years of shabbiness; there are low, dreadful, tumbledown shacks; the children empty themselves wherever the need overcomes them, and I would not be surprised to find rotting corpses below the mounds of paper. And yet it is completely free of the stifling atmosphere which grips you in the clean middle-class suburbs. It is difficult to grasp why the proletarian suburbs should cast such a spell; all I know is that the atmosphere generates something vital. It is, perhaps, this realisation that takes hold of one's moral sense, which at its most serious is one with the artistic imagination. Filth has its own aesthetic appeal, not for what it is, but for its potential in our imagination, just as the colours of dead flowers can be more fascinating than the colours of fresh ones.

The link between the workers' suburbs and art is a real one. Millet discovered this when he began to draw in the suburbs of Paris before he left for Barbizon. And in our time the Italian painter Mario Sironi created a lasting epic of pictures out of the proletarian suburbs of Milan. Rouault preserved this same spell in many of his works and so did Dostoevski; so does Beckett. Perhaps the unique poetry of the proletarian suburbs belongs to an as yet undefined branch of aesthetics.

Within no time we were on the outskirts of Madrid and it was only then that I felt like singing. Driving the car N. sang too, and David, our one-year-old was bouncing up and down on my knee, his face one big smile.

The way south is mostly desert and sand. My arm, leaning out of the car window, was thickly covered in yellow dust. Though it was October, the heat was as great as in summer. The hills on the horizon were of white chalk and of such oblong shapes that they looked like cities. From Malaga to Torremolinos it is 'civilisation'. You can even find a tractor now and then. The road is busy with cars, buses, motorbikes, scooters and the greatest variety of donkeys imaginable. A peasant carrying a turkey... A peasant woman carrying an old-fashioned gramophone horn... All the expected and the unexpected, all is out on the road.

We very quickly managed to make the house we rented look our own. We

brought enough books to keep us going, even for the fast readers we both are. Some books I read more than once, and will go on reading and re-reading: Delacroix's journals, Van Gogh's letters, Istrati's novels, Wagner's *Ring*, the diaries of Paula Modersohn-Backer, as well as the works of the few poets I particularly like – Whitman, Rimbaud and Pasternak.

One thing I never do is to read histories of the place I happen to be in, nor that country's literature. I do not like to *know* about a place. Nor do I like to visit people who are established in the district and have become 'celebrities'. I like my outward and inward eye to use their own energies, without the bias of pre-conceived ideas.

Once I got into my routine – rising at five and painting until midday, early lunch, siesta, a late afternoon stroll into the fields or into little streets with a sketchbook, reading in the evenings, and so to bed, I felt myself to be in a state of bliss, there is no other word for it. What more could anyone want? With me were the woman I adored and the child I was crazy about; I could do the work which gives shape to my life, and for months ahead there would be no financial worries. In such conditions there was no room for the anxieties which usually loom large in my mind, nor even for the thousand-and-one doubts which often drive me to despair. I was brimful of gladness.

I can best describe my feelings with a quotation from the Jewish mystic Bal-Shem-Tov.[43] It is said that Bal-Shem was heard crying out to God: 'Oh God, so much happiness is more than I can endure. Free me from happiness and let me go back to ordinary living!'

I had no need to pray for a return to ordinary living, but my ordinary life in these extraordinary conditions was one long, long moment of loveliness. Days passed as though they were moments.

Our first friends were the children of the village. N. trained them to come to us only in the afternoons. And every afternoon there was noise, there were songs, there was play in the garden and those who could not yet walk, crawled everywhere. When a child grew hungry and came over to N. and said so, we knew we had won the day.

It was through the children that we established our first link with village life. We quickly got to know their parents and within days we had rid ourselves of the stigma of strangers.

Torremolinos at the time had its fair share of Americans who had taken to the road as a way of life. The road became a symbol of the freedom that no young person could find any more within the framework of his homeland. The road was leading from one rainbow to another. A new age of nomadic freedom was dawning. Some travelled in groups, some in twos, but mostly they travelled alone. And if peace did not come from the rainbows they searched for it with the needle. They rejoiced at having freed themselves from all ties. They talked, but did not sing. They walked, but did not dance. They were a prey to vast fears, to tremendous apathy, to a great longing. Their eyes were dead. A young writer, Jack Kerouac, was their prophet.

Of all those young men and women who passed through Torremolinos and left

no trace behind them, only two Germans caused something of a commotion. They were camping on one of the beaches beyond Torremolinos. One day a tall, cold-eyed and tight-lipped Swede and his companion, an Englishman just as tall and tight-lipped, told the police, and anyone in the main street who cared to listen, that their dogs had disappeared. Two policeman, the Swede and the Englishman and a small crowd made their way to the beach. They searched behind each stone and among the bigger rocks, and found first the skin of one dog, and a little farther on the skin of the other one. Traces of bones here and there led them to the tent of the German boys. The boys were half naked and fast asleep. The commotion of voices awakened them. They at once admitted that they had eaten the dogs. The Swede went white, and the Englishman was beside himself; he was ready to skin the boys there and then. The two young men were arrested and we never saw them again. Apparently dogs and cats had been their diet since they were children in the days of the war. The policeman whom I questioned about the boys told me that they had been beaten up and then taken to the border, and that they would never be let into Spain again. The Englishman told me that all his life he had been pro-German but he was now convinced – and so on. The phantoms of war still lingered, even then.

The account of our winter in Torremolinos would be incomplete without a few words about the arrival there of two friends of mine, the poet Jimmy Burn Singer and his black wife Maria. Jimmy was recovering from severe pleurisy, and Maria, on the doctor's advice, had brought him to the sun. Unfortunately they arrived at the time of the great floods – the snows of the Sierra Nevada were melting rapidly and a few days of warm rain made matters still worse. The Singers were flooded out of their ground floor rooms in the hotel. The flood was a one-night destructive nightmare, but for the best part of a week afterwards we walked ankle deep in mud. All the shops were covered in mud, and a great part of the road had been washed away. Those living near the hills came off worst. Bedding and chairs floated in the brown waters. People ran about crazed with terror, they cried and were helpless.

Somehow the floods passed us by; only the garden suffered and was full of water; but none came into the house. In such a situation N. is fantastic, and she went all over the village, wherever help was needed. All our thoughts were with the local people. The atmosphere was charged with defeat though no lives were lost. Only one child was caught up in the torrent of swirling waters, but was quickly saved. The poor lost what little they had. Everyone worked to save what he could – the women and children working hardest for the rest of the day. Flood or no flood, the men had to report to their work. The sky remained clouded for the next few days. No relief came from anywhere.

Life got back into its stride, and people talked less and less of the night of terror.

Jimmy and Maria walked the streets slowly, arm in arm. Maria was the bigger of the two; Jimmy had the physique of a boy. His hands were pale, his fingers long and delicate. After only one week he recovered his usual rosy complexion. His eyes shone with an incredible, vivid blue. His hair was thick, smooth and

blond. Only when he was drunk did his face lose the childish look. He would sit, not saying a word, forlorn, dozing; he never felt safe awake, and drink, he told me, helped him 'in not being'.

At the best of times Jimmy was not a great talker. Whatever he wanted to say he said, unhurriedly, almost in a sing-song way, rolling his r's in the Scottish fashion. His thoughts were usually very precise – a discipline which remained with him from the days when he had studied marine zoology. But his pauses were longer than his sentences. As with other true poets, he seemed always to be thinking of the perfect line, and this slowed down any conversation with him. He was a pleasure to talk to because he was an impassioned listener, he always gave the impression that whatever you said was worth-while.

Gerald Brennan, whom both Jimmy and I saw often that winter, once praised him as 'the man who knows more about poetry than anybody I know'. Jimmy retorted that this brought down a curtain of suspicion which made his own poetic efforts invisible – people thought them too intellectual. 'But,' continued Gerald, 'this also makes you the most reliable literary critic now writing in England.' 'That is not what I want... Not at all what I want,' replied Jimmy, so quietly that it sounded like a painful sigh.

One afternoon, returning from Gerald, we decided to walk through the mountains. It was splendid weather, and there were marvellous views at every turn. The hills, the snakes, lay in a warm rose light, and a fine steam rising from the grass seemed to give them mobility.

We did not talk. Silence was more eloquent. We did not conceal our emotions though, and now and again we stopped, each understanding what went on in the breast of the other.

Years later, when Maria informed me of Jimmy's sudden death, this walk of ours in the mountains of Andalusia came back to me. In silence we had sealed our bond of friendship. And now the memory of that bond, in a different silence, became my cry.

Israel

In the autumn of 1952 I went to Israel. I should add in all humility, that I did not go there 'to see things for myself'. I went, as I would have gone to any other place with no plan, uncertain of what to expect, prepared both for enchantment and for disappointment.

Nor can I say that I lived there 'the life of the people'. I enjoyed the privileged security of the visitor. I experienced no personal discomfort worth mentioning. I was luxuriously free, even from guides and official literature. Thus in blissful ignorance I walked the streets of Tel Aviv, Haifa and Jerusalem. I stayed in some villages, Jewish and Arab; in one or two kibbutzim and in the Negev; nowhere longer than a few days, everywhere guided by the logic of my emotions, every-where trying to sense things. Oh yes, I attended one informative talk on the Histadruth, the equivalent of the TUC, but the evening was rather cold – it was late December, I was tired and after a meal I could scarcely keep my eyes open. Fortunately the speaker was a dear friend of mine with a sense of humour. He never asked me what I thought of his talk. He only said sympathetically: 'You should not have come.'

I am saying all this to explain that just as I went of my own free will I wan-dered about there in my own way. This I found easy. Israel seems somehow to dislike the idea of keeping a visitor at a courteous distance. It lies open, candid and inviting. Nevertheless, the intimate texture of any country is not very likely to reveal itself immediately to the eye. Reminiscence at a distance also plays a part. It is only now that certain atmospheres become hauntingly real. Some ques-tions are disturbing and puzzling, some answers need sorting out, and from the experience of those ten weeks I strive to establish some kind of synthesis of all those impressions which left a lasting imprint on my mind.

To sit on the white stones of the Judean hills, at twilight, when all matter merges in the finest shades with the air, and the late sunlight pours all over the valley, gilding the rocks with the sheen of mirrors, warming the landscape into a glowing red as though seen through a bottle of wine, to sit in this atmosphere and contemplate the antiquity of the land – it is a temptation difficult to resist. For even more than Greece, Italy or Spain, the atmosphere of Israel is heavy with the ever-presence of history. Yet immediately below the eye, and beneath the pearly wall of hills, Israel has the faint buzz and all the appearance of an unfinished factory. Here and there proud steel constructions reach out, concrete mixers rotate, lorries come and go and men no bigger than ants move swiftly

about. A wondrous yet familiar world unfolds before the passive eye. There is hardly any smoke, for there are few, very few chimneys, but a silver dust rises and floats. Not even the desert is 'asleep' any more.

There is no link between the past and the present. The gap between has been too great. Israel has not walked into the present – she has jumped. The archaic is a silent witness – the Arab hamlets growing on the hills (how organically they grow!), the camels, the green half-moons of the palm trees, the cactus. New externals are interfering and having their emphatic say. A new physique is being imposed on a small scene suffused with rose-red light.

Rush of labour here. Humming tractors there. 'The dashing wheel', as someone has called Israel, is turning madly because urgency, with all its rough force, is the driving current. Time does not stop in the life of any people. But sometimes all clocks seem to run faster.

I cannot make comparisons. I have never been there before. But one needs no great imagination to suspect that there has never been such a spurt of labour, noise, building, road-laying, or continuous planning. But in all there is more purpose than direction. Buildings are growing up. Even in those designed with a view to permanence, the spirit is more functional than organic. (I may have been slightly prejudiced by the naïve pride with which certain buildings were pointed out to me.) Perhaps some school buildings are an exception. They are often as beautiful in design as in the use of their natural surroundings. On the whole, the direction of the 'dashing wheel' is not towards an abyss. What it cannot as yet show in terms of achievement, it can and does demonstrate in terms of the human will. Exasperating will! Israel is not favoured by conditions but by the potential of its people. It is a potent humanity that takes pride in building a sewer or planting a glass factory in the desert, and considers this a unique triumph. And this is how the Israeli thinks: in a continuous blast of enthusiasm. Europe's habit of thinking and feeling its way in the dark is strange to him. And what he thinks he does not say in whispers. The country is loud with human speech and boasting. I do not mean the proverbial whirl of words we usually associate with the East. I mean the echo of Europe's own voice when Europe was younger and herself guided by a vision.

The people, even more than the land, bear the new physique. The economics of Israel may be little more than improvised schemes, the social pattern still a jigsaw puzzle with bits not yet fitted together, the cultural aim based on a naïve 'quest for happiness', but the new physique has an entity and completeness all its own, typified in one particular representative.

Whom exactly do I mean? Do I mean the young administrator, calm, poised in an impersonal world of facts and figures, the prototype shaped by the London School of Economics, pillar of Party or State? Do I mean the little businessman, perspiring, grumbling, rushing about anxiously, yet uninvolved in this new venture? Do I mean the hollow show men, the big shots with their lawyers and advisers, who look at this land to see only whether it is fit or unfit for business? Do I mean the ancestors of Mendele's 'little Jew', living now in the religious

quarter of Jerusalem, Meah Shearim, and inwardly wrapped up in his own brand of piety? Do I mean the Yemenite, the Bokharan, the Moroccan or any of the colourful Oriental Jews? (Should I not admit that they all kept me in a trance of strange fascination?) Or do I mean those among them most willing to be fused into one people by common citizenship and national adherence?

No, I mean the kibbutznik – the very type and personification of Israel, the source of the new physique, who transmits his example and purpose to his fellow countrymen. Earthy, in pale khaki, heavy-postured, he differs from peasants the world over by his wider consciousness, being perfectly aware of what he is doing and saying. Larger than life, proud of his humanity (national adherence he takes as a matter of course), he has outlived a lot of sceptical resentment, and he is Israel's moral advance. He does not comprise all Israel's labouring humanity, he is its physical synthesis. Within the ideological turmoil of israel's institutions the kibbutz alone is a new spiritual landmark.

Although the fate of the kibbutz is no longer Israel's fate it seems to me that on the advancement or collapse of the kibbutz – both are still possible – the character of the State itself may well depend. The pioneering spirit is so buoyant that one is apt to forget that it has created not only shining examples of voluntary acceptance of duties, unselfishness and a communal attitude to property; it has also created its own problems, internal as well as external. How to keep transient political groups from interfering in wider ideological matters, how to keep the original idealism from congealing into hatred? A split is most certainly not the answer. Oh, there are too many puzzling questions to start enumerating them here. In the main, however, the atmosphere of Israel feels like spring air. After all, mankind as a whole is still in quest of how to live and every new venture is a hopeful call.

Now, it has not been my intention to repeat Israel's heroic story. A story of heroism it primarily is. But it is also a story of human endurance. The country was not over-flowing with goods or food, but I saw no grey faces suffering from starvation, no queues displaying excessive ill-temper. On the whole life was neither lavish nor rich. But to tell a poor man that he is poor is neither very sensitive nor helpful. For the incentive here is neither milk nor honey. It is something more fundamental. It springs from the same instinct which prompts us to shelter from a storm. It springs from the group feeling which reassures the individual that he is not alone on this forsaken earth. It springs no less from the consciousness of a continuing tradition. The citizens of Israel are varied. Their task is to establish a normal everyday existence. The realisation of this is a rough business. And this is why, to many, Israel appears a rough country.

Amsterdam

We approached the Hook in a vicious storm, the rain pounded the deck with the violence of stones.

There was no sky and no sea; nothing above and nothing below; it was one huge tangle of wind and water. It was not dark, but surprisingly bright, with a light as cold as ice.

I stayed on deck. To begin with the captain was nervous about me, but I explained to him that if I were to go below, or into a cabin, I was sure to be sick, so he shrugged his shoulders and left me in peace.

Then the madness of the storm stopped. For a short while there was still a rain as fine as dust, then this stopped too. The surface of the sea became as smooth as a polished table and green as fresh grass. The sky was now distinct, all white with blue shapes like animals here and there.

The pilot came aboard and the captain took him to the steering cabin, and it was he who now took over and glided the ship smoothly into port without a hitch.

The quay was in the usual turmoil of ports when ships arrive – a madding chaos of embraces, shouts, confusion and people running about like crazy marionettes.

The commotion was of course understandable, but I could not get away from it all quickly enough – so much stirred-up emotion, mostly lasting no longer than a moment, but with so many people about that the moments ran into each other and on and on into an eternity. I knew no one and expected no one. But I was wrong. A figure in a bright raincoat with the collar turned up to the brim of his hat, waved towards me. It was Dr van D., a Dutchman who lived in Amsterdam whom I had met at some friends' a short while before in London. How on earth did he know that I would be coming to Holland, and arriving at the Hook this day and hour? He did not. He had come to meet his wife, had noticed me and thought to say 'Hello'. The ritual of handshaking over, I promised to ring him when in Amsterdam, and he left me to welcome into his big arms a woman as big and as sombre as himself.

A few minutes later C. arrived with the car, and in no time we were on the road.

The Dutch countryside looks like the pictures on the tourist posters... Willows, windmills, tulip fields, areas of pastureland with black and brown cattle, small patches of woodland, and in no time one sees the outline of a town. The town passes, there are more willows, tulip fields and so on. But the expanse of sky seems larger and more prominent than anywhere else. It simply lies on the

grass and makes the fields and surrounding areas shrink into insignificance. I have never seen so little of the landscape and so much of the sky. But the small towns and the not-much-larger cities are of such great beauty that I would like to stop in every one and stay on to unravel the mystery of its loveliness. Much of the beauty comes from having so much water around, from the lustre of so many canals. I had not felt so calm for a long time, looking into these canals and seeing there much of the cityscape upside down, the people walking on their heads. What terraces are to the Mediterranean hills, the canals are to the Dutch cities.

Delft at lunch-time is probably the most silent city in the world. Alleys of tilted trees, houses as purple as only old bricks can be. A cyclist on a narrow bridge, and not another soul about. The whole city lies in a cool grey light which is somehow different from that of the colder England, though the two have much in common. After such prolonged and intense staring into the water I felt as though in a trance. All around me seemed a dreamland.

I knew Amsterdam well from earlier visits, and it is the city I love most, but at first sight it somehow looked different. Daylight was fading, and the streets reminded me of a hospital ward. Pale faces floated in the dusk; their gaze was lifeless. The houses alone had some solidity but they were stark, and the street lights made them look green. Even laughter sounded hollow and frightening. There was a strong feeling of uncertainty everywhere. It was not Amsterdam, it was the hour of the day. Every big city at twilight looks a bit out of its mind.

It is a commonplace to call Amsterdam the 'Venice of the North', but as soon as you begin comparing these two cities, the differences become glaring. The two cities have only one thing in common: the water at their base. Venice is the most extravagant invention of the human brain – Amsterdam is a sober calculation. Venice is pink, Amsterdam is grey. Venice has artifact written large over its fantastic shape. What square on this earth is more theatrical, and makes a better setting for pageants and carnivals than St. Mark's? Venice is distant and historic. Nothing in Amsterdam is as lofty and festive. Here history is not an extraordinary church but a warehouse, a tower-clock, and the art of the hydraulic engineer. The working present is a continuation of the past. No picturesque gondoliers here. On the canals of Amsterdam you see heavy barges and cargo boats and silent fishermen, all moving in quiet concentration, serenely, as though half-awake. There are few 'edifices', and no ornaments at all: and the whole city has a practical down-to-earth spirit. Even in the most crowded streets you get the impression that the impulses of life are well under control. This may not be so good but this is how it is here.

I have never fared well in night clubs. I respond badly to places of 'entertainment'. Walking through the streets is better and far more refreshing – looking at buildings – being arrested by an unexpected shape or passer-by, man, woman or child. All this I love and enjoy immensely. And so, relaxed and deep in thought, or talking myself hoarse without lifting my voice, I can walk for miles. All streets have an appeal to me: the dark ones and the bright, the crowded and the empty and the lonely. But in Amsterdam I found myself more often walking alongside

the quays with their rows of brightly-lit taverns. Through the open windows came screams and laughter, you could almost see the passions flying around like birds. It is extremely pleasant to sit on a terrace, sipping coffee and a favourite liqueur and looking at the lights breaking up the black surface of the waters.

When I rang Dr. van D. he suggested that we should meet without our wives. I was not surprised by the objects I saw at his house. He lives in a spacious penthouse in a very smart district. Everything was up to date but on the whole the rooms were sparsely furnished. Everything in every room had that metaphysical aroma of modernity and of geometry; nothing was soft, everything was as hard as the Suprematist's dream-world. You could feel hygiene creeping into your eyes, your nostrils, disinfecting your insides and above all your mind. How well his collection of Mondrians became this setting.[44] Not once did D. use the artist's surname. It was always 'Piet' – he knew Piet – Piet this and Piet that. When I was given a circular cup of coffee I was rather surprised; I had expected a cube with a handle! I can be a good listener and van D. made his points clearly. (Like so many intellectuals, van D. did not talk, he made points.) He was certain that to understand Piet one had to understand the nature of the Dutch. He said in a slow, dark voice: 'Piet is a Calvinist. In his art all our national obsessions appear. Our mania for clean surfaces and order... We have no nature in the way the French or the Italians have. Our landscape is mostly man-made. What does our landscape consist of? Constructions. Canals. Yes, construction and geometry. Above all, geometry...'

He became very excited, in his cold way. And although talking to me, his eyes wandered from one picture to another. Then he got up and asked me to come with him to the window: 'You have to understand what it means to live below the level of our greatest friend and greatest enemy, the sea. Only then can one hope to understand Piet's genius. The Dutch are insecure with nature. The only security we find is in metaphysical speculation. Metaphysical squares, that's what Piet painted.' His voice grew darker and darker. 'Piet was Dutch, very Dutch.'

He pointed out to me all the horizontal lines of the long, low walls which cut across Amsterdam's sea. The point made, he led me back to the table and to the coffee. I began to feel uncomfortable. I remembered that when very young I first saw the drawing in which Vitruvius imprisoned a man in a precise circle, I grew very worried. In the same way this room began to worry me. But Dr. van D. was still determined to tell me why our wives could not benefit from our meeting.

'Ah,' said van D. and his face almost lit up, 'women and metaphysics don't go well together, that's why Plato...' And so on.

On leaving him I went straight to the Stejdelik to look at Van Gogh, who, according to van D.'s logic could not have been a Dutchman. Presumably Rembrandt, too, must have been a Turk – or something else – but certainly not Dutch. At the Stejdelik I looked at and was once more impressed by the works of Breitner,[45] especially his still-lifes and nudes, and by his lovely painterliness. As for Van Gogh, I could not find even a trace of Dutch 'cleanliness', 'order', or any other bees from the geometrician's bonnet.

How do the Dutch sixteenth-century genre painters survive today when one is no longer shocked or amused by all that delousing, vomiting and pissing? They stand up to the test of time very well indeed. Teniers is a great designer and Brouwer belongs to the group of the greatest colourists. With what extraordinary liveliness the smallest form is handled. Genre painting or not, theirs is painting by any standards of any time.

As for Rembrandt, well, what is one to say? In front of that formidable picture, 'The Jewish Bride', I could have wept with the ecstasy that its dim radiance stirred in me. I recalled what Delacroix had written in 1851: 'We will discover one day that Rembrandt is a greater painter than Raphael.' There is no one today who could doubt this. My mind wandered into history. I recalled how cold and calculating humanist art was until Rembrandt came along and did away with all that glorification of nature and slavish service to Greece. From the depths of his own experience he began painting man with a soul within him. No longer was there just a clever formula for composing a painting, as Alberti had thought, but a way of illuminating the intrinsic qualities of the human spirit came into being. This still had to be achieved with the hand, but it was now a hand guided by trembling feelings, not a self-assertive intellectual and arrogant hand. When I am told by some know-all that Rembrandt's 'Changing of the Guards' has faulty composition I want to pull him by the eyebrows and make him look into the eyes of each man in the picture; these are eyes with an inward look; sad eyes, to be sure, but full of a terrifying awareness of what it means to be human. Nobody asked Rembrandt to carry his sincerity to the ultimate depth, but as an artist he could not do other-wise, and was punished for it.

The fog was so thick that outside the window there was absolutely nothing... It was not until midday that the faint contours of the city began to emerge. What was visible of the sky had a rusty yellow colouring. In this atmosphere one realises still more clearly that Amsterdam is a city of ships; fog horns sounded from all directions.

In the dining-room, waiters serving the first breakfast have uneasy faces... Adolphus, a waiter I became friendly with, whispers into my ear that fog horns frighten him.

In the afternoon the streets were back to normal and a bright sun, full of fire, stood as though motionless over the glittering waters. The Dutch do not take well to the sun. Never having enough of it, they have learnt to live without it. In the full glare of light all the streets looked a little crazy. People began to behave as if they were out of their senses and looked at each other with smiles full of mis-chief. Children danced on the pavements. The movement was most lively on one of the waterfronts, and small things began meaning very much more to one and all. In this mood it was easy to befriend total strangers and small talk paid big rewards. Fishermen, young and old, women with blood-and-fat stained aprons, fish scales on their big naked arms and faces, sat on low boxes and yelled and sang and swayed their bodies and stamped their wooden clogs. A giant with a

red-striped vest played a barrel-organ; with him was a small girl in some region-al costume of bygone days, holding a pewter plate in her tiny hands. In the distance, ships were sliding above our heads. Sailors shouted from the decks and people from the shore yelled back at them; everyone laughed and the sailors and men in the crowd tossed their caps in the air. Then from nowhere, a fire-eater made a large circle for himself in the crowd, lit a few torches and began his feast of fire. When he threw the torches into the air, and caught one with each hand and the third with his teeth, the crowd was overjoyed; all laughed and cheered and clapped and threw small change to the fire-eater. There were also tourists in the crowd, but their faces were puzzled. Amongst all this gaiety and simple splen-dour they found the Dutch more confusing than ever.

At dinner that evening we shared a table with a businessman from Leeds. He loved the Dutch – 'Absolutely honest people... Very reliable in business deals... Very exotic too.' The previous night he had been taken to a club where he saw 'something you never see in London': a wrestling match between two Indonesian giants of women. 'Stark naked too!'

All our luggage was in the hall. We were still waiting for our bill, when we bumped into Frau L.

'Yes, Frau L., we are leaving. Indeed, we have had a good time. I too love Amsterdam. Yes, I have been here before... No, I know nothing of Amsterdam's history. I am sure your guide told you all you need to know. Well, well, Amsterdam was built on a bog. When was it still a fishing hamlet? In the thir-teenth century? Your guide took you to the streets of Heeren Gracht – considering what the Germans did to the Jews it must have been very uncom-fortable for you to walk those Jewish streets? No? It wasn't? You found it educational? Yes, I know that Rembrandt went there very often, and that Spinoza lived there at one time. No, I have not seen the house in which Anne Frank hid. Your guide took you also to see the Scheierstoren? Why did your guide feed you with so much sadness? Indeed, the Scheierstoren is a memory of hunger, emi-gration, and how the rich Dutch got rid of the hungry Dutch. I too could have wept. No, I do not think it is going to rain. Amsterdam is often grey but it does not always mean rain. Yes, it would be better to have your dachshund on the leash. You will see, it will brighten up... Auf Wiedersehen.'

Adolphus, the waiter, handed me a box of cigars. It had arrived early that morning. It was from Dr. and Mrs. van D.

A last look through the window... The city was its normal grey. But there was a strong wind. The sea touched the walls of the town and now and again heavy white waves, shaped like prehistoric sea-beasts, leapt over the walls and drenched the nearby pavements. Into my mind came the village in Jules Superville's splendid story *Child of the High Seas*, always ready to vanish beneath the water. The wind grew more and more ferocious. The trees swayed in all directions. People walked at an angle, and held on to their hats. But it was not so much the wind as the swelling waters that made the heart anxious. A great city,

yet always threatening to vanish! And once it nearly did, by the choice of its elderly queen during the early days of the last war. That it was saved and did not vanish is also part of its incredible history.

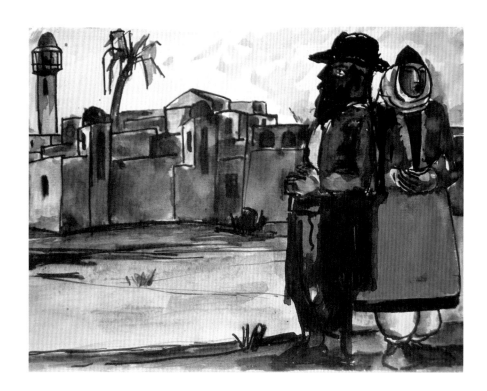

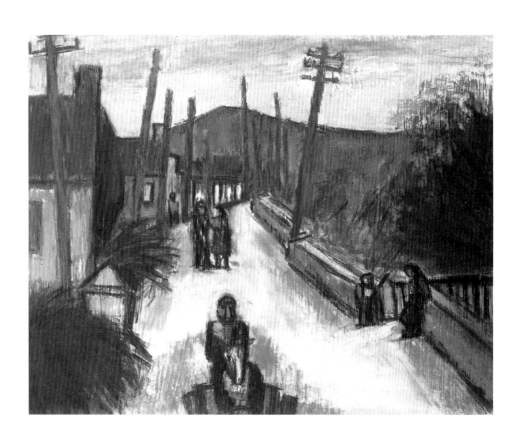

New York

I have never been a pub-crawler, and night-clubs depress me beyond measure. In cities new to me I spend most of my time walking the streets. The streets are for me museums of architecture and engineering.

It is April. It is spring. New York feels as fresh as a longed-for cool drink. This city may have nothing of the charm of the old, as for instance Amsterdam has. New York is not as casual and inviting as Paris, nor is it as solemn as London. Vigour is the prerogative of the young, and New York has vigour, vitality and a grandeur all of its own, unique to the eye and as original, in its way, as Venice. No circles, no crescent lines, only cubes, monumental cubes; only squares, monumental squares; only oblongs, slim and tall... When I crane my neck to take in the height of the tallest building, my head grows dizzy. Central Park is an oasis of green but around it is the vast dominance of grey cement, black and brown marble, and the lustre of glass.

If you feel unfriendly you will call New York an idealised pile of concrete but even so your sense of fairness will force you to put the accent on the 'idealised', for this city has form, a monolithic form of strange effigies not unlike the stones of Stonehenge. Today, all those tall effigies are in a mysterious pool of light – from that light I guessed that the sky was azure. It is an April day. It is a day of spring. The light falls down like a cascading water-fall and is everywhere on the walls and on things and on men; in its aura the streets look like a golden pool and I feel myself floating as when I first learnt to swim. At twilight the city's glare is strongest and you absorb it with tenderness. In this atmosphere it is easier to grasp the spirit of the city. Walt Whitman[46] established a giant rhythm which this city tries to catch up with. Like Whitman's rhythm it has a purposeful nostalgia and a challenging optimism fastened to a dream. It is the nostalgia more than the optimism that saves the dream from monotony. New York may not have a single piece of 'democratic architecture' – as Lloyd Wright[47] put it – but New York's amazing totality amounts to nothing less than the offspring of a democratic dream.

New York's dialogue with space has no imaginable ending; like Whitman's epic it seems unfinished; what was yesterday the tallest building becomes on the morrow the second tallest or the third. Today everybody's eyes are on two towers already taller than the Empire State Building, two of the tallest oblongs in the world. True, you may search the whole city for a fascinating detail or a masterly fragment the eye might select and praise: it is always the totality, the brimming sea of the city as a whole, as one single mass; and from no other place is the city

so beautiful as when seen from the waters of the East river. Free of decoration and ornamentation, the basic architectural blocks fit well with one another; the city shows that through generations it has grown from one state of mind and owes its consistency to that state of mind as to a master blue-print. A state of mind singularly free of aristocratic priorities and dark liturgies: nowhere have I seen so many bad imitations of the Classic and of the Gothic!

Yet the democratic dream is not without the wildlife of class strife. Most of the effigies bear the stamp of the god Mammon with its own hierarchy of priests and privileges. 'Getting on' began to mean giving in and this has been written about by many – by Americans and non-Americans. In the streets everyone is in a race against time. No one walks in a leisurely way. Like frightened rats, masses of humans run in different directions. If a stranger loses his way and asks a passer-by for directions, the passer-by cannot afford to stop; walking on he will turn his head and shout out: 'You're a long way from... take the sub... Get out at... Then ask again...' You will hear but not understand; such is the speed with which the words are thrown at you. You will feel as lost as on a turbulent sea. Men, women, cars, buses, all are so many items carried on fast-moving waves.

This is no place for intimate whispers. Those who love silence must get off the streets. 'This is a tough city, brother,' a worker in a café told me. 'Nowhere can you be as lonely as in New York,' a poet told me. 'New York is a city of rough and tumble,' a businessman told me, and I saw for myself what he meant. You can see

jewellers, art dealers and others sitting in their shops behind bullet-proof glass and locked doors even in broad daylight, and in the busiest centres. You ring the bell and a pair of eyes looks you over and decides whether the door should be opened for you or not. One dealer in pre-Columbian pottery and clay figures told me that only a short time ago a band armed with sticks came into the shop, swept all the shelves of their contents – and what did not break from the fall they crushed with their boots. It was not a hold-up. They did not ask for money. It was done for the joy of destroying. The damage done, they laughed and left. Now this businessman, too, sits behind bullet-proof glass and locked doors. Are these problems inherent in Whitman's giant rhythm, or just a difficult phase in a democracy which has yet to learn how to become a meaningful social democracy? With whomever I talked I got the feeling that social life here was cracking at the seams and the causes lay deeper than Vietnam and Watergate – and perhaps were something else altogether.

I had been warned not to go to Harlem alone. I ignored the warning. I told the taxi-driver to put me down anywhere in Harlem. He turned round to look at me (he, too, sits behind bullet-proof glass). He had a kind, elderly face. First he asked me where I was from, then he said 'Sure, I'll take you to Harlem, but you should know that Harlem's not what it was. It's a battle front. Understand? Still want to go? O.K. I'll take you there.'

It was a warm morning, bright and bewildering with spring's uncunning

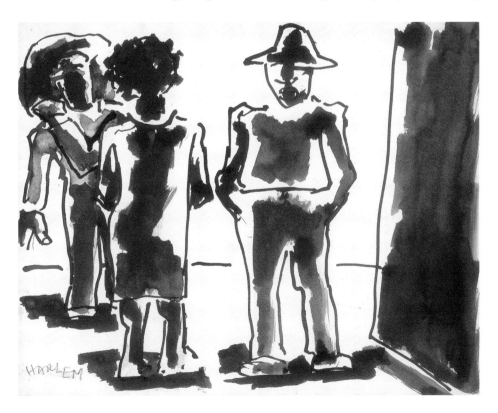

hopefulness, but my buoyant mood left me as soon as I began to look around. I am something of a specialist on slums, having lived in many. The slums of Harlem are a world apart. Few white faces were to be seen, and the black ones seemed strangely taut. No one paid particular attention to me. When I opened my sketch-book some did look at me, more perhaps out of curiosity than anything else. Children gathered around me, standing on their toes to try to see what I was drawing. Nothing worse happened to me on that first visit. I noticed slogans on some dirty walls and they told their own story: 'The nigger is a slave' – 'Black is beautiful' – 'Call yourself BLACK' – 'There is no good white folk' – 'Hit the Jew where it hurts him most' – 'Fire and force is what the whites understand. You can talk this lingo too!' Besides these aggressive slogans there were also two of human pathos: 'Save Angela Davis' and 'Jackson was your brother not some nigger bastard'.

My second visit to Harlem gave me an indication of what might have happened to me, and almost did. I was standing on a street corner and attempting to draw the people standing around and passing by. Then a few young fellows, five in all, two dressed in leather jackets and cossack boots, walked towards me. They halted a couple of paces from me. One stepped forward and asked what I was doing, I answered: 'Drawing.' 'Hand over that book,' he yelled. 'No,' I said. 'It would be of no interest to you.' Now another one of the group shouted: 'Why don't you white pricks stay were you belong and draw your fucking mother's cunt... Don't come here. We don't want you. Understand?' It was at this moment that their yells drew the attention of others and some men and women came over; soon quite a crowd had gathered, all asking questions, all shouting. And in this commotion I managed to slip away, not unnoticed but not attacked.

Every afternoon I spent in the museums.

No other museum in New York is housed in as splendid a building as the Guggenheim. It sits well in the corner assigned to it in Fifth Avenue (to be a section of a terrace it would have to be of a different design); but in this corner it has all the prestige of a public building and within these terms it has originality and exemplary perfection. In its style it is on the same lines as that other work of Lloyd Wright's, the Kalita Humphreys Theatre in Dallas, Texas. Inside, it has the spiral space of the dome of a snail. The top light is directed only on the floor, thus the sides are in gentle shadow. This evokes a lyrical mood and in terms of pure feeling invites the visitor to participate in the mystery called a building. Such is the setting for the pictures or sculptures on show.

That day Rodin's drawings and watercolours were on exhibition. I must add that they looked grander here and were seen to greater advantage than in any of the old-fashioned buildings where I had seen them displayed before. What is more, the spirituality underlying their physical liveliness gave them a greater permanence in that setting than, for instance, the 'permanent' mural by Miró! The notion that abstract art alone is right for modern architecture is not borne out by fact. The few abstract pictures hanging here and there, part of the Guggenheim

permanent collection, deadened Lloyd Wright's design either because they were dead in themselves, or because they appeared so against Wright's spiritual vitality.

At the Metropolitan Museum I used to shake at the knees whenever I entered any of those pompous 'shrines' of the old masters. Today I no longer do so. After all, with age and experience, one learns to give to the great picture its due and not to be taken in by the great name; no artist of any time was immune to failure. This is in a strange way heartening.

The rooms with the nineteenth-century paintings make for a gratifying experience. After the Titians, Grecos and Rembrandts these works, too, hang as though by natural right, and who is to say that the Cézannes, Van Goghs, Degas, Monets, etc. have not earned this right? I am not that certain that the upstairs rooms with the Pollocks, Gotliebs, de Koonings, etc., have a similar convincing right, though I can think of quite a few works of our century that would fare better. Has national conceit blurred the judgement of the anthologists a little perhaps?

At the Frick Museum I made the following notes: 'The little "Pietà" of the School of Provence, a truly great small work! Andrea del Castagno's picture, another great small painting! But the greatest of the paintings I have so far seen is Rembrandt's large self-portrait in an apron, resting for a while in between the hours of work. For once the drama is not in the conventions of dark and light but in the magical use made of the pigments themselves! The hands are as alive as the eyes and the apron as alive as the face! Never have ochres so gleamed, strong as gold! In the darkest recesses can still be found gradations of subtle tones! There is no end to the depth paint can go when activated by the human spirit. Rembrandt is the most spiritual of all painters, and this self-portrait is the most spiritual of all his works.'

Outside it was raining and cold, but my mind was aglow with the memory of that painting and no amount of water and wind could extinguish it. I walked all the way to the friends with whom I was staying, and only when I arrived at their home did I realise how soaked I was!

Museums today are crowded with people from all over the world, conducted by 'explainers' of various ages, though more often than not they are brash young men to whom, believe it or not, the mysteries of any given picture have been revealed! Nothing as simple as feeling, being puzzled or transfixed or grasping another dimension of inner life; not if the 'explainer' can help it. *They* tell you what to feel, when to feel, where the puzzle begins and ends, and that all is in the form, and that every bit of colour is put to this or that end. They know it all! An intelligent thinker has suggested that museums today are what temples were in more religious times. Some temples! With so many 'explainers,' ready to explain everything! Children are better off; they are permitted to scurry about like mice. Not, of course, if they have arrived in a bus-load with their teachers; then they, too, are nailed to one spot and have to listen to explanations.

Even so, the times are not so good for the flesh-and-blood guide now that he has a competitor in the shape of a little gadget you can hire at the entrance – a

transistor, with tapes, that tell you everything. So a new breed of men and women stroll about the museums like sleep-walkers, with transistors in their hands and wires plugged into their ears; with so much listening there is hardly any time left to look! At best the sleep-walker may give the pictures a brief glance, before walking on, listening! He must not lose a word! In this pre-cooked way 'art' now reaches hundreds of thousands.

In the prestige papers there are columns every Sunday under the heading: Arts and Entertainment. Our society sees a place for the artist only when he is degraded to the level of an entertainer. His product must go with an after-dinner cigar and an armchair. And should his product prove too complex, there is a small army of critics to tell you how simple in fact it all is – if, that is, you can understand the critics!

So it happens that New York today is a centre of word-guided art. Oh, give me the straightforwardness of a tribal society! This, I dare say, must also have been the feeling of the American painter Marsden Hartley when he made up his mind to live among the fishermen of Nova Scotia, and how this sojourn revived him! What pictures of marvellous simplicity he eventually painted! But about him, and Ryder, another American who impressed me greatly, I write elsewhere in this book.

One evening I walked the streets, enchanted with New York after dark. High, very high up in a pool of darkness, electric lights no bigger than grapes mingled with the stars of the universe and one could hardly tell the ones from the others. Lower, and in a wider cavity, was a denser concentration of lights; some flickered crazily, others stood out brilliantly. In this cavity, too, were the inevitable advertisements in bright squares and circles and triangles of neon stripes in various colours; red, yellow and green, every colour, all equally hideous, because neons by their very nature give off hideous colours. But this blemish apart, there was so much beauty in the suspended lights, and such staggering intensity, that the effect went straight to the heart. The beauty lay in the sum of it all. In no other city in the world have I seen such a mass of glitter. The whole space was studded with the sparkle and radiance of precious stones. This was a feast for my senses! I could ask for nothing more and for nothing grander.

Artists

Constant Permeke

He was a strong, stocky man with a large double chin. His belly was too heavy for his legs and he swayed when walking. In the Flemish fields this kind of a figure trotting alongside a cow or a heavy horse was a common sight; in a port he was indistinguishable from the fishermen and elderly sailors.

The congenial nature usually associated with this type of build was true of him too. He laughed with the whole of his body. His handshake was hearty and firm and he would only shrug his shoulders when disagreeing with you. These were broad shoulders and could take a lot of disagreement.

As sometimes happens, though I would not stake much on it, his very physique seemed to assert itself in his work, but the opposite is also true: Permeke's body became bigger once you got to know his pictures.

It is easy to underestimate the intellectual powers of a man who did not strike one as having a restless, questing mentality, who did not express himself in a clever, bookish way or obscure his words with fashionable jargon, who did not assume the ponderous quasi-clerical gravity which became the hallmark of a large section of intellectuals and artists.

Permeke's mind was a combination of child-like directness and peasant-like shrewdness, and with these qualities he managed to get to the root of the matter somehow quicker than others. The gesticulating arms gave added emphasis to his words.

One day, after seeing the exhibition of a surrealist painter, Permeke, not at all convinced by these pictures of big-eyed nudes with meticulously painted pubic hairs and little men in bowler hats lost among antique columns, summed up his feelings in one phrase: 'Je ne crois pas que tout le monde rêve tant... d'ailleurs... pas d'une façon si compliquée...' Which meant that the theorizing painter could put his self-conscious attitude in a pipe and smoke it! He himself practiced a kind of art wonderfully free from any theory.

Not that he was uninterested in what was going on around him. At one stage in his beginnings he tried his hand at the methods of the Fauves; his 'Maison dans le Devonshire' (1917) is of particular interest from this point of view. At another stage he adopted some linear inventions of the cubists. But in the main his interests were of a different kind.

Rich in instinct for what is true and for what is real in life he searched and found more personal means which were to meet both the nature of his subject as well as the nature of his imagination.

Only diehards confine their gifts to 'pure painting'. The greater natures in modern art did not mind overlapping into matters usually associated with the fields of architecture, sculpture or literature.

Like many a romantic temperament, Permeke liked telling a story. His masterpiece 'L'Etranger', painted as early as 1916, is a great epic story. His picture 'Les Fiancés', painted in 1923, is a story which, because of its monumentality may not seem so at first, but it is enough to look closer at the woman's blouse and see the care which Permeke took to render the texture of cheap cotton, or at the different characters in the two faces, which Permeke painted in two different ways, or at the way he synthesised the typical elegance of a working-class young woman strolling with her fiancé. The picture 'Le Mangeur de Patates', painted in 1935, is a story. Permeke's landscapes, his farmyards with all the paraphernalia and the animals, his seascapes and dock scenes, are all stories – great stories, rich in formal and colouristic inventions.[48] Stories in the best Flemish tradition, but painted in a way that only a painter of our times could have painted. As with other figurative painters the subject was with him an emotional and imaginative necessity and in accord with his formal interests.

He knew, as a painter after Van Gogh and Munch would know, that the eye leaves much out and that the only truth an artist can authoritatively substantiate is that which has involved him through his emotions.

We can be sure that the landscape of Flanders looked exactly as Permeke presented it, but we may also be sure that the emotional intensity, the grandeur of design, the synthesis of form and the quality of paint, rich in physical and spiritual suggestions, have purely human sources, which, with a painter like Permeke, are not different from his painterly sources. Like Rembrandt and Turner – who both have a definite bearing on Permeke's art – it is impossible to tell whether he could have been so committed to life if he had not been so committed to painting.

The very act of painting is already well on the way to expression, but only one's natural genius for thinking with the material can raise technique from mere method to an integral whole with the thought, the feeling, the how and the why of a work. Hence the significance of good painting, hence the significance of the masterpiece. This is old stuff and would not have been worth mentioning if not for the fact that even at the time when Permeke painted his 'L'Etranger', much of modern art became recognisably modern because of its amateurish look.

In this mastery of Permeke's, perhaps even more than in his originality, lies his significance. At times, I think, he was fully aware of this. He once said (admittedly, he was hard pressed to it by flattering friends): 'Qui, je sais... un peu... peindre' and as though he had overpraised himself, he flushed red to the roots of his hair. Yet his voice was as nervous and humble as Degas' must have been when he said: 'I like to draw.'

Sironi's Black Pictures

Let me make clear at the very beginning that I find many things connected with Sironi's name repulsive.[49] Not unlike his Futurist friends, he identified himself with Italian Fascism; he found it akin to his own vision of life and for this he was ready to accept its cruelty, its inhumanity and its intolerance. Of all the major artists in Italy he alone served Fascism well. Sironi was not simply an all-eye-and-no-tongue artist. He was articulate – brilliantly so – and in a number of articles he attempted to formulate a consistent theory of Fascist Art, embracing architecture, sculpture, painting, town-planning, mosaics, murals, stained glass and so on. It was to be what he called a 'public art' with, strong echoes of the Roman – he himself did not hesitate to use in his iconography the Roman eagle and the fasces. He tried his hand at many media and had no difficulty in visualising cities integrated through the employment of the arts.

Too much has been made of Sironi's 'all-round gifts'. He was not as versatile as he liked to think himself. His murals are just so many fragments pieced together, often using commonplaces like muscle-bound men in warrior-like poses. Designs he thought grand were in effect merely colossal. Nor can one admire his stained-glass designs; these were most of the time unbearably conventional. His 'monumental sculpture' was surprisingly melodramatic and styleless, considering that his finest drawings are sculptural in the best sense of the word. Though competent, his political cartoons for the Fascist press are hamfisted and unimaginative and show no sense of humour or of satire; to put him in the same category as Daumier, as some Italian writers do, is irresponsible. Admittedly, he was head and shoulders above other artists who equated their personal ambitions with the Fascist salute, but, I repeat, he was not an all-round genius. And if there did not exist a considerable body of works whose quality, originality and humanity rank amongst the greatest in modern art, he would be negligible. But there it is, this same man has produced some of the most moving pictures of our time.

However, before I go on to these, there is something else which needs to be said in favour of his genius. He was more successful in the variety of styles he used than in the variety of media he employed. He experimented a great deal and his early contribution to Futurism and to Metaphysical painting are quite considerable; in each case he was extremely prolific and very inventive. And the virtuosity of his Multiple Scenes (and they constitute a great part of his output) still more underline his talent for variety. None the less, even they are only a borderline achievement.

Much as I admire immediate creation and spontaneous emotion, I think we have rather overdone these ungovernable indications of strong feelings; by now it has become an academic procedure. Now the tendency is to look with suspicion at a 'finished surface'; we seem to wonder whether a more 'finished picture' does not belong to what Cézanne called 'le fini des imbéciles'. Many of Sironi's pictures have a 'finished' look and this has often been held against him. Also, many of his oil paintings have an old-master look and this, too, has been counted against him. This is rather foolish. Sironi was a first-rate painter and particularly so in oil painting; for he knew well that a picture need only carry an expression of an experience; the marks of 'spontaneity' or 'finish' mean very little. Unlike many of his contemporaries who did not care about truth to their material, Sironi did care, passionately. His instinct for oil paint, for instance, told him that it is by its nature fat, and should not therefore be used for opaque effects as though it were gouache or distemper. This also goes for his use of varnish. He was not a picture-maker, and he expressed himself in a truly painterly way, that is to say that his feeling for the material was at one with his desire to express the deepest emotions of an experience. And he was never so successful as with the Black paintings of Milan's proletarian suburbs and other cityscapes and railway stations, and figures either in groups or isolated. Here his style is at its most personal and profound, and his intelligence at its sharpest. The mood, though strongly personal, belongs also to a recognisable social milieu, and the poetry has a hallucinatory power.

Besides being so highly imaginative he was also a consummate observer; the long wall around a factory, the shape of a lorry or of a lone figure on a bicycle, the texture of a tall chimney or the design of a road are all remarkable records which make the strongest impact on our emotions. And the light, or metallic glare – usually a bleached sort of green – contributes to the intensity of the human as well as the plastic drama of all present elements. Such pictures could not have been painted without a great deal of identification with the subject. In the nakedness of his soul Sironi's humanity is enviable. That he saw fit to put a uniform on it is truly a matter for deep regret. Because many of these pictures originated very early in his career, it is tempting to think of them as a phase, or, as it is fashionable to say, a 'period' in Sironi's working life.

In fact he was still working on the same theme in the 'forties and the late 'fifties; they form, so to speak, the theme of his life. And with this theme he proved himself to be an artist of the same calibre and the same significance as Rouault and Permeke. Some writers have even felt bound to put up a defence against any possible influence by Permeke and Rouault on Sironi. I see no need for this. It is a well-known fact that in any given epoch, there are many people who feel and work alike; they do not have to meet or even know each other; it is a kind of family likeness brought about by the times, which cause similar temperaments to appear simultaneously. The originality of each of these artists is unmistakable. Their personal styles are their own. Their kinship is of a spiritual kind. Ours is a time of a *popular humanism* and Sironi's contribution to its formulation is great, very great indeed.

Mexico's Revolutionary Art

In Mexico conversation is bound to turn to the few brief but significant words: The Revolution, The Great Renaissance and The Big Three. The Revolution refers to the 1910 National Revolution which disposed of the Diaz dictatorship; The Great Renaissance are the years 1920-25, the revival of mural painting; and The Big Three are not generals or political leaders, but three painters: Orozco, Rivera and Siqueiros, in that order (when Rivera was alive he came first but now it is different).[50]

The way the conversation is steered one gets an unmistakable feeling that all this is past history. Painters of today show little nostalgia for either The Great Renaissance or The Big Three. Most of them work in the 'international style', quite happy to paint like everybody else, anywhere else in our present world. As they are neither worse nor better than other adherents of the 'international style', and are not particularly distinguished, the great event in twentieth-century Mexican art remains The Great Renaissance and especially the works of The Big Three. No one has yet superseded their achievement.

How mural painting became the dominant expression of modern Mexico is not as complicated as some writers make it out to be, but some of the more obvious legends must be disposed of. The story that the Obregon Government was the first post-revolutionary government with most 'socialist' plans which included mural painting, is no more true than that it was all due to the Minister of Education, José Vascenelos, who it is said suggested a didactic mural as part of a mass education programme. It is true that without the sympathy of this Minister (who was also responsible for the Fine Arts) and without Government commissions The Great Renaissance could not have come about; but it is equally true that without pressure from influential intellectuals and less influential artists the Government would not have cared less.

Spurred by the spirit of nationalism and tired of the French rules of academism which had dominated teaching since Napoleon III put Maximilian on the throne of Mexico, artists revived a nostalgia for native art, including ancient Indian wall-painting. But discussions were still vague. Rivera was then in Paris and although echoes of these ideas may have reached him, he arrived quite independently at the notion of reviving wall-painting. Art born of art no longer inspired him. Cubism seemed unsatisfactory and he came to dislike the role of the artist as a social outcast. He looked for a more positive situation.

In 1919 Siqueiros came to Paris. The two artists met and discussed the future

of art and the future of Mexico. Long before the arrival of Siqueiros the great influence in Rivera's life was the poet Elie Fauré. Fauré told him on more than one occasion: 'Art is the appeal of the instinct of the communion of man... We recognise one another by the echoes it awakens in us... They have told you that the artist is sufficient unto himself. This is not true...'

That sounded familiar. Rivera had come to a similar, collectivist conclusion about the nature of art: 'To be one with one's people', he wrote at the time in a letter to a friend.

Then came his trip to Italy. After looking at all those walls, those images from Giotto to Michelangelo, he gained a greater confidence about his dream of what he now called 'socialist art', images not for private collectors but ones which everyone could see and enjoy on public walls. This dream became an obsession. Memories of his native land came into sharper focus, the Indian tradition of wall-painting, the monumental forms which usually go with such paintings. He also thought of ancient carvings displayed in the open and recalled the dynamism of native folk-art, the popular art of Posada who could tell a story in pictures as well as any ballad writer in words, and yet remain a true artist! Thus seen through the prism of nostalgia and hope everything Mexican seemed to him grand whilst the whole hothouse life in Montparnasse seemed insignificant.

Siqueiros was a different sort of animal; less poetic and more political. At the age of thirteen he already knew the inside of a prison (for 'political violence'); at the age of fifteen he commanded a famous youth corps known as 'Battalion Mama'; at the age of eighteen he organised the Congress of Artists Soldiers; and so on. He later headed a group of Stalin's henchmen in Mexico to kill Trotsky but nothing came of this plan. (In the later assassination of Trotsky he played no part.) He was as passionate an artist as he was an organiser, and no less gifted. He did not need triumphant echoes from the past to convince him of the proper place of art in society; he declared: 'No more painting for individual pleasure. The artists belong to the people!'

Rivera returned to Mexico in about 1921, not, as some say, at the invitation of the President, but in response to a telegram telling him his father was dying. In Mexico he looked into the possibility of selling a few pictures, at the painters with whom he would like to exhibit, but above all at the chances for putting his theories about wall-painting into practice. He knew that others had already tried to interest the Minister in the idea of murals. Rivera never lacked courage nor eloquence. He told the Minister that he was prepared to work 'for a labourer's wage'. The Minister was not over-enthusiastic; however, he gave Rivera a commission to do a mural at The National Preparatory School in Mexico City. Another painter, Alva de la Canal, was also given a wall. De la Canal chose for his theme an historical episode, 'The Landing of the Spaniards', but Rivera, his head full of impressions of Italy, chose a symbolic theme: 'The Creation'. With these two murals The Great Renaissance was launched.

It is not my object here to consider the merits or failings of the two works. Rivera himself, although he worked for a year on his mural, regarded the result

as a failure. A friend of his says 'he was bitter at heart'; but he was certain that he could and would do better things. In spite of this failure, useful discussions followed and the press made mural-painting a topic of the day. Again his eloquence and undoubted integrity served Rivera well. The Government was won over. Artists now had a common cause and grouped together. They recommended each other for commissions, the less fortunate working as assistants to the luckier ones. A collective spirit dominated the artists. There was more at stake than money; in fact pay was disregarded and was, to quote the Minister of Education, 'miserable'.

In 1922 Siqueiros organised the Syndicate of Technical Workers, Painters and Sculptors, which established some sort of pay agreements and conditions of work. But more than this, the syndicate aimed at clarifying its members' 'artistic and socio-ideological' quest. To this effect a manifesto was published. The opening lines have a different ring from earlier manifestoes published in Europe by the Futurists or Dadaists, though there is some similarity in the aggressive tone:

> 'Social, Political and Aesthetic Declaration from the Syndicate of Technical Workers to indigenous races humiliated through centuries; to the soldiers converted into hangmen by their chiefs; to the workers and peasants who are oppressed by the rich; and to intellectuals who are not servile to the bourgoisie. 'Not only noble labour but even the smallest manifestation of material and spiritual vitality of our race spring from our native midst. Its admirable, exceptional and peculiar ability to create beauty...is the highest and greatest spiritual expression...which constitutes our most valid heritage. It is great because it surges from the people; it is collective and our own aesthetic aim is to socialize artistic expression.
>
> 'We repudiate so-called easel painting and all such art which springs from ultra-intellectual circles for it is essentially aristocratic.
>
> 'We hail monumental expression, because such art is public property.
>
> 'Our supreme objective in art, which is today an expression of individual pleasure, is to create beauty for all...'

This mixture of bombast and half-truths – it would have come as a shock to Courbet, Millet, and Daumier that, being easel painters, theirs was 'essentially an aristocratic art' – but the key words were spelled out clearly – 'heritage,' 'monumental' and 'beauty for all'. The lack of reference to academic realism speaks for itself – it was no longer an issue, and by 'heritage' they meant something more distant and more primitive, and adherence to a more creative and expressive massive form. All this was in sharp contrast to Stalin's call for 'socialist realism'. which had yet to come. So much so that when some years later (in 1928) Rivera visited the Soviet Union, he saw for himself that the Mexican programme had nothing in common with that of the Soviet artists. In his eyes Soviet Russia was still 'a country without art.' He advised his Soviet comrades that to follow academic realism would get them nowhere and that they should follow the native tradition of icon painting and folk art. This of course did not go down well with Soviet bureaucracy and his further stay in Russia was made difficult.

But we are jumping too far ahead; we must recall the immense impact of the

Bolshevik Revolution on idealistic intelligentsia everywhere and remember that in 1923 the prestige of the first Workers' State was high indeed and much was expected from it in every field of human activity. The very wording of Siqueiros' Syndicate's manifesto reveals Russian influence. Artists described themselves with genuine pride as workers when addressing other workers, peasants or soldiers.

By that time many Mexican painters had already painted a number of walls with political subjects and their artistic success assured them that art and politics could go together. Under the Obregon administration artists had complete freedom of expression and choice of subject. No one interfered with the new symbols the artists introduced (the red banner, the hammer and sickle, the five-pointed star, etc.) and no one remarked on the personal styles developed by artists. The Big Three prove themselves highly individual personalities and their styles differed immensely. Each had a personal way of interpreting 'socialized art'. Orozco put great importance on what he obscurely called 'Idea': 'In every painting, as in every work of art there is always an Idea, never a story.' Rivera could not do without a story and 'Idea' to him meant 'theme'. Siqueiros had little patience either with story or 'Idea': 'The artist must follow the expressive nature of the subject before him.' But these were merely justifications of their temperaments. What united them was the 'native tradition', the arts of the Olmecs, Aztecs and the Mayas, the method of simplifying form in their styles.

Whatever one may say against their art, their individual styles are impeccable, witness to their absolute sincerity. This has to be emphasised because it is too often assumed that artists whose subject happens to be political or social are mere propagandists. These *were* political and social artists and not in their themes alone. They truly express political passion in art. We must remember that in the twentieth century the Sermon of the Soap Box *was* the Sermon on The Mount. For the Mexican artist to paint political themes was as natural as for the medieval artist to paint religious ones. We must therefore discard the connotation of politics associated with hand-to-mouth politicians and view it through the minds of visionaries and revolutionaries: a vehicle of moral and ethical attitudes, an underlying philosophy of life. And like everything noble in the human mind, political art too surges forward towards the metaphysically good and just and noble.

Links between Mexican muralists and medieval artist-craftsmen are more than accidental. The very first murals of the Mexicans were with few exceptions religio-symbolic – not only Rivera's 'The Creation' but also Orozco's naked flying figures around the naked 'Virgin with Child'. Even Siqueiros chose for his first mural 'Christ with an Angel', just as early sociologists looked for the justification of 'collective Man' to the medieval monastic system. But sooner than one would have expected, the Mexicans followed a more direct political inspiration. This was not new in European art. The works of Urs Garff and Callot, Goya and David, Courbet, Millet and Daumier, Pissarro, Van Gogh and Meunier all have politico-moral implications; Louis David, more than mere implication, expressed open political involvement, as did some of the works of Delacroix and Gericault.

But all these artists worked within the conventional iconography of their times. Even so, political work such as Delacroix's 'Liberty Guiding the People', when removed from the subject, remains within the Romantic aesthetic. What modern Mexicans were the first to do was to find a *specific iconography for their political dreams*, and this is their unique contribution.

Of course there were didactic elements in their most serious works. As Pedro Rojas points out in his excellent book, *The Art and Architecture of Mexico*, they attempted to 'rouse in the people a positive and strenuous attitude to reality and the significance of their life.' Below the surface, however, were truly artistic quests and higher aesthetic ideals. Rivera was forthright when asked in Moscow whether his art was for the people:

> 'The workman, ever burdened with daily labour, could cultivate his taste only in contact with the worst and vilest part of bourgeois art... This bad taste stamps all the industrial products which his salary demands...
>
> 'Popular art produced by the people for the people has been almost wiped out by an industrial product of the worst quality...
>
> 'Only works of art themselves can raise the standard of taste...'
> [Quoted in B.D. Wolfe's book, *The Fabulous Diego de Rivera*.]

Speaking of the Baker Library frescoes at Dartmouth, U.S.A., Orozco carried this point even further, but it relates to the general direction of the muralists:

> '...the important point regarding the frescoes is not only the quality of the idea that indicates and organises the whole structure, it is also the fact that it is an American idea, developed into American forms, American feeling, and, as a consequence, into American style. ...'

(Rivera and Siqueiros also believed that Mexican painters spoke for the whole continent of America.)

There is no question of compromise for the sake of propaganda. The most significant part of their search was for 'the American Style,' for a form which would enhance the meaning of the iconography and express it completely. They believed that this demanded concentration on specific subjects of an epic nature, such as National Rebirth and Human Labour, Revolt and Idealism, the Brotherhood of Man and, Exemplary Heroism (Emiliano Zapata being the most frequently represented hero), stories of pre-Conquest times and Modern Civilisation, and so on. In this quest they succeeded best when the style was synthetic, as with Orozco's 'The Mother's Farewell', or Siqueiros's 'Burial of a Worker' or Rivera's figures in the Champingo Chapel (rightly considered his greatest work). Rivera also succeeded in the creation of monumental forms in details on his more 'literary' and overcrowded murals, such as a fragment showing Zapata leading his white horse. Their styles become weaker when 'bent' towards the 'story'.

Curiously enough, though the muralists called for an apotheosis of the machine, in the very representation of the machine they were less successful. In Rivera's and Siqueiros's work the machine is idealised out of existence; it is clean

and shining like the inner works of a clock. Only Orozco treated the machine as monumental and often as having a fearsome nature, as though symbolising the dramatic path of human existence. Orozco was the least prone to idealisation. Cruelty is not a one-way traffic, nor is fury, nor is force. Thus his revolutionary battles are real butcheries, no matter who does the killing, and with him nature is an active participant, part of the human as well as of the cosmic tragedy. Where Rivera succeeds above all the others is in the accumulative quality of the totality of his oeuvre. It has something colossal about it! His biographer, B.D. Wolfe, calculates that one group of Rivera's murals in one building, placed alongside each other, would measure three miles! With such an output the level is bound to be uneven, the masterpieces few and far between.

The Big Three were the pinnacle of a wider base of talented artists, often with their own independence of expression. In his lecture given in England in the 'forties (later published in book form by Zwemmer under the title *Modern Mexican Art*), Manuel Maples Arce gives quite an impressive list of names. But although they added new subjects and a few individual moods, their explorations never go beyond the basic findings of The Big Three. This is not only true of men like Reveultas, Charbo, and Leal, but also for artists of greater individuality like Rufino Tamayo. In his murals there is pleasant colour, but he hardly manages to fuse incident with emotion, at any rate not with the depth of Orozco nor on the scale of Rivera. Though his reputation is high – and in Mexico he is often considered the fourth most important name – his murals would have made greater aesthetic sense if done on a page rather than on a huge wall. Later he became a painter of soulful abstractions, seductive in colour and inventive in form. Small wonder that the present-day generation of young painters clings to him.

In spite of the Syndicate's, manifesto, easel painting was far from abandoned. Even Siqueiros, the most dogmatic of all, continued to produce admirable easel pictures. What is more, Francisco Goitia's easel picture 'Tata Jesuchristo' is possibly a greater synthesis of Mexican feeling than many of the murals can claim to be. It represents two women, one covering her face with her hands, the other disfigured by weeping. A candle at their feet lights the scene, leaving much of the picture in darkness. The two tiny hands of the weeping woman on the right would be sufficient to make the picture a masterpiece of expressionistic art! This is how Goitia himself describes what he was aiming at and how he went about it:

> 'I tried my models sitting this way and that, but no, I didn't feel it exactly right. At last I investigated everything I could about them. I then made them come and sit for me on the Day of the Dead, when of their own accord they would be dwelling in sorrow, and little by little I uncovered their sorrow and the revolution and their dead. And they writhed, and one turned her foot up in pain, I would never have thought of it myself, but of course that is the way grief is, and so I was satisfied at last. They weep the tears of our race, pain and tears our own and different from others. All the sorrow of Mexico is there.

The picture was painted in 1928. In 1929 Siqueiros painted one of his greater easel works, 'The Proletarian Mother', and about the same time Orozco painted

his no less important easel picture 'Zapata'. As for Rivera, though he was the first to be commissioned to paint a wall, and had more commissions than anybody else, he never gave up easel painting either. One thing is certain, however, the same public spirit, the same monumental approach to form, permeated both easel painting and murals, underlining the total coherence of the Mexican approach.

With a new political upheaval and the fall of the Obregon Government, commissions for murals came to a temporary halt. The murals were never popular with the right wing of the bourgoisie who were now in the saddle. Neither did the new Minister of Education have any patience with the muralists, their ideas or their work. If it had not been for the popularity the murals gained outside Mexico – 'Mexico was always very sensitive to foreign praise,' wrote Rivera – and the fact that they boosted the tourist trade, their fate might have been sad. They would probably have been whitewashed, as the new Minister of Education boasted they would be. Others, with a greater sense of history, managed not only to preserve the existing murals but also to secure commissions for more. Rivera, thanks to his great popularity in the United States, was once again the first to be commissioned. In time Siqueiros and Orozco and others were also employed, but whereas before there had been a flood of work, now it was a mere trickle. Jean Charlot, himself one of the pioneers of the mural movement, cites 1925 as the critical year. The crisis may have come earlier. At any rate the Syndicate as dissolved before 1925 and its journal, *El Mechet*, was bought up by the Communist Party of Mexico. Important works continued to appear in the late 'twenties, 'thirties and still do occasionally, even today. Siqueiros, who is the last survivor of the Big Three, is at present working on a mural he began in the early 'sixties before he was arrested for 'incitement to rebellion'. But it is no longer the same. The heroic mood, the heartbeat characteristic of all pioneering periods, has gone, but an important page in the story of twentieth-century art remains.

Marsden Hartley

I can no longer remember the circumstances or the year in which I first saw a painting by Marsden Hartley.[51] But I remember the effect it had on me – it made the pump of my heart work at double or treble its normal speed. I was in ecstasies. It was not an over-large canvas, but the image on it was on a grand scale of the imagination. It was the picture which is now in the New York Museum of Modern Art, called 'Evening Storm'.

A few years ago there was a small retrospective exhibition of Hartley's work in the rooms of the American Embassy in London. I went to it several times, each time with the same feeling of elation, as though I were going to celebrate with a friend. Each time I was saddened by the complete absence of other people. But in a way I was glad. I had Hartley to myself. And his pictures acted on me with an incredible strength, and enriched my spirit.

Of all American painters I prefer Ryder of the nineteenth century and Hartley and Hopper of the twentieth. They may or may not be the best American painters, but they have a singular integrity, a primitive strength and a supreme freedom of spirit. Of the three, Hartley was the most restless, wasting years on 'experimentation' and 'theoretical' styles, but he did finally reach the port of artistic arrival where individual imagination and passions are the most significant. His nature has a strong bent towards severe self-examination. In their quest for expression such painters usually use their gifts for writing as well, and Hartley was a prodigious writer. Though not of the same kind, he was of the same class as Rouault. Hartley's enthusiasm for Rouault is understandable both in the light of their artistic kinship – both men were devoted to the craft of painting – and because of their similar temperaments. He paid homage to Rouault with true veneration: 'I would do myself a wrong in leaving out of the list of artists [he preferred] one of the grandest names of all in the modern art world, perhaps the last of the great school of modern painting, Georges Rouault, with his faultless technical knowledge, and his deep powerful humanism – a great spirit, great artist, great performer.'

Hartley himself was no mean humanist, and this perhaps accounts for much of my admiration for his work. His late painting, 'Fishermen's Last Supper', is one of the masterpieces of modern humanism. Modern humanism? Let me explain myself. People today still tend to write about humanism, meaning the classical humanism of the Greeks, but there exists also an intermediate humanism – the code of the Renaissance artists. There is also a modern humanism,

which differs in its very essence from the other two. Greek humanism aspired to bring man nearer the abstract ideal; Renaissance humanism endeavoured to bring man within the laws of nature; but modern humanism, under the impact of socialism, aims to bring man nearer to Man. 'Fishermen's Last Supper' is a masterpiece of this kind of humanism, like the total *oeuvre* of Rouault, Permeke, Orozco and Gromaire, and like Sironi's 'black pictures' of the proletarian suburbs of Milan.

It was the years which Hartley spent in Nova Scotia amidst the fishermen that shaped his definitive style. And this is a combination of the popular, the decorative and the epic form of monumental grandeur and child-like directness, mixed with a consummate simplicity rarely found among the many categories of sophistication. Hartley's own kind of sophistication was responsible for his comparatively late arrival at the final clarification of his quest. Even more, perhaps, than his form, his colours went through a great transformation from incoherent variety to an almost ascetic sparseness. His predominant colours became cool greys and cool blues, burnt umber, ochre and red, usually in a localised position. In spite of his reliance on the reality around him, Hartley's pictorial ensemble is that of a visionary with the brilliance of ice rather than the customary radiance of fire. In addition to these colours, he used powerful blacks for drawing the outlines and features of both men and objects. The phrase 'features of objects' in this context is not as far-fetched as it may at first appear: after all, Hartley often used the words 'portraits of objects' rather than the traditional 'still-life'. If you can imagine that for Hartley the black line fulfilled the functions of both line and colour, you will come as near as words can indicate to the originality of his images.

Hartley's artistic pilgrimage, for this is what it was, began with a Blakeian insistence on the supremacy of the imagination; then he changed course and began to believe in what he called the 'authoritativeness of theoretical painting', only to return finally to an art of the imagination. In 1928 he wrote; 'I believe in the theoretical aspects of painting', but perhaps the first line of this paragraph shows the still greater force of his dogmatism: 'I have greater faith that intellectual clarity is better and more entertaining than imaginative wisdom or emotional richness.' But in 1941, settled among fishermen, he wrote: 'Theoretical painting has little or no meaning for me, because it takes place above the eyebrows.' This we may take as his final belief – if, indeed, other proof is necessary besides the evidence of his last paintings.

André Derain

In the Diploma Rooms of the Royal Academy, some years ago, there was a retrospective exhibition of André Derain's work.[52] Reviewers shouted themselves hoarse with praise for Derain's 'Fauve' pictures but had nothing good to say about his later work. Admittedly, his 'Fauve' paintings have all the qualities which juvenile pictures usually possess: they are fresh, they have spontaneity, they have vitality; they are not as good as Matisse's work, but they far surpass the works of Vlaminck and Dufy of the same period. I see no reason to quarrel over them. But that Derain did not stop there speaks for itself: true mastery and a full individual style on the whole take longer to attain, except for the rare few who achieve both at their very beginning. With Derain it did take longer but he got there and he achieved a level of painting difficult to match amongst his contemporaries. He was insulted, he was mocked, he was called a 'mere academician'. Even Picasso in one of his bitchier moments called him 'a museum guide'. Café intellectuals laughed, but Derain went on as unperturbed as though he were deaf, as unmoved to answer back as though he were dumb.

He painted in the most unfashionable styles, all highly personal, and with techniques few would dare to use for fear of losing their up-to-date image. Derain became a masterly painter, not 'old masterly' and not 'new masterly', but masterly in the timeless sense of the word. He became an easel painter *par excellence*. At times his style was decorative, as though he were in a mood for painting freely on a wall, but more often he was after intimacy, and his small canvases are diminutive not only in their physical scale but also in the quality of his experience; his small pictures are true to the lyricism of their very size. They are endearing and have to be seen at close quarters so that not a single nuance of their endearing painterliness and their pictorial culture may be missed. Because this is a dimension missing from the best of modern painting it also adds to the significance of Derain today. An eloquent American writer has said, 'If abstract is indeed impoverishing, then such impoverishment has now become necessary to important art', to which Derain in all probability would have answered 'Over my dead body!'

I do not wish to imply that Derain's is the only way to achieve quality in painting, but to emphasise that quality is important, if only because the striving for it brings an artist half way towards the expression of his experience. The search for quality served Derain well; to turn our eyes from it is to support artistic obscurantism, and to make a merit of sheer incompetence. In many ways Derain is a painter's painter.

Judging Derain's achievement in this light has brought him into line with the painters, modern and ancient, that I admire most.

On the whole I am shy and do not particularly enjoy meeting artists, even those I like. But it so happened that sometime in 1953 I travelled with a friend to Italy, via France. This friend had to see Derain in order to get from him some

form of identification for a few Derain's he had in his collection, and not know-ing French he wanted me to act as interpreter. I was far from overjoyed at the prospect, but agreed to his proposal, and so we set off for Chambourcy where Derain lived. It is a small village, and we were surprised at the difficulty we had in finding Derain's house. No one we stopped seemed to know him or to have heard of him. We were even directed to the patron of a small paint factory in the vicinity. We finally got the address from the postman.

Derain's chateau was not an extravagant edifice. It was a very modest build-ing – perhaps looking more so because the morning was very grey and dark, and nothing in the whole village looked particularly interesting. Small and painted white, the chateau was set in an open field of patchy grass. The architecture was plain, even severe, and not of any particular style. Nearer the house we could see how small the estate really was. The door was opened by one of that particular breed of old French women who are eternally in their slippers with a black wool-ly over their shoulders. I explained our business and she took us into a smallish, circular room with little light. I cannot recall anything arresting on the walls but I do remember shelves with Greek pots and Etruscan figurines in one corner. Many of them were lovely pieces.

Then Derain made his entrance, or rather he just suddenly appeared, for I heard no footsteps. He was tall and well-built, wearing a workaday grey suit with a few spots of oil paint on the trousers and on his fingers. His shirt was open at the neck and on his head he wore a cap cheekily slanted towards the left ear. I was reminded of the strong porters one used to see by the dozen at Les Halles. All that was missing was a carcass of beef on his shoulders! His smile was encouraging and his eyes good-natured. He took us to another room, large and furnished with many canvases, all leaning with their painted surfaces to the wall. My friend finished his business rather quickly, Derain obliged him with all the documentation he wanted for his pictures, and recalled with a childish delight the circumstances in which he had painted them. Although our business was concluded, we stayed on and chatted.

I knew that these were lonely times for Derain. Because of their collaboration with the Germans, he, Vlaminck and Segonzac had been suspended from exhi-bitions. Some French writers, painters and other intellectuals had demanded even more severe punishment. This was not a time for compassion. I was not at all surprised to hear from Derain's lips that he never went to Paris. But Paris in one way or another did not forget him. Rumours suggested that should any of the three painters show their faces in the capital they would be 'properly' dealt with. At the same time, Derain's name was talked of in a different way. Some writers, inspired by de Gaulle's nationalistic purism, wrote long articles extolling the Ecole Française and separating it from the Ecole de Paris which, though it had talented artists in its midst, was nevertheless alien to the French. The Ecole Française, they said, descended in one straight line from Fouquet, through Ingres and Delacroix to Matisse and Derain. I told Derain that I had read this only the night before and he smiled and then began to laugh: 'I detest politics, in

particular the politics of the artistic cliques! All my life I have loved the arts of all countries, and Dutch art is at present my guiding force. Of course, I loved French painting, too – ah, the works of the uncle Corot! Does this mean that I have to love *any* painter because he is French? What nonsense! I love the Dutch! Even now, in my old age, I am still learning from the Dutch! And let all those chauvinists write what they want...' He shrugged his big shoulders. Here was a man of strong common sense and a naïvety of which it was only too possible to take advantage. He did not give me the impression of being a schemer or an opportunist.

We followed him to another room on the first floor, with a surprisingly low ceiling and little light for a work-room. Yet there was an easel and a low working-table on which was pinned a small canvas. The paint was fresh; it was a still life of three apples and a knife, all dark green, but radiating a greater luminosity than the white light from the window. He continued his reminiscences, talking slowly and nostalgically, a few words of love for the great Courbet, a few passionate words for Brouwer. He showed us portraits and nudes and landscapes but when we left what remained in my mind was a vision of pure paint, delicious, amazingly rich and refreshing, as only the works of a true painter can be. His handshake was firm, so was mine. He asked me to come and see him whenever I was in France. There was no other occasion. A few months later he was killed in a motor accident.

Giorgio Morandi

I visited Morandi at his home in Bologna a few days after I had called on Derain, with the same friend and for much the same reason.[53]

Our visit to Morandi began sadly. That year the Americans – dealers, collectors, and just busybodies – had discovered Bologna! They all wanted to buy Morandi's works, no matter what, drawings, etchings and paintings, and be able to gossip later about the artist Morandi whom they had met in person. Because of all this commotion Morandi contracted a nervous diarrhoea! Whenever the bell rang he had to run to the lavatory.

He told us very politely that we were already the fourth group of people he had seen that afternoon. I asked whether he would rather we came again the next day. 'No, no,' he answered nervously. 'Tomorrow, after tomorrow may be worse.' He left the room. I felt like leaving too. But my friend's business was of some urgency; he was handing over his collection of modern Italian art for an exhibition in a provincial museum and he felt that his collection was not complete with only one Morandi; he hoped that Morandi would be sympathetic to his cause and sell him some drawings and at least one other painting.

While Morandi was out I had a good opportunity to look around his workroom. It was late afternoon and the room was lit with one naked bulb of low voltage. The walls were tall, painted white and had one long narrow window which at that moment was deep blue – almost black – with a crescent moon in the top corner. A three-legged easel (the kind that Victorian spinsters used) stood there with an unfinished painting of minute pale pink roses. Against the left wall was a small platform and a table covered with a grey tablecloth, and on the table was a slender white vase containing pale pink roses, the model for the picture on the easel. The floor was by far the most cluttered part of the room; a narrow path led from the door to the easel and from the easel to a faded carmine divan – otherwise the floor was littered with bottles, all different sizes, shapes and colours. I had no difficulty in recognising some of the bottles I had seen in Morandi's paintings; only in the paintings they possessed a dignity and a life of their own, they became personages with an individual and secret poise! The live bottles had nothing of the kind. The nobility of the colours and the textures was obviously an invention of Morandi's.

When he returned and I explained my friend's business, Morandi became very serious and pensive. Like all people who are used to being alone, he talked nervously and fast, talking himself into a stammer. He said he would like to help.

But he was a slow worker and at the best of times he had little to show, but now with all those people coming and going he had still less. I translated this to my friend and my friend took a quick glance at the wall and requested me to ask Morandi for the picture he saw there. Morandi said yes, yes, my friend could have it, the spaces were not yet to his liking, but the shapes were good – he was very pleased with the shapes – the colour was also good, he was pleased with the colour, but the spaces were bad, incredibly bad, what should he do? He did not know when he would know what to do to make the spaces right, he could not make the shapes bigger or smaller, it was a tremendous problem! 'Well, your friend can have it but you must explain to him how bad the spaces are,' he said finally, then added that he had some drawings.

From under the divan he pulled out a large portfolio. With long, nervous fingers he tried to undo the knot which held the covers together but could not; he used his teeth, but still the knot wouldn't budge; he pulled both covers but the knot only tightened; he pulled even harder at the two ties, still knotted together, tore away from the covers and leapt into the air like a snake out of a magic box. The covers fell open. Morandi gave a sigh of relief. He turned drawing after drawing with such rapidity that all we could see were objects in continuous movement, not unlike the early 'flicker-pictures' with which people used to amuse themselves in pre-cinema days. Nevertheless, my friend managed now and again to notice a drawing which interested him and would gently stop Morandi's hand. Morandi would take the drawing in both hands and quickly respond: 'No, no, no, this one is too bad.' This was a little puzzling, for very often the drawing so condemned would be signed. My friend asked me to draw Morandi's attention to this fact and the reply I received was illuminating. 'It took me a long time to understand why I was so dissatisfied with the signatures on pictures or drawings, my own and by other painters. The line is conditioned by the shape of the letter and therefore is by its very nature different from the line in drawing.' He turned towards me, 'Have you noticed that?' I said I had, and for that reason I had given up signing my own work. 'Ah, I did not give up,' said Morandi, 'I found a solution. If you think of the signature while you are still drawing and use the same line as in drawing, the signature becomes a decorative part of the drawing. But you must practise. It takes a long time. Tell your friend that is the reason why even bad drawings of mine sometimes carry a signature. Yes, sometimes...' Seeing by my face that I was not very enthusiastic, Morandi added: 'A line in writing comes naturally, but a line in drawing through years of cultivation becomes our distinguishing line.' Then I looked carefully at some of the signatures, and more often than not they had the same quivering tentativeness as the lines in the drawings. What had now become clear was that all this colossal unity of design and signature was part of a conscious quest.

Morandi began showing signs of tiredness. He handed over the whole portfolio to my friend and sat down on the platform at the foot of the table. I could see now very little of his body; two very tall columns of legs, two long arms supporting the pale oval of the bespectacled head.

In a low voice, as though to no one in particular, he mused: 'What do all those people look for in my bottles?' I looked at him and he now looked at me. 'It is already forty years since I looked for some element of classical quiet and classical purity, a moral guidance perhaps more than an aesthetic one.' Then he changed the direction of his meditation. 'It takes me weeks to make up my mind which group of bottles will go well with a particular coloured tablecloth. Then it takes me weeks of thinking about the bottles themselves, and yet often I still go wrong with the spaces. Perhaps I work too fast? Perhaps we all work too fast these days? A half dozen pictures would just about be enough for the life of an artist, enfin, for my life.' And unexpectedly he asked me, or perhaps I imagined it, perhaps the question was just another link in his monologue: 'Who is the greatest modern painter? A silly question but I think about it in some rare moments: undoubtedly the Douanier Rousseau.[54] Enfin, pour moi...' He asked me to follow him into his bedroom and proudly pointed to a picture on the wall. It was a flower piece in pale whites and pale greens and pale pinks, signed by Rousseau – the most Morandi-like Rousseau I have ever seen.

Paul Klee

Whatever Klee's difficulties might have been with the public – for years he could hardly sell a thing – painters always respected his gifts. He was a painter's painter. He aroused no conflict in other painters. Unlike his friend Kandinsky, Klee did not come to change the course of painting. He brought together what had been invented since the Fauves and the Cubists and made use of it in a highly personal way. Even as a theoretician he said nothing which was not on every other artist's mind, but again, he said it so much better and so much more beautifully and in so much more personal a way than anybody else. His essay 'On Modern Art' is a masterpiece of imagination and language; it is also a map of one man's soul. Self-knowledge was very important to him and painting as well as writing was to him a means of unifying, or what he called 'bringing order' into his internal life. 'What counts is to be a personality, or at least to become one'. Until the end of his life he referred to his pictures as mere 'signs that I have been *there*'. The '*there*' was his real world.

When still a young man, Klee was clear in his mind about the kind of painter he would eventually be. As far back as 1902 he wrote: 'I want to do something modest; to work out by myself a tiny motif, one that a pencil will be able to hold without any technique. One favourable moment is enough. The little thing is easily and concisely set down. It was a tiny affair but a real one.' Hence his preference for the tiny pieces of paper or cloth he used for his images. With the exception of a few short years when pressed by his dealer to paint larger pictures – which Klee tried and failed at, and after the unsuccessful exhibition of these – Klee never touched so-called 'large paintings' again. The late Jankel Adler, who was for a time an intimate friend of Klee, once described to me Klee's work table: 'Three sides of the table were piled up with finished or unfinished pictures; the smaller the size of the pictures the larger the pile!'

Through trial and error Klee had also to find what was most natural to his medium, I think he knew that he was a poor painter in oil and used oil colours as little as possible, always returning to watercolours in which he excelled, and to mixed media which gave him the fullest scope. But even admitting Klee's excellence as a watercolourist, too often there is something wrong with the stylistic components of his images. If we compare Klee's pictures with other modern masters of watercolour, for instance, the 'one hundred unpainted pictures' by Nolde, we can see at once Klee's stylistic difficulty. Like all teachers of the Bauhaus, Klee was obsessed with the idea of mixing the 'fine arts' with the

'applied arts'.[55] Over much of Klee's work hangs a rather thick veil of *Kunstgewerbe* in spite of the fact that of all teachers Klee was the least gifted in applied art; only one tapestry exists which was made after a design by Klee, and this is far from being something which provokes rapture. Klee was a pure painter with a strong mystical response towards moods of nature, and sensitive in the extreme to the poetry of his own feelings. The more his squares of colours radiate this mood of nature and this inner poetry, the truer they are as works of art and the greater their expressionistic power. The symbols he invented may thicken the atmosphere of the surface and make his pictures look like a strange alphabet, but they never belie the authenticity of the underlying experience. He and Morandi are the two great quietists in modern art. In any ways both are saintly figures.

Because Klee often achieves the simplicity of a lullaby, many people were tempted to see in his works a kinship to children's drawings. Klee himself, in humorous though not uncertain terms, repudiated this. His was a process of continuous refinement and sophistication. And although his object was 'to be almost primitive', simplicity did not come easily to him. He had to work towards it, and work hard. He was the first to know when he had achieved it. His work is cultured in the same way that precious stones are cultured.

Having disposed of objects and forms he set himself a free use of shapes, line and fantasy; as for stimulation, this came to him from the study of the decorative and calligraphic elements of many cultures. His pictures needed no other structure; these elements were enough to give his pictures a 'pure-painting' look, though their appeal is primarily literary, poetic and philosophic. As Klee wrote: 'Thought is the father of feeling.'

His studio was sometimes a laboratory for experiments, sometimes a theatrical stage, sometimes a street pavement with children playing and drawing, sometimes a lunatic cell or a hermit's cave, but most often it was only a painter's work-room.

Jacob Epstein

Every artist living in a community other than that of his native land must expect some degree of suspicion. After all, nobody has asked him to make his home there. He arrives with a parcel of hidden gifts that the indigenous people are not sure they want. For his part, to prove himself often implies a refusal to assimilate traditional modes which are not his. A trial of strength follows, a battle not always fought in a fair way. But no matter who the stranger, it is he who started it. He is the intruder. If his intentions – however disinterested – do not manifest themselves in a way which is acceptable to the 'natives', they may be mistaken for arrogance – as Epstein's were.[56]

There was no precedent for Epstein in English sculpture. His blunt humanity, his pathos, his lack of reserve, his unashamed wearing of his heart on his sleeve, are qualities not easily detectable in an Englishman nor indeed in English art, but they were his, from his mysterious parcel of gifts, and also from his Jewish background. The roots of Epstein's attitudes lie within the wider European tradition. Many of his conflicts in England can be put down to a collision of temperaments. But that is not all. To appreciate more fully Epstein's position in English life and art, something else has also to be considered: English sculpture – what there was of it – was due to come out of its doldrums and it was pure coincidence that it was Epstein the stranger and not a native Englishman who made the first move. And the way is never smooth or easy for pioneers. He was one of a handful of artists, but in sculpture he was alone.

The generation which followed, though willing to acknowledge his pioneering spirit, saw no relevance to their problems in the direction he had taken. True, there was none; theirs were problems limited to their time, his preoccupation was with history at large. He could have lived in any of the last six centuries and been equally at home. He happened to live in ours. He was in the great tradition of well-made sculpture, of naturalism-plus. Others were on a feverish quest to make sculpture new. They left him at a revered distance – well, perhaps not always revered. And if Epstein had good reason to lose patience with the way sculpture was going, he showed little desire to affect its course. He stood aside, though not always silent. He remained alone and undisturbed in his ways. And so he produced masterpieces of a highly personal order. To think there are still 'connoisseurs' and even artists who sneer at the very mention of his name!

His gift lay in his sense of clay, and what a sense it was! I once arrived at his studio when he was working from memory on the head of a child. I stood behind him and he merely said: 'One minute, Herman, and I'll be with you.' And

he carried on. Every modeller, when pulling a piece of clay from the larger lump, presses it between his index finger and his thumb to tell whether it has grit in it – if it has, he throws it away and pulls another bit. Thus around my feet there was soon a small pile of rejected flakes of clay. I bent down an took one of them in my hand and I could not believe my eyes. And I took another flake and another – each flake as already a recognisable Epstein long before it had any form. He had his genius in his fingertips, not metaphorically but literally! But this very sense of his for clay has often been held against him – 'Epstein? He is merely a modeller!' – and it is not only the ignorant who say this! The twentieth century has done much to revive the art of carving. Because of this, all the prestige of sculpture goes to the carver. This, typically of our time, is to make a mountain out of a mole-hill! The art of sculpture can only be limited by the nature of an artist's gifts and not by a definition. Who is to say that a sense of clay is less of a sculptural gift than a sense of stone or wood? Epstein's failings as a carver prove nothing; in his early days under the influence of tribal African carvings he produced a sufficient number as good as any of his contemporaries. The fact is, however, that his greatness lies in his bronzes.

To Epstein, material was not an end in itself. In this also he differed from other sculptors of our time. While others made a great to-do about the material and explicitly linked it to the mystery of *nothingness*, Epstein took his material for granted and filled it with strong emotions, so that his surfaces suggest the animation of life. His style, and he was fully aware of it, was something elementary, pre-conditioned by nature, as all individual, true styles are. In an age when style is thought to be an invention (a gross one at that!) he was once again bound to cause some misunderstanding.

Epstein, like other great lone wolves of our time, did not labour to convince mankind about artistic causes. Whatever he achieved in style was by way of searching for a strong and exact expression. Here, once again, I need to draw attention to the significance of the texture of his work; the rugged pattern engages all our attention, and before we are aware that it makes a neck, an eye, or hair, we are presented with emotional confidences at once primitive and refined, intense and direct. We are faced with a scorching sensitivity, dazzling our defenses and making us see humanity in an art which, expressing itself through a subject, transcends it. Matter becomes alive because of the spirit within it.

He worked around a theme, a universal theme, of man. To that theme he devoted all his conviction, trusting his two thinking hands and being guided by them. He linked one work to another with that secret logic of his inner vitality, and instead of a concept of art we are left with something much rougher, less elegant, not always easy to bear, something so elemental it is almost as if we were being made aware that we are born with a cry!

He grew old, but not disappointed, nor frightened, nor bitter. The last time I saw him was near the Burlington Arcade. He was as alive as a young tree! His creative powers had not left him – 'Not yet,' he said, laughing. He must have still been full of them when he died.

Henryk Gotlib – Portrait of a Friend

It is rather inhibiting to write about a painter who was also an excellent writer – in his native tongue, of course – and who has left no mean body of writings.[57] Gotlib has written two books: one on Polish painting, published in London during the last war, and one considerable work: *The Travels of a Painter* which is now being translated into English and may soon be available to the British reader. Besides these he has also written a number of articles, essays and polemics, all in impeccably beautiful language.

Not only his writings but his conversations, too, were characteristic in their individual flavour and precise thought. I remember once going with him round the large Monet exhibition at the Tate, some years ago. While concentrating on the pictures, he said very little, but on the way out, on the steps of the Tate, he suddenly stopped, looked into my face, and said: 'You know, there is something quite great about him. All his life Monet was what I would call a prose painter, but by the end of his life, already three-quarters blind, with the lily-pond pictures, he became a poet. He struck true art!'

Gotlib was short of stature but broad in the shoulder. A pleasant, longish face, dark in the summer, sharp eyes and shining white hair. In his younger days, when his hair was black, he looked very Latin. His manner was that of a highly civilised man. He was a socialist by conviction and a democrat by instinct, tolerant of other people's opinions, warm-hearted and lovable. Most memorable was his voice: soft and passionate, it had something of the secrecy of twilight. Its quiet sound made people want to listen to him.

Most of his ideas were shaped around painting and all his writings were about painting – not generally about art, but specifically about painting. He was interesting to listen to on other subjects but there could be no mistake that here was a painter speaking his mind.

In his paintings, he would use his intellect more often, perhaps, than other painters; he not only did things in a certain way; he also wanted to understand why this was for him the only way. His mind was constantly active and his eyes were constantly watchful. He was a hard worker; he worked all day, every day. In his notes we often come across this kind of phrase: 'It got dark and I had to stop painting.'

He had a sensuous love of pigment and for many years he was in search of a scheme of colours which would express this sensuality absolutely and completely. As a young man he found his mentor in Bonnard. Here I must digress for a

moment. Gotlib was of the generation of Polish artists for whom Paris in the 1920s was a Mecca. Their formative years were devoted to a complete assimilation of the ways of the great modern French painters from the post-Impressionists onwards. While most European painters of the time did the same, what distinguished the Poles was their worship of Bonnard. Gotlib tells us why, but first gives the plain fact:

> 'Pierre Bonnard was a French painter whose influence on European art and particularly on the younger generation of Polish painters was of such significance that the date of his death is also an important date in the history of our own art. Now that we shall no longer see new canvases by Bonnard, this is perhaps the right moment to understand in what sense and to what degree this painter marked the way for Polish painting for at least twenty years.'

To make his point, Gotlib divides all French painting since the Impressionists into two main streams: one structural and formal, which comes from Cézanne, and the other of pure colour composition, which comes from Bonnard. Gotlib further asserts that having chosen Bonnard as their guiding spirit,

> 'Polish painters remained true to our tradition of painting, and our natural inclinations, which have always been an enthusiasm for colour and a disregard (noticeable in all epochs of our art) of structure of form and style.'

This love of colour was in Gotlib quite fundamental. In the closing chapter of his book *The Travels of a Painter*, a chapter to which he gave a precise and telling title: 'In the Land of my own Vision', he tries to explain each phase of his arrival at seeing the world in terms of colour 'independent of the physical reality of objects'. Philosophically, he concludes:

> 'This world of colour is real though it cannot be tested with the sense of touch, just as the existence of the human soul cannot be tested with the sense of touch. This way of feeling and seeing the world is, or can be, just as unquestionable as feeling the ever-presence of God is for the religious man.'

Having arrived at such an intense way of looking at the world, one critical summer, in a fishing village in Brittany, Gotlib worked out his own 'blond palette'. From his pictures it is not difficult to reconstruct the small range of colours he left himself with. Blacks and browns were out. The darkest colours were now one or two ochres, cobalt blue and violet. The colours that dominated this palette and gave it a 'blond' look were orange, yellow and red (from which he extracted his pinks) and, of course, white. If there were any other colours on the palette – possibly one or two greens – they were there in a sort of subsidiary capacity. What is also certain is that no colour was used at full strength; each was dissolved in vapours of subtle tones, corresponding to a state of pure feeling; with this palette of predominantly 'paradise' colours, Gotlib also hoped to transcend physical joy into mystical certainty. He even felt compelled to point out in an article called 'Mysticism and Reality' the link between the act of painting and mystical experience.

This whole period of intellectual and artistic activity which lasted well into the 1950s was in many ways a period of 'cloudless happiness' – a happiness which marked also his external life. I know of no other modern love story which so well corresponds to the unfolding of the story of one man's art. In 1938 Gotlib married Janet, a girl many years his junior. In her very appearance she answered all his artistic cravings. Janet stood for paradise, for youth and joy. Gotlib had an immense gift for connecting facets of life with facets of art. And the world was filled with Janet's presence. We would look at quite an ordinary meadow which had a bit of yellow here and there and a rose light on the texture of the grass. Gotlib's face would light up and he would say with much satisfaction: 'This field has all the gleam of Janet's flesh'. Many a still-life was brought to a conclusive unity after it attained the overall peach-like colouring of Janet's youthful cheeks, and Gotlib would tell you this when showing you the picture.

Because Gotlib used the 'blond palette' for such a long time, people failed to recognise that he was searching for other things besides. In the late 'forties, in a letter to his dealer, Gotlib wrote:

> 'Sometimes people call my pictures Bonnardish. I think this is not right. Bonnard paints atmosphere. I paint the thing itself. It means Bonnard is impressionist; I am not.'

There is some truth here. By aiming at painting the thing itself, Gotlib hoped to give himself a classical discipline. He also tried to give his pictures a muralistic texture and a monumental bigness. A picture like 'Paradise' is one of the more consistent realisations of his classical aspirations. Nevertheless, the most personal expression in his painting had yet to come.

It is impossible to say when the new mood unsettled his imagination; his was a constant backward and forward traffic of creative ideas. After months of work in one direction, he would take out an old picture and if he found it good, certain of its elements would find their way into the new pictures. However, from the late 'fifties until his death he battled with the realisation of a new kind of vision. It changed his mode of painting considerably; perhaps also him as a man.

In his outward appearance Gotlib still seemed the same. He remained good company. He could still laugh with the whole of his body, and yet... About what mattered to him most, his paintings, he spoke now very little and with great difficulty. To see this highly articulate man now groping for a word in between long and oppressive silences was something unexpected and puzzling. All I can say of his last visit to me, in the summer of 1966, is that he strongly stressed his mistrust of words. He gave up writing completely. 'Perhaps we need new signs,' he said uncertainly, and fell back into another long silence. It became obvious that he was now caught up in the most dramatic eruption of sombre feelings.

As regards his work, the subjects did not change: it was still the landscape, the still-life, the nude. In some works of the late 'forties black had appeared as an arabesque line and sometimes even as a colour, but now it began to dominate the picture. He now used colours for their emotive force rather than for their

sensual glitter. He did not mind even when colours became dirty, or if the textures became rough, as long as he obtained the intensity he was after! It was this intensity that was his final obsession. Even the models he worked from (this habit continued to the last), whether a girl, a field or a group of trees, were now less important in his battle for expression. The actual vision which stimulated the painting came from inside himself like a helpless groan. Even Janet was outside him, though on the everyday plane his love for her did not diminish. But he no longer wanted to paint her, or other women in her image. He was now alone and very conscious of the inevitability of human loneliness. His works now had all the marks of a personalised expressionism and it is small wonder that from time to time we find in a picture echoes of Kokoschka, Munch or Rouault; but none could claim a lasting influence. That the echoes can be found shows only how desperately Gotlib was battling to get away from the purely visual, purely tactile and purely colouristic, and how desperately he was trying to externalise what he called the 'energies of the spirit'. If we compare any nude of the 'blond' period with the later nudes we will see immediately and far better than words can describe the nature of the change that Gotlib had undergone. The early nudes need no comment. They were a tribute or hymn to the eternal girlishness in woman; one never thinks of them as potential mothers! Whatever else they may be they are on the canvas for their rose colour and for the erotic rôle assigned to them in the tapestry of the 'earthly paradise'. It is the other nude of the later years that puzzles. First one is struck by what Rouault called a 'holy clumsiness' in the very execution. No *belle peinture* here. The contrast is stated with the directness of a scream. And when we look for details, there are few – most have been absorbed in the process of simplification. Why are the nipples of the breasts black? On the psychological level their blackness may indicate the non-sexual intention in painting this nude, but what is more likely is that the two black blobs belong to the calligraphy of the design, as do also the heavy black lines of the legs which are in this way made to dominate the whole composition with their desperate force. Gotlib knew and admired Far- and Middle-Eastern decorative arts and was particularly drawn to the expressiveness of the brushwork in their lettering. And in this spirit he used the black lines to stress strong emotions. This nude may be sexually repulsive, but as an image she is easier to identify with precisely because of the painful humanity Gotlib invested in her. Admittedly this nude belongs to the most extreme examples of Gotlib's new direction. There are other pictures of the same time, easier to take, but it is the extreme which is the norm of an artistic quest.

Gotlib had a life-long love for all archaic arts, yet it was only now that he was actually involved with the liberating forces of primitivism. He opted for a more spontaneous way of working, so that no second thoughts could unsettle him with doubts. Whether he knew it or not, this is the significance all expressionists ascribe to rapidity of work. This does not mean that his way to the final expression was not tortuous and at times even slow; he often had to put away a canvas for weeks and then return to it. We can also see scars on some surfaces from the

impatient scrapings of large passages of paint with a razor blade. But each time he returned to a picture it was like attacking it anew, quickly, with a fury, not merely 'to correct mistakes'. Though there are quite a number of pictures painted at this time which are excellent in themselves – for instance, the admirable self-portrait – it is nonetheless their totality that unravels their significance and is a monument of artistic sincerity carried to the limits of one man's gifts. It is my belief that with this group of pictures Gotlib, too, 'struck true art.'

Albert P. Ryder

I do not know why, but making a list of painters who worked on my imagination, and paintings which have changed the course of my life, seemed to me more than a mere pastime; it seemed to me at one time an important and even urgent task. Ryder was one of the artists on my list.[58] When I was in New York in 1972 I re-experienced most vividly the feeling that I had had on seeing a picture by Ryder for the first time. This experience came too late in my life to have any influence on me, but like steel girders in concrete, it reinforced my beliefs, it added strength to my obstinacy, and confirmed my belief that the artist stands alone, no matter what. In this sense he became part of my autobiography. Also, in New York I heard many harsh words spoken against him and he was made the scapegoat for the cultural anarchy, for social disintegration and what not. The point here is that nineteenth-century America produced two artists who have a great bearing on the division in American artistic opinion today: Eakin[59] and Ryder. Those who think highly of Eakin have no good word for Ryder and the followers of Ryder are just as unfair to Eakin. I never had much patience with artistic disputations. No artist can help being what he is, no artist has any say in the nature of his talent or his genius. Eakin is Eakin and Ryder is Ryder and camp followers cannot change this. If an artist, by the nature of his temperament, feels himself drawn to one, this does not mean that he has to abuse the other. Viewing an artist's work, or what is called art criticism, is also a matter of compassion. At least, that is how I see it.

All the pictures by Albert Pinkham Ryder that I have ever seen were small canvases, and they were invariably big in design and far-reaching in vision; in fact, so far-reaching that were it not for a cloud or two their space would be as immeasurable as the source of light he liked to indicate. The only thing which brings his eternally turbulent seas nearer the human scale is the lone sail amidst the waves. Considering how often he repeated this single subject, we can see that all his striving was for an exact externalising of an inner vision, and for this a limited number of subjects is sufficient. The light, the cloud, the sea and the boat, and over and over again the same territory of experience. How solemn and severe; how grand, how universal and how intimately human; how sad, joyous and serene; how ecstatic; how restless and still and peaceful the final contemplation of a picture by him eventually becomes. One is voiceless with wonder. And all the magic of his pictures has been achieved with the least fuss about colour. The pictures are almost monochromatic. They are dark against bright, graded with nuances for which music has specific signs and words have not.

One of his most brilliant pictures is 'Toilers of the Sea', in the Metropolitan Museum, New York. The picture has a glow of bright colour which cannot be measured by any professional standard. Its radiance goes beyond the picture frame and seems stronger than anything in nature. The pigments here were guided by the luminous strength of his own spirit and this is why the picture has a spiritual rather than a physical effect on us. Of course, such a light presence could only have come about through Ryder's immense capacity for observation, but also through the spontaneous transformation of the physical into terms of spiritual experience. Blake, who had no such sense of observation, could never realise, but only hinted at, the light of his inner striving. Ryder, better than anyone, knew the sun and the moon intimately, but to follow either on an optical track was not his purpose; this is why he could not but transform the lure of dull naturalism into a voyage of rare excitement.

There is not a trace of self-consciousness, nor of striving after virtuosity in performance; only the work of a labourer who loved his material and had to get to the last layer of his experience no matter what the technical price. He took technical liberties not out of arrogance or disrespect for the material, but out of innocence and impatience. He was a 'better' painter at his beginnings than in his more mature life. But each picture bears out his devotion to painting, the sincerity of his mind. And even if many of his pictures wear badly, we still have to admire the unique humanity of his vision. A warm heart, uncompromising in its communication. A witness to our spiritual depth.

Jean François Millet

Some years ago, a representative exhibition of works by Millet was held at Wildenstein's Gallery in London.[60] From the reviews it was obvious that the critic's attitude towards Millet and his work has changed; he was welcomed by one and all.

I am old enough to remember the time when to utter Millet's name brought laughter on one's head. Every writer on art and every artist who thought himself 'of our times' either ignored him or damned him.

It is difficult to understand what has brought about the change. In many ways young artists of today are further removed from his spirit than at any time before. Perhaps the great popularity of Expressionism has had something to do with it. With such works, human values came once again to the fore; between man the psychological being and man the social being there is only a narrow line; but it is a dividing line, and a line which cannot be ignored. Be that as it may, Millet was no longer ignored, he was even praised; where, before, they had seen only 'sentimentality' they now discovered 'poetry'. The frequent accusation of 'trite folksiness' gave way to the acclamation of an artist of 'ideas'.

Of course, scholars will go on debating whether 'The Gleaners' is Millet's only masterpiece or whether pictures like 'The Sower', 'Going to Work', 'End of the Day' and one or two others also deserve the title. But the silly season, I think, is over, and Millet has his rightful place among the great, both as painter and as draughtsman.

Denis Sutton did a useful piece of demolition work regarding the 'Millet myth' in his excellent introduction to the exhibition catalogue. For instance, he pointed that in intellectual terms Courbet was a stonebreaker, and that far from having a narrow, bible-shaped mind, Millet was in fact, after Delacroix, the second best-read painter of his time.

What about Millet 'the peasant's painter'?

Naïve as Sensier's understanding of Millet's works may have been, it was he who noticed with unusually fine perception that: 'The peasant is to him a living being who formulates more clearly than any other man, the image, the symbolic figure of humanity.'

The softness with which Millet often approached his subject is a little confusing, but once we have overcome this we can see his quest more clearly: he was after a human presence as haunting as if it had come to him through the channels of fantasy.

In this context, Millet's leaving Paris – to return only for the occasional sale of a picture or drawing – his 'escape to Barbizon', was something of a challenge to big city civilisation; but it also had some of the purposefulness of Gauguin's escape to a distant, sunnier place. Both were quests for something basic if not primitive, free of the smartness and sophistication which obscures the elementariness of human existence. Hence, the symbolism of Millet's giantific forms is of greater significance than the realism upon which it was based.

This quest always represents to the artist an intellectual ordeal and Millet accepted it, as do all artists who are sure of their destiny. The wrangle with the angel had already begun before Millet arrived in Barbizon.

The supposition that when still in Paris Millet was completely absorbed in 'museum art' is wrong. Years before his departure to Barbizon, he had already made 'excursions' to the 'other Paris' – the working-class suburbs – and there exercised his hand and eye with formal ideas from reality. And it was also while still in Paris that he made his first efforts towards an image of pantheistically-united man and nature. What was missing was a subject still nearer to his heart which would unite his creative energies into one coherent synthesis. Barbizon fulfilled this need and it was the peasant figure which thus became necessary for its revelation.

Millet's letters of that time are very lyrical – the most recurrent words refer to the 'poetry' of what he sees. At the same time – in spite of his drawing continuously from nature – his work developed a mythological density, a vastness of form and design, a simplicity very much akin to the primitives of any people – Italian, Flemish, French and even non-European.

An inability to penetrate the link between Millet's primitiveness and his symbolism is at the heart of much of the misinterpretation of his art. Even an art critic of such fine insight as Baudelaire could write that Millet's peasants have 'altogether too high an opinion of themselves'. This is the risk every painter true to his vision takes: that the letter might be mistaken for the spirit!

It is often forgotten that while for painters like Millet the subject matter may be part of their socio-moral sensibility, it is still more indispensable to the aesthetics of their style.

Gustave Courbet

Of the three great French painters of the first half of the nineteenth century – Ingres, Delacroix and Courbet – Courbet is the least written about.[61] A complete bibliography would hardly take up more than a modest page. Of course Courbet's politics and materialistic philosophy had something to do with it then, but has it still today? It is true that he is a very 'uncomfortable' painter to write about – as one historian has said, 'Even a criticism of his works has to be a sort of commitment.' Despite Courbet's profession of objectivity, it is difficult to keep his personality out of his work if only for the purely subjective reasons that he was the first modern poet of painterly matter, that so much of him is already in the very act of handling pigment; handling paint must have been, to him, as much of a joy as handling colour was for Delacroix.

We owe to the Cubist theoreticians the discovery that much of Courbet's effect lies not only in the presentation of the matter of objects, but even more in his handling of painterly matter. They saw him as their uncle in pure painting, their father being, of course, Cézanne. Making old masters do the job of the modern is a bit like recruiting convenient witnesses, but in this case the truth reveals what has for a long time been a secret if not an outright mystery: Courbet is the poet of painterly matter. Long before the Cubists, Pissarro had written that Courbet was the master to whom 'we moderns owe everything'. But Pissarro and the Cubists did not mean the same thing. Pissarro, for instance, saw that the materiality of painterly matter can be combined with the science of optics and be none the worse for it. Also it may fit the social subject in its crucial battle against the historical subject of the academicians who no longer knew how to care about paint and in whose hands paint disintegrated completely. Though there was a difference between the Impressionists and the Cubists, there was not a contradiction; both set their values on what they rightly understood to be Courbet's supreme originality.

But here Courbet's complexity does not end – rather it begins.

Courbet was a great designer, though a poor draughtsman – if we restrict drawing to the media of pencil, chalk, charcoal and other black and white materials. But this has not affected his tremendous sense of design one iota. His 'Stonebreakers' has all the rhythm of any great frieze ever conceived by an artist: the line of the boy's arm down to the hand begins the most wonderful wavy line which is carried to the shoulder, arm and hand of the old man holding the hammer. Thus the two silhouettes complete each other, not only by their tasks but

above all by the symphonic nature of their movement. Until Cézanne there was no such pictorial link of forms, and this Cézanne learnt from Courbet. Courbet did not compose pictures in the Renaissance Alberti-like way, he related forms in order to set off the plastic expression of the picture, and he seems to have been fully aware he could achieve this only through a well-thought-out design. That this was his life's preoccupation can be seen in the stretch of time from his Le Nain-like picture 'After Lunch' to his magnificent 'Grotto at Loir'. His landscapes testify to the consistency of his plastic concepts as much as his figures: in both cases his language of form is clean cut and incisive, in both cases austerity and energy, pathos and strength are brought together by an unfailing sense of cosmic unity.

Much has been written about Courbet's 'savage' treatment of men and women in his pictures; he has been accused of bringing them back to their animal nature. Well, it is perfectly true that in his portraits as well as in his subject pictures Courbet departs from the canons of 'physical beauty'; and some of the heads in the painting 'The Funeral at Ornans' do have the expressiveness of a Rouault. But this is to invest the physical presence of man with moral stature – that is to say, to remove his further from his 'animal nature' rather than to portray him in his animal skin! Baudelaire put it this way: 'Here is a painter, a true painter, who makes us see how grand and noble we are behind our shabby ties and workaday jackets.'

Courbet painted man with as much compassion as any humanitarian before or after him. He has been represented too often as a hard-boiled realist. Courbet himself sometimes wanted it this way – it was a pose. In fact, Courbet was a poet, at times lyrical but more often a great epic poet. What would Courbet's realism have been without his sense of wonder, without his sense of the dramatic and without his power? It is difficult to say.

That Courbet wanted his reason to govern his painting need not be taken too seriously, for the very act of painting played havoc with his best-laid plans. Being a true painter he accepted his destiny. He painted from the position of his passions.

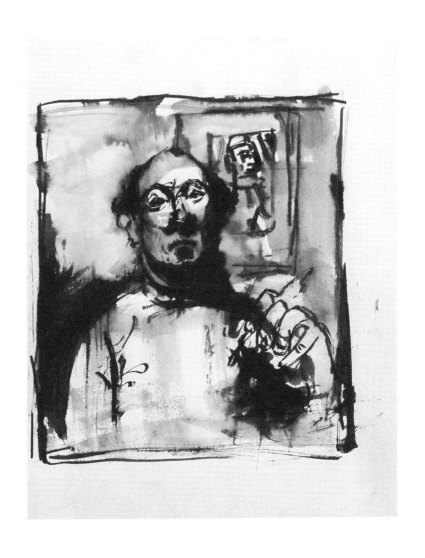

Notes

1. Nini Herman: *Josef Herman A Working Life*, London, Quartet Books, 1996, Josef Herman's 'Reflections on Drawing' essay, pp.220-24
2. *ibid.* p.221
3. Nini Herman: *My Kleinian Home - into a New Millennium*, London, Karnac Books, 2001, pp.67-68
4. *ibid.* p.157
5. Bridgend, Seren, 1997
6. *Josef Herman: A Working Life* p.101
7. *ibid.* pp54/55
8. *Related Twilights* p.131 (page references given for this edition)
9. *ibid.* p.145
10. *ibid.* p.158
11. *ibid.* p.154
12. *ibid.* p.52
13. General Joseph Haller led almost 20,000 Polish soldiers on the western front in the First World War. They were known as 'Haller's Army', or 'the Blue Army', as they wore blue uniforms. The history of Poland during and after the First World War was complex and confusing: both German and Russian forces fought their way into the country; as Josef Herman's account indicates, it must have been very confusing even for those who fell victim to wave after wave of occupation and pogroms. Celebrated as a war hero by some Polish-Americans, the darker side of the return of Haller's troops to Poland is less well known.
14. Aleksandra Mikhaylovna Kolontay (1872-1952) was one of the leading Bolsheviks and became an ambassador for Soviet Russia before losing her influence. She was, infamously, banned by the USA from travelling across America to reach Mexico because of her reputation as a femme fatale.
15. Peter Kropotkin (1842-1921) was an anarchist aristocrat who was exiled from Czarist Russia, living and writing in England for about forty years. He returned to Moscow after the 1917 Revolution but died four years later in Moscow, disappointed by the direction that the communists were taking.
16. Rudolf Rocker (1873-1958) was a German anarcho-syndicalist writer and union activist. He was involved in setting up a federation of Jewish anarchist groups in England and Europe but was expelled from England after the First World War. He left Germany in 1933 when the Nazis came to power and spent his last years in the USA where he was the most famous anarchist in that country.
17. The Suprematists were an abstract movement begun in Russia by Malevich in 1913 and supported by the poet Mayakovsky. They emphasised the importance of minimal, geometric painting – white on black, black on white and, supremely, white on white.
18. The Constructivist movement was founded by Pevsner and Naum Gabo in Russia in 1917. Their *The Realist Manifesto* in 1920 was in reaction to Tatlin's social realism arguments. They emphasised the aesthetic values of art over the social and socialist purposes and championed the exploration of new materials in sculpture. Gabo was later an important influence on Henry Moore and Barbara Hepworth.
19. Leon Battista Alberti (1404-72) was one of the leading architects and art thinkers in Fifteenth Century Italy. He worked on major buildings in Florence, Rimini, Mantua and Rome and stressed the humanist value of the arts. His *Della Pittura* (1436), to which Josef Herman probably refers, was an important early discussion of perspective.
20. Edvard Munch (1862-1944) the Norwegian Expressionist is most famous for 'The Scream'. His early works were driven by personal grief and emotional suffering. He worked in Paris and Berlin before returning to Oslo where a large number of his works were bequeathed to form the Munch Museum.
21. Julio Jurenito was a fictional character created by the Russian Jewish novelist (not the biographer) Ilya Ehrenburg (1891-1967). Jurenito was the central character of *The Extraordinary Adventures of Julio Junerito and his Disciples*. A parody of the Gospels, this novel satirised both capitalist and communist systems and involved in its plot real figures such as Picasso and Chaplin.
22. Constant Permeke (1886-1952) is the Belgian artist most often cited as the major early influence on Josef Herman. With de Smet and van den Berghe, Permeke formed the second Laethem-Saint-Martin group of painters active before the First World War. Permeke was injured in the war and convalesced in

England. He became influenced by the German Expressionists Die Bruke and, in turn, was a formative influence on Herman. See later chapter for their meeting.

23. Joan Eardley (1926-1963) is now recognised as one of the leading social and landscape painters of Scotland. Born in Sussex, she went to Glasgow School of Art in 1940. Her concern with figure painting in the Glasgow slums may well have been influenced by Josef Herman. She is also known for her expressionist landscapes and seascapes inspired by her time living in Catterline, a north-east of Scotland fishing village. Joan Eardley died of cancer at 37.

24. Benno Schotz (1890-1984) was an Estonian Jew who moved to Scotland before the First World War and worked for a time as a draughtsman in Brown's shipyard in Glasgow. He enrolled for art classes at GSA and subsequently determined to be a sculptor. He eventually became Professor of Sculpture at Glasgow School of Art and many of his sculptures, including 'Rob Roy', are in public locations in Scotland. His early work was inspired by Rodin, but he later moved closer to the approach of Epstein.

25. Jankel Adler (1895-1949) was born in Lodz of Jewish parents. He studied in Barmen, Germany and after the 1914-1918 war settled in Dusseldorf where he was a friend of Otto Dix and Paul Klee; on returning to Poland he helped found the Ing Idisz group of young Yiddish artists, all expressing their Jewish identity and many working in an Expressionist mode. Adler later moved to Paris and met Picasso. He joined the Polish Army of the West in 1940 and was evacuated to Britain from Dunkirk. He met Herman in Glasgow, but soon moved to London where he associated with Colquhoun and MacBride, Minton, Vaughan and Dylan Thomas.

26. Paul Klee (1879-1940) was a Swiss painter who joined the Bauhaus faculty in 1921. In 1912 he had shown with Franz Marc, August Macke and the Blaue Reiter group in Munich. There he was again closely associated with Kandinsky and Feininger, with whom he helped found the Blaue Vier group. He commuted himself fully to the intensity of colour after a visit with Macke to Tunisia in 1914. He was given a major exhibition at the Museum of Modern Art, New York, in 1930 and received international acclaim. Not surprisingly, he was included in the Nazi exhibition of 'Degenerate Art' in 1937.

27. J.D. Fergusson (1874-1961) had, by the end of the First World War, established himself in Britain and France as a notable painter in the Fauvist style. With Peploe and Hunter, he is characterised as one of the 'Scottish Colourists' and was the subject of a major group exhibition in the Royal Academy in 1999. Was married to dancer Margaret Morris (see page 67) with whom he lived in London and France, returning to Scotland at the start of the Second World War. He founded the New Art Club in 1940 and the New Scottish Group in 1942. In 1943 he published *New Scottish Painting*.

28. *Ballet of the Palette* was a dance production by the Celtic Ballet Company based on an idea of Josef Herman's and performed in 1941 at the Lyric Theatre, Glasgow in aid of medical supplies for Russia. *The Scotsman* described this as 'an attempt to express in rhythmic dance the moods of different colours as they mix with each other... against the background, a huge palette.'

29. L.S. Lowry (1887-1976) the painter of the 'matchstick' figures of the northern working class, observed during his working life as a rent collector in Manchester. He was elected to the Royal Academy and now has an arts centre named after him in Salford. Both Lowry and Rousseau (q.v.) would have appealed to Herman's sense of recording and celebrating the lives of workers.

30. Ludwig Meidner (1884-1966) was born in Silesia and moved to Berlin to work as a fashion illustrator. He was greatly influenced by the Futurist exhibition there in 1912 and went on to form the Die Pathetiker group of painters. He lived in England from 1938 until 1952 when he returned to Germany. As Herman says, he was a prolific producer of prints, in the Expressionist style and with apocalyptic subjects.

31. David Bomberg (1890-1957) was born in Birmingham, the son of a Polish immigrant leather-worker, but grew up in London and studied at the Slade. He served in the First World War and continued to paint and write poems in that period. He exhibited at the N.E.A.C. between the wars, and was later associated with the London Group. He travelled widely and painted in Spain, Wales, Scotland, Devon and Cornwall, Palestine, Morocco, Greece and elsewhere. He was the influential teacher of both Frank Auerbach and Leon Kossoff and led the Borough Bottega Group of British Expressionist artists.

32. Martin Bloch (1884-1954) was born in Silesia and studied art and architecture in Berlin and Munich. He fled the Nazis in 1934 and eventually settled in London where he opened a school of painting with Roy de Maistre at which Heinz Koppel studied before moving to Wales. Martin Bloch himself worked in north Wales for a period between the forties and fifties and his 'Down from Bethesda Quarry' (1951) was commissioned by the Arts Council for the Festival of Britain exhibition that year.

33. Robert Colquhoun (1914-1962) and Robert MacBride (1913-1966) were 'the two Roberts', who, as Josef Herman writes, were a well-known 'bohemian', homosexual couple in London at the time. They were both painters, born in Scotland, whose reputations, particularly Colquhoun's, have grown in recent years. Colquhoun was at Glasgow School of Art from 1933-38. He served in the RAMC and was invalided home in 1941 and set up home and studio with MacBride. Their circle of friends included John Minton, Jankel Adler, Dylan Thomas and Wyndham Lewis and they were notoriously and deliberately badly

behaved in the London Fitzrovian set. John Minton (1917-1957) was a key Neo-Romantic painter in Britain, recently invalided out of the army when Herman knew him in London. His *oeuvre* included partly homoerotic paintings of young men in charged settings. Michael Ayrton (1912-1977) was serving in the Pioneer Corps at this time and painting army life in the Neo-Romantic style.

34. Itzik Manger (1911-1969) was born in Romania. He fled to London in 1940 and stayed until 1951 when he moved to New York. His *Humesh Lider* was a series of poems in which biblical figures appeared as Jewish figures living in the shtetl. He produced the lyrics for the Yiddish film musical *Yiddle with his Fiddle* and remains one of the most popular Yiddish poets. In 1969 the Annual Manger prize for Literature was established in Israel, where he died.

35. Dr. Henry Roland of Roland, Browse and Delbanco, Josef Herman's gallery in London from 1946 until 1981. Roland bought constantly from Herman's exhibitions and built a formidable collection of drawings. He published *Fifty Drawings from the Roland Collection* in 1974 and wrote the catalogue for Josef Herman's 1969 exhibition in the Scottish National Gallery of Modern Art.

36. The Contemporary Art Society for Wales was founded in 1937 after a meeting at the Great Western Hotel, Paddington. It has purchased four of Josef Herman's works: 'Head of a Miner' in 1946, 'Mother and Child' in 1950, 'Sad News' in 1958 and in 1961 'Two Miners'. The Welsh Arts Council was founded in 1962 and is now known as the Arts Council of Wales.

37. Josef Herman was introduced to this art by Jacob Epstein when they became friends in London in the early 1950s. Epstein encouraged Herman to buy examples of African carved art whenever possible from the Portobello Market. The Herman collection of African Art grew into one of the finest in private hands in the world. It was sold in a dedicated auction by Christie's in Amsterdam in 1999.

38. 'Shwmai' is the Welsh greeting, 'How are you?'

39. Vinchevsky was a Yiddish poet born, like Chagall, in Belarus. He later worked in London and the USA.

40. Josef Herman visited Mexico in 1965 and 1966; a number of drawings and paintings were produced. See *Josef Herman: A Working Life* pp.172-73.

41. Francisco de Zurbaran (1597-1660) was a notable painter of portraits, still lifes and religious subjects.

42. Goya (1746-1828) produced a series of late paintings known as 'Black' because of their harsh portrayal of life and painted while the artist lived in La Quinte del Sordo – the House of the Deaf Man. Herman would have seen such works as 'The Witches' Sabbath' and 'Saturn Devouring his Son'.

43. Bal-Shem-Tov (1698-1760) was a visionary born in the western Ukraine. His name means 'Master of the Good Name'; he published his vision of life in *The Holy Epistle*.

44. Pieter Cornelias Mondrian (1872-1944) was born in Amsterdam and later worked in Paris. He helped to found *De Stijl*, the influential journal which promoted abstract art, developed his signature geometric style and coined the term 'neoplasticism'.

45. George Hendrick Breitner (1857-1923) was an Impressionist painter in Amsterdam, much admired by Van Gogh.

46. Walt Whitman (1819-1959) was the major American poet of the nineteenth century. His long poem 'Leaves of Grass' is a lyrical vision of the emergence of modern America.

47. Frank Lloyd Wright (1867-1959) was a prolific, distinctive and hugely influential American architect of Welsh extraction. He was an early and important advocate of 'organic architecture' in which open space plays a significant role.

48. This work, together with several other major works, hangs in the Museé Royaux de Beaux Arts in Brussels.

49. Mario Sironi (1885-1961) suffered critically, as Josef Herman suggests, after the Second World War because of his involvement with the Fascists. He designed the Italian Pavilion for the 1937 World's Fair in Paris, but had been a prominent radical artist and art thinker throughout the period between the wars. Having volunteered for the Italian army in the 1914-18 war, he was involved in the manifesto *Against all Revisitations in Painting* in 1919, though he later moved away from his fellow Futurists and made films and several public murals. This work linked him irrevocably with the Fascists.

50. Jose Clemente Orozco (1883-1949) completed many major murals in public in Mexico, including the University of Guadalajara. From 1927-1934 he worked in the USA and completed 'The Epic of American Civilisation' at the Baker Library in Dartmouth College, twenty-four panels representing American civilisation from the Aztecs to the arrival of white man. Diego Rivera (1886-1957) was the most famous of Mexican artists and the most influential of muralists. A commuted Communist, he travelled widely, including the USSR, and befriended Trotsky when he lived in Mexico. He worked in Paris before the First World War and married the notable artist and beauty Frida Kahlo. In 1932 he was commissioned by Henry Ford to produce a mural for the Detroit Institute of the Arts, but in 1934 his mural for the Rockefeller Center in New York was destroyed because of its depiction of Lenin. David Alfaro Siqueiros (1896-1974) was consistently one of the most politically active artists: he fought in the Spanish Civil War and was, at the age of 64, imprisoned for organising a student revolt in the 1960s. He travelled

widely and ran a workshop in New York in 1936 where Pollock was among the young artists influenced by him. His murals are in many public buildings in Mexico and the USA.

51. Marsden Hartley (1877-1943) Born in Maine and exhibited with Stieglitz in New York, but travelled in Europe and knew Gertrude Stein in Paris. His German Officer Portraits were inspired by the loss of a young German officer, his lover, killed in the First World War. He later worked in Mexico and, in the thirties and forties, in Nova Scotia where his paintings of the landscape and the fishing communities were the works much admired by Josef Herman.

52. André Derain (1880-1954) was one of the leading Fauvists, with Maurice de Vlaminck and Matisse. He was commissioned by Volland to visit and paint London in 1905-06. He also painted Collioure with Matisse. He served in the French Army throughout the First World War and soon after designed ballets for Diaghilev. Between the wars he became more interested in classical art. His apparent collaboration during the German occupation of the 1939-45 war and family problems effectively finished his art and his reputation, though he continued to work on ballet design. At the end of his life his eyesight failed and he was killed in a road accident.

53. Giorgio Morandi (1890-1964) was born in Bologna and lived his life almost exclusively in Italy, teaching in schools and, in 1930, becoming Professor of Etching at the Accademia di Belle Arti. Winning first prize at the Venice Biennale in 1948 brought him international acclaim and his paintings were featured in Fellini's film *La Dolce Vita* (1960) as signifiers of sophistication and chic. As Josef Herman found, Morandi remained modest and somewhat reclusively focussed on his still-lifes. In 2001 Tate Modern had a high-profile retrospective. The Estorick Gallery in north London has a collection of Italian art heavily centred on Morandi's work.

54. Henri Rousseau (1844-1910) was the celebrated naïve painter, known as Le Douanier because of his years of service as a customs officer. His fresh, untutored approach would have held great attraction for Herman.

55. Bauhaus was the state-sponsored school of art, architecture and design opened in the Weimar Republic in 1919. Its first director was the architect Walter Gropius. It epitomised idealistic movements to enhance everyday life by better designed objects and buildings. The Bauhaus closed in 1933 under pressure from the Nazis who came to power in that year.

56. Jacob Epstein (1880-1959) born in New York, he studied with Rodin in Paris and later settled in England. He had been knighted the year before he met and befriended Josef Herman. An outstanding public sculptor of the early twentieth century, his most notable works include Oscar Wilde's tomb in Cemetery Pere-Lachaise in Paris (1912), the 'St Michael and the Devil' on the outside of the rebuilt Coventry Cathedral and 'Christ in Majesty' in Llandaff Cathedral in Cardiff.

57. Henryk Gotlib (1890-1966) was born in Krakow, Poland, studying there, then in Vienna and Munich. After the First World War he helped to form the avant-garde Formist group in Krakow, but soon moved to Paris and worked in a number of European cities, seldom returning to Poland. He settled in England in 1939 and the following year was invited to join the London Group.

58. Albert Pinkham Ryder (1847-1917) was born in New Bedford, Massachusetts and studied in New York with William E. Marshall. He had considerable success with his painted memories of the whaling communities of his childhood and later with scenes inspired by Shakespeare, Wagner and the Romantic poets. He notoriously loaded his small canvases with so much paint and varnish that they were prone to disintegrate, and many have not survived.

59. Thomas Eakin (1844-1916) was the most notable American Realist painter of the nineteenth century. He studied at Pennsylvania Academy of Fine Arts and, after periods in Paris and Spain, returned there to teach. Forced to resign in 1886 because of his use of nude models in mixed classes he stressed the importance of studying anatomy and was involved in the Edward Muybridge experiments with photography. Eakins is now widely regarded as a significant painter, while Ryder is accorded much less attention.

60. Jean-François Millet (1814-1875) was one of the most important painters in what became known as the Barbizon School, which included Theodore Rousseau, Jules Dupré, Constant Troyan, Charles Daubigny and Narciso Diaz de la Pena. These artists were influenced by the example of Constable in England whose work depicted rural workers and the life of the land as having significance beyond their calling. 'The Gleaners' has assumed an iconic importance in this movement of rural painters and Millet's later work dealt exclusively with landscape.

61. Gustave Courbet (1819-1877) was the major Realist French painter of the nineteenth century. Like Millet, he painted rural life and peasants, with great sympathy, though always in realistic settings. He was a socialist and was imprisoned for political activities in 1871. He died in exile in Switzerland six years later. His later seascapes undoubtedly influenced the Impressionists. Both Millet and Courbet were, clearly, informing spirits in the treatment of manual workers in Josef Herman's work.

Index

Acknowledgements

Josef Herman regularly left works untitled, which accounts for the lack of titling of work in this book, much of which belongs to the Herman Estate and has not previously been published. The majority of the drawings included (and some of the watercolours in the colour plate section) are works on paper sized 29 x 20 cm approx. Acknowledgement is made to the generosity of the Estate of Joseph Herman in allowing the reproduction of these images and those used on the jacket. The portrait photograph on the jacket is by J.S. Lewinski.

Three images require separate acknowledgement. The landscape on page 8 of the colour plate section is entitled 'Autumn', a pastel, 50 x 63 cm, in The Roland Collection. The peasant women on page 7 of the colour plate section is 'Cretan Women', 1979 oil on canvas, 91 x 71 cm, from a private collection in Wales, which also supplied 'Miner', 1951, mixed media, the left hand image on the back of the dust jacket. Grateful acknowledgement is made to both.